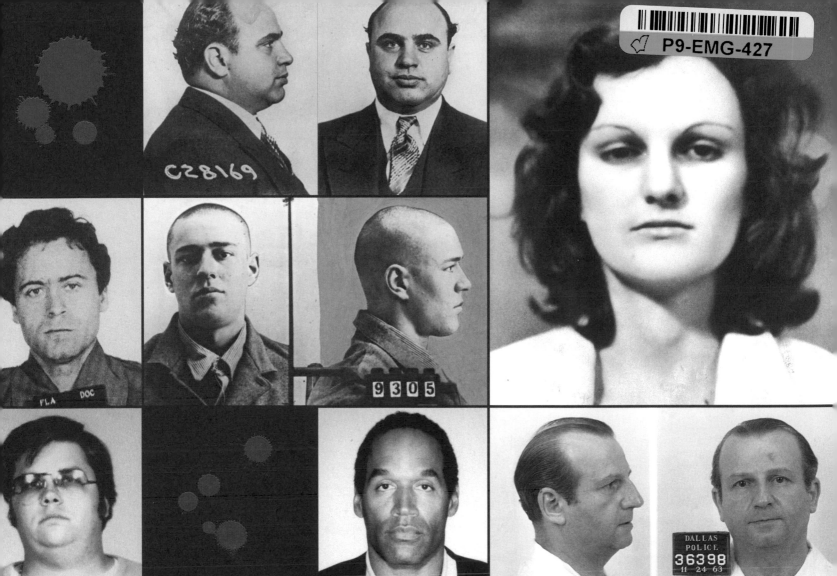

C28169

9305

FLA DOC

465 1382

DALLAS POLICE 36398
11 24 63

WHO ARE THESE GUYS? And these gals, for that matter? To find out, see the endpapers at the back of this book, where there are more mug shots—plus our guide to who's who.

417073

NEW YORK CITY POLICE

2051

95 057
04 19 95

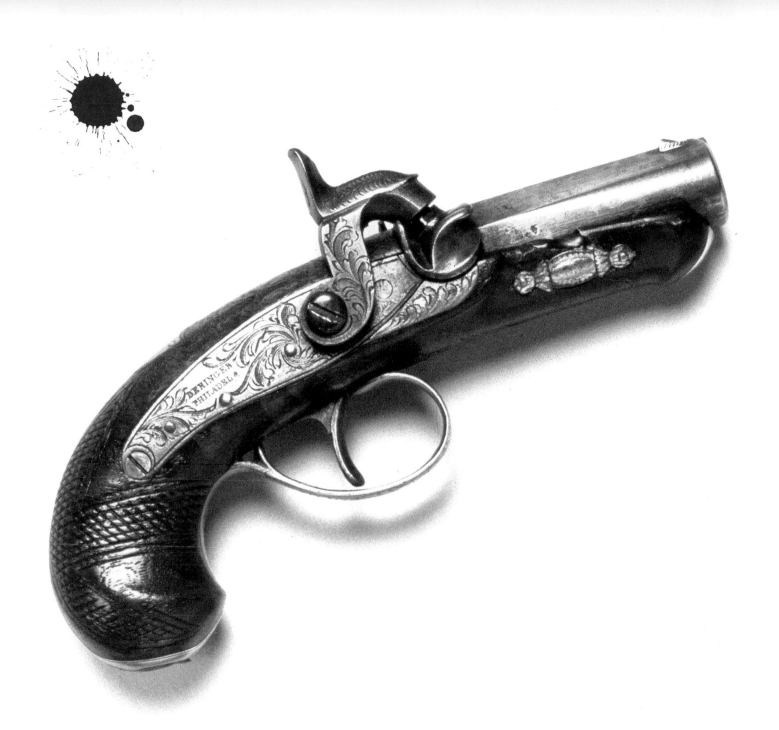

THE MOST NOTORIOUS CRIMES
★ IN AMERICAN HISTORY ★

This is the derringer John Wilkes Booth used to assassinate President Abraham Lincoln. How many shots issued from it? Please see page 10.

LIFE Books

EDITOR Robert Sullivan
DIRECTOR OF PHOTOGRAPHY
Barbara Baker Burrows
CREATIVE DIRECTOR Richard Baker
DEPUTY PICTURE EDITOR Christina Lieberman
WRITER-REPORTER Hildegard Anderson
COPY Danielle Dowling (Chief), Barbara Gogan
SENIOR WRITER Bob Woods
CONSULTING PICTURE EDITORS
Mimi Murphy (Rome), Tala Skari (Paris)

SPECIAL THANKS TO Melissa Fuller Cross,
Larry Day and Karen Smith of the LAPD

PRESIDENT Andrew Blau
BUSINESS MANAGER Roger Adler
BUSINESS DEVELOPMENT MANAGER Jeff Burak
BUSINESS ANALYST Ka-On Lee

EDITORIAL OPERATIONS Richard K. Prue,
David Sloan (Directors), Richard Shaffer
(Group Manager), Burt Carnesi,
Brian Fellows, Raphael Joa,
Angel Mass, Stanley E. Moyse (Managers),
Soheila Asayesh, Keith Aurelio,
Trang Ba Chuong, Ellen Bohan,
Charlotte Coco, Osmar Escalona, Kevin Hart,
Norma Jones, Mert Kerimoglu, Rosalie Khan,
Marco Lau, Po Fung Ng, Rudi Papiri,
Barry Pribula, Carina A. Rosario,
Albert Rufino, Christopher Scala,
Diana Suryakusuma, Vaune Trachtman,
Paul Tupay, Lionel Vargas, David Weiner

TIME INC. HOME ENTERTAINMENT

PUBLISHER Richard Fraiman
GENERAL MANAGER Steven Sandonato
EXECUTIVE DIRECTOR, MARKETING SERVICES
Carol Pittard
DIRECTOR, RETAIL & SPECIAL SALES Tom Mifsud
DIRECTOR, NEW PRODUCT DEVELOPMENT
Peter Harper
ASSISTANT DIRECTOR, BRAND MARKETING
Laura Adam
ASSISTANT GENERAL COUNSEL
Robin Bierstedt
BOOK PRODUCTION MANAGER Jonathan Polsky
DESIGN & PREPRESS MANAGER
Anne-Michelle Gallero
MARKETING MANAGER Joy Butts

SPECIAL THANKS TO Bozena Bannett,
Glenn Buonocore, Suzanne Janso,
Robert Marasco, Brooke Reger,
Shelley Rescober, Mary Sarro-Waite,
Ilene Schreder, Adriana Tierno,
Alex Voznesenskiy

COPYRIGHT 2007
TIME INC. HOME ENTERTAINMENT

PUBLISHED BY LIFE Books

Time Inc., 1271 Avenue of the Americas,
New York, NY 10020

ISBN 10: 1-933821-08-6
ISBN 13: 978-1-933821-08-5
Library of Congress Control Number: 2007905173

"LIFE" is a trademark of Time Inc.

We welcome your comments and suggestions about
LIFE Books.
Please write to us at:
LIFE Books
Attention: Book Editors
PO Box 11016
Des Moines, IA 50336-1016

If you would like to order any of our hardcover
Collector's Edition books, please call us at 1-800-327-
6388 (Monday through Friday, 7:00 a.m.–8:00 p.m.,
or Saturday, 7:00 a.m.–6:00 p.m., Central Time).

Classic images from the pages and covers of LIFE are
now available. Posters can be ordered at
www.LIFEposters.com.

Fine art prints from the LIFE Picture Collection and
the LIFE Gallery of Photography can be viewed at
www.LIFEphotographs.com.

Above: An ax found at the Borden
house in Fall River, Mass.
Did Lizzie use it to kill her parents?
Please see page 104.
Opposite: Augusta Gein's bedroom.
What horror movie does it
remind you of? Please see page 114.

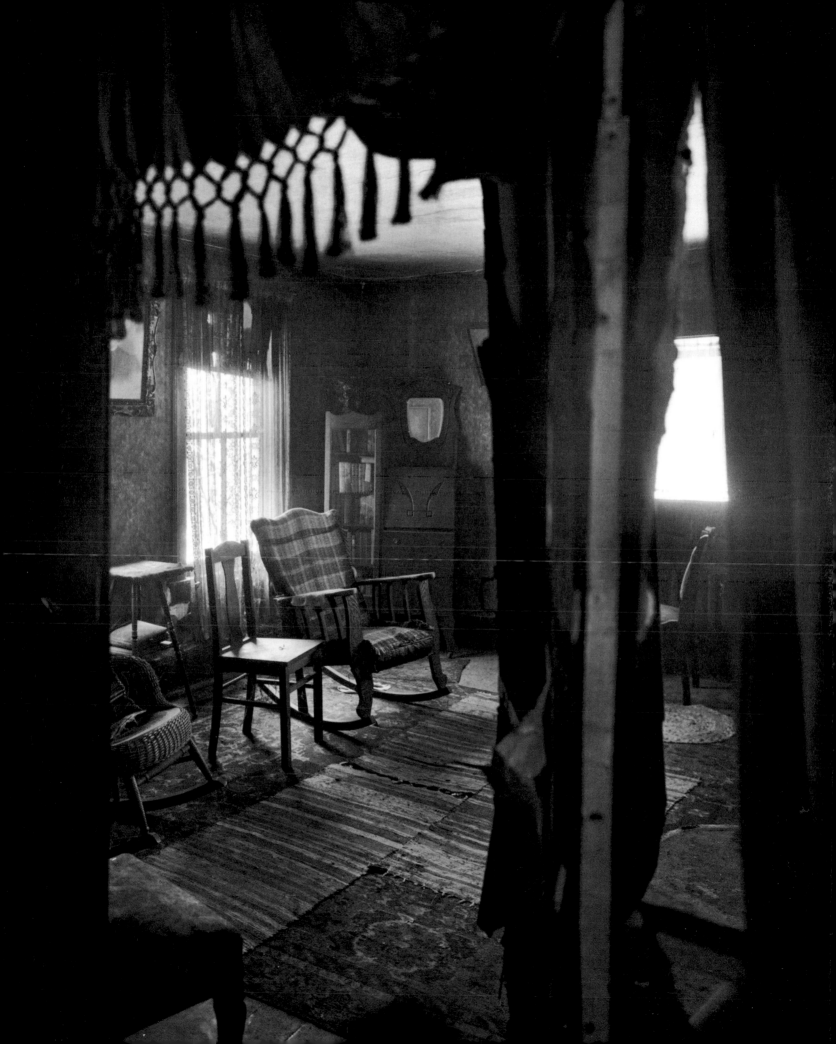

LIFE
THE MOST NOTORIOUS CRIMES IN AMERICAN HISTORY

Left: A bloodstained knife dropped by Susan Atkins at the scene of her crime. Which one? Please see page 122. Opposite: A cold-blooded killer named Smith. To learn his story, please see page 90.

Opposite: Photograph Richard Avedon
© 2007 THE RICHARD AVEDON FOUNDATION

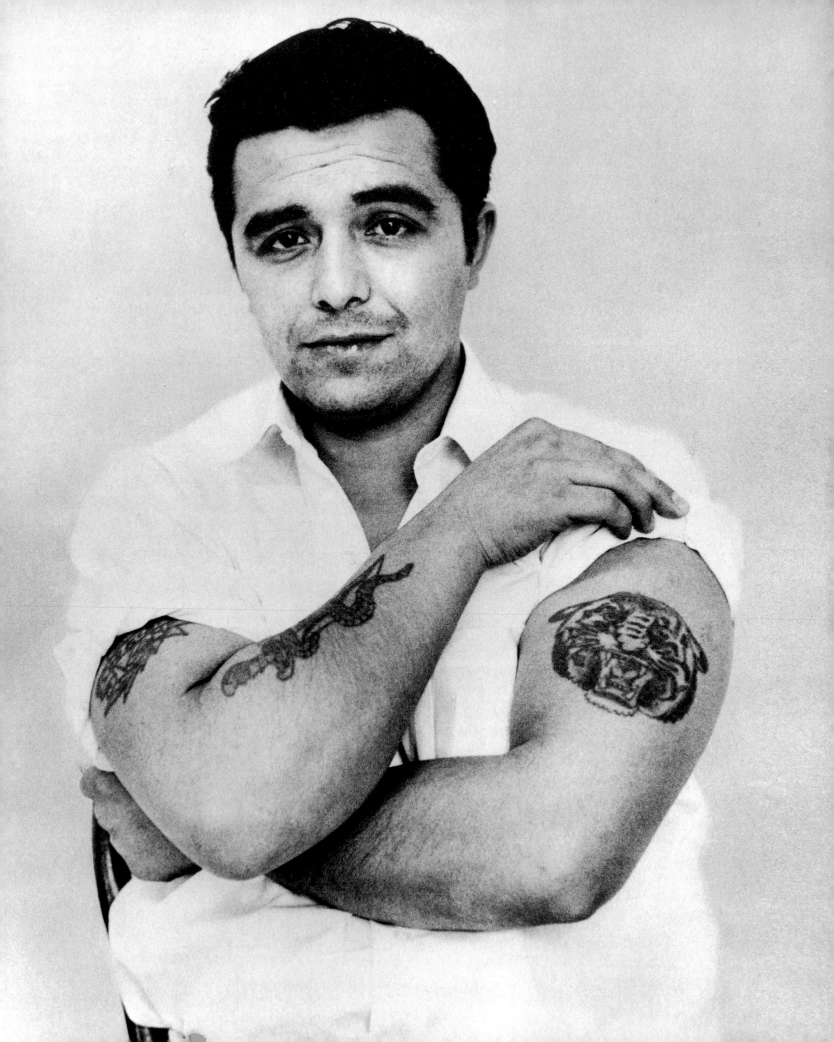

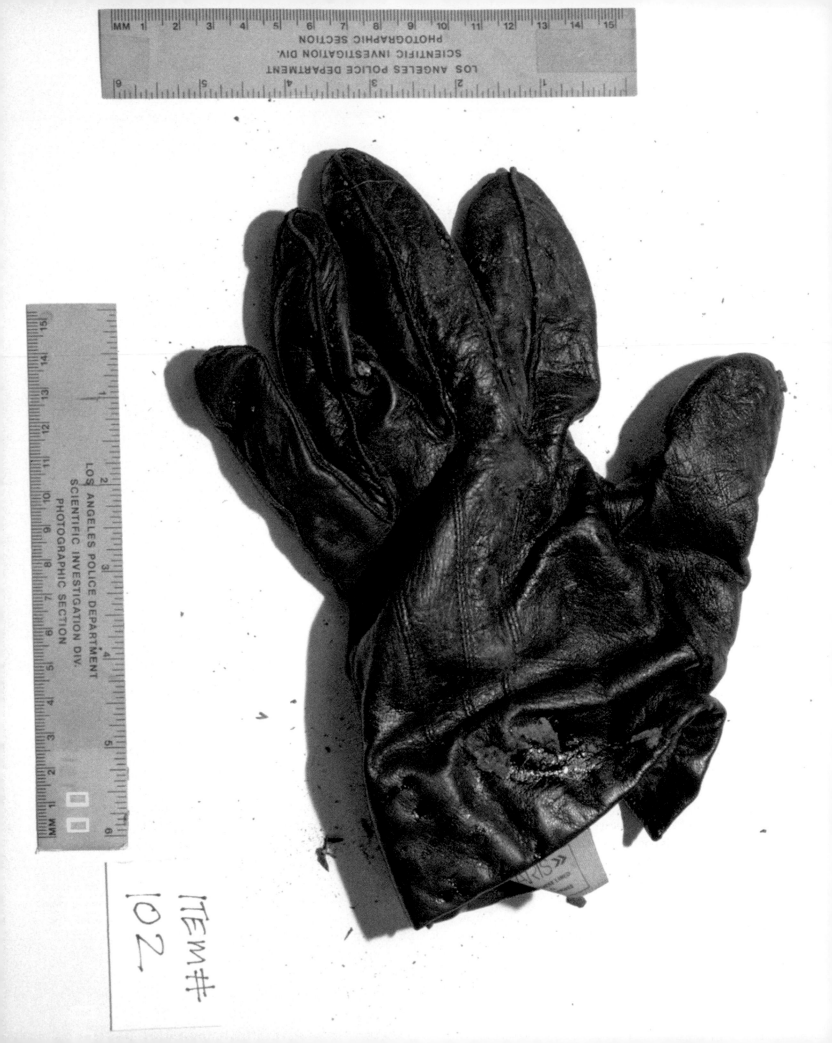

ITEM # 102

The Sinister Allure of Crime

The 18th-century Italian tragedian Vittorio Alfieri wrote in his play *Orestes,* "Providence sees to it that no man gets happiness out of crime." In his version of *Antigone,* Alfieri added another thought: "Disgrace does not consist in the punishment, but in the crime." Both Dick Tracy and the Shadow echoed this sentiment in the 1930s with the famous slogan "Crime doesn't pay!" which is hammered home today by superheroic successors from Spiderman to Scooby-Doo.

And yet, throughout history, many millions have risked disgrace and whatever cheerlessness providence might exact to pursue what they saw, rightly or wrongly, as the profits of crime. Crime has been with us since Cain and Abel; it is endemic to the human condition.

Crime is a nasty business, to be certain, but it is also a fascinating one (as Alfieri well knew when he filled his pages with crimes large and small). We disapprove of crime, but we devour the fictions of Elmore Leonard and Robert B. Parker. We deplore crime, but we find ourselves addicted to *The Sopranos* and *CSI.* We fear crime, but we read the police blotter every morning and are riveted when a car chase is broadcast on live TV. We are captivated by real-life dragnets, days-long fugitive hunts, months-long courtroom dramas. We can find ourselves shocked and appalled by a story, and then find a moment later that we simply can't get enough of it.

Crime is awful, but it can be, in the retelling, awfully exciting.

Not all misdeeds are created equal. Some are more sensational than others, some more baffling, some more audacious. The 50 notorious crimes revisited in this book are all of these things, and they share another aspect: At one point, they gripped the nation. A few of these stories have faded with the passing years from the collective consciousness, but trust us: The Bath School disaster was the Columbine massacre of its day, and the "American tragedy" of Grace Brown and Chester Gillette in

The most famous bloody glove in world history. Will we ever know to whom it belongs? Please see page 70.

1906 was every bit the spellbinding saga that, decades later, the Laci and Scott Peterson case would be.

Pearl Harbor is not in this book, nor is 9/11. The thinking behind their exclusion is that they were acts of war, visited upon Americans by foreign foes. One could make the argument—King George III certainly did—that the first Minuteman to take a shot at a Redcoat back in 1775 committed a crime. But that is not an argument we will subscribe to in this collection of notorious crimes. The events that took place on the battlefields of the Revolutionary War and the Civil War and the unjust campaigns against Native Americans are similarly missing from these pages.

Now, we at LIFE fully realize that folks such as John Wilkes Booth or Timothy McVeigh would insist that their violent deeds were wartime acts. The Olympic Centennial Park bomber said he was fighting the government, and the mastermind of the Beltway sniper attacks had jihad on his mind when he planned his spree.

But we say those were crimes, and those guys were criminals.

In choosing which crimes to include, we kept an eye on history and variety. You could easily do a book on 50 notorious crimes of the past quarter century, but we wanted to look back and find some surprises and relative obscurities. You could easily do a book on 50 famous murders, but we wanted to recount the art heists and bank jobs, too—in the hopes of enlivening our book.

When researching and writing these chapters, we were struck by how much we thought we knew but didn't. Some generally held conspiracy theories are, in fact, relatively groundless; and certain "solved" crimes—the Boston Strangler, for example—remain inconclusive. There are many big-time cases that have never been closed at all: the Gardner art theft, the Lizzie Borden episode, the disappearance of Jimmy Hoffa. For that matter, nobody ever pinned the rap on Al Capone for the Saint Valentine's Day massacre, and no one has been convicted of the murders of Nicole Simpson and Ron Goldman. Did you know that more than a million dollars in loot from the Brink's robbery is still missing more than a half century later?

We hope you didn't know that, and we hope there are other tantalizing surprises in store for you on the pages that follow.

And now it's crime time.

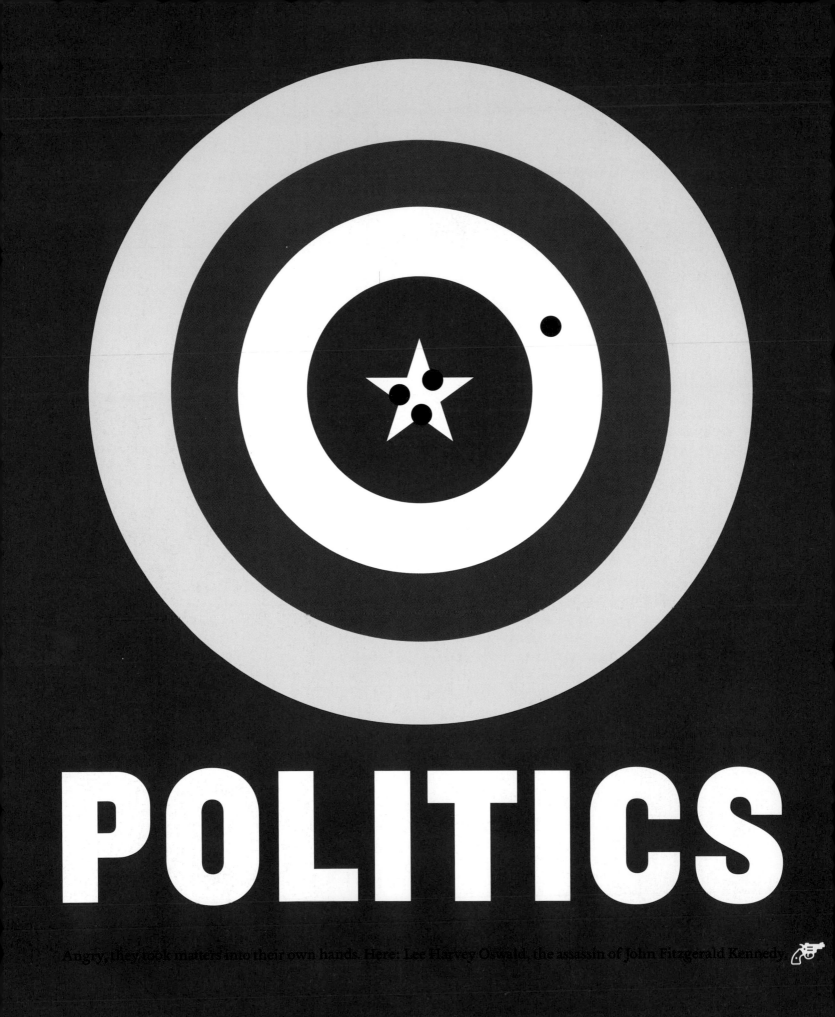

POLITICS

Angry, they took matters into their own hands. Here: Lee Harvey Oswald, the assassin of John Fitzgerald Kennedy.

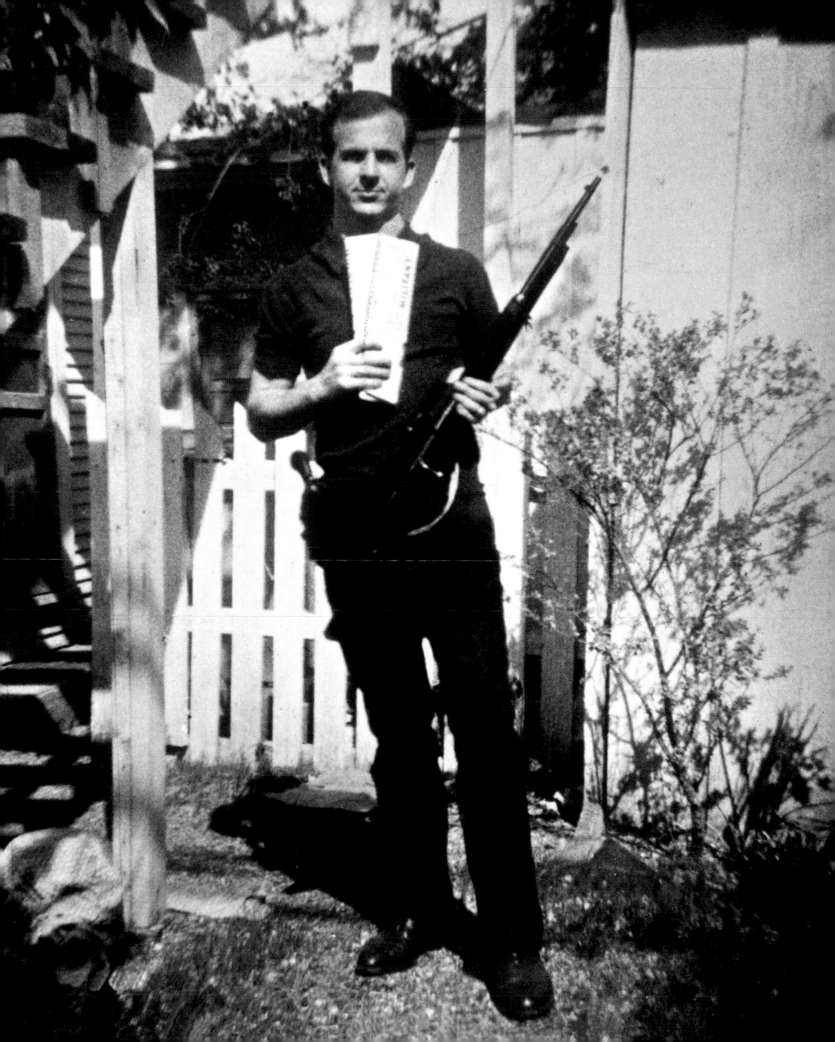

The Assassination of Abraham Lincoln

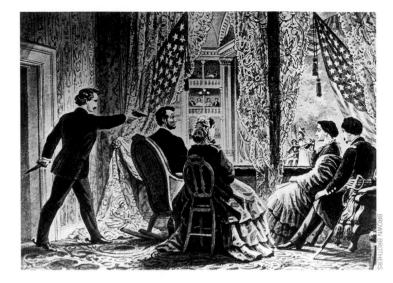

BROWN BROTHERS

W

e begin our survey of crime in America with one of the most famous and heartrending murders the nation—indeed, the world—has ever known. Abraham Lincoln was the quintessence of a great man; he was honest, courageous, wise, inspirational, caring. He had just succeeded in rescuing the Union, which is to say rescuing the United States of America. And then he was struck down. He was taken from us.

John Wilkes Booth is, as any schoolkid can tell you, the name of his assassin. But who was this American Brutus? He was, in fact, the son of a Brutus, the ninth of 10 children sired by Junius Brutus Booth, a prominent Shakespearean actor who emigrated from England to the U.S. in 1821. Born on May 10, 1838, in Maryland, John Wilkes Booth gravitated toward the thespian life, as did two of his older brothers, Junius Jr. and Edwin. Onstage, the youngest Booth was the most successful, achieving a kind of matinee-idol status throughout the land.

In the late 1850s, as slavery became an increasingly contentious issue between North and South, J. Wilkes Booth—his professional name—was philosophically drawn to the fray. Much in the mold of today's entertainers who feel compelled to share their political beliefs, Booth made no secret of his allegiance to the Confederate cause nor of his disdain for the President. In 1859, he joined a Southern militia in Richmond, Va., and one of his duties afforded him the opportunity to stand alongside the gallows when abolitionist John Brown was hanged for treason. Some historians believe that

after the Civil War broke out, Booth joined the clandestine Knights of the Golden Circle, which sponsored various anti-Union activities.

Booth's political passion took on an increasingly fanatical tone. In 1864, as Lincoln campaigned for reelection, Booth plotted to kidnap the President in hopes of exchanging him for thousands of Confederate prisoners of war. He and a band of co-conspirators refined the scheme and made plans to execute it shortly after Lincoln's second inauguration. Remarkably, Booth was an invited guest at that ceremony on March 4, 1865; he recounted to associates that he had been close enough to shoot Lincoln. Two weeks later, the plan to nab the President was thwarted when Lincoln's itinerary underwent a last-minute change.

Confederate General Robert E. Lee surrendered to his Union counterpart, Ulysses S. Grant, at Appomattox Courthouse, Va., on April 9. Now, Booth concluded, assassination was the only recourse if the South had any hope of rising again.

On Good Friday, Lincoln and his wife, Mary Todd, made their way to the Presidential Box of Ford's Theatre in Washington, D.C., where they

planned to enjoy the popular comedy *Our American Cousin*. Booth's earlier performance at the venue afforded him an insider's familiarity. The President and First Lady were watching the play as Booth crept into the box, drew a .44-caliber derringer and fired a single shot at the back of Lincoln's

UNDERWOOD ARCHIVES. OPPOSITE: BROWN BROTHERS

Left: The President, in a portrait from 1865, the year he was killed. Above: An illustration of the assassination. Opposite: The casket on its catafalque in Philadelphia, en route to its final resting place in Springfield, Ill. Some 300,000 viewed the open coffin in this city, one of 10 major stops on Lincoln's 1,654-mile funeral procession.

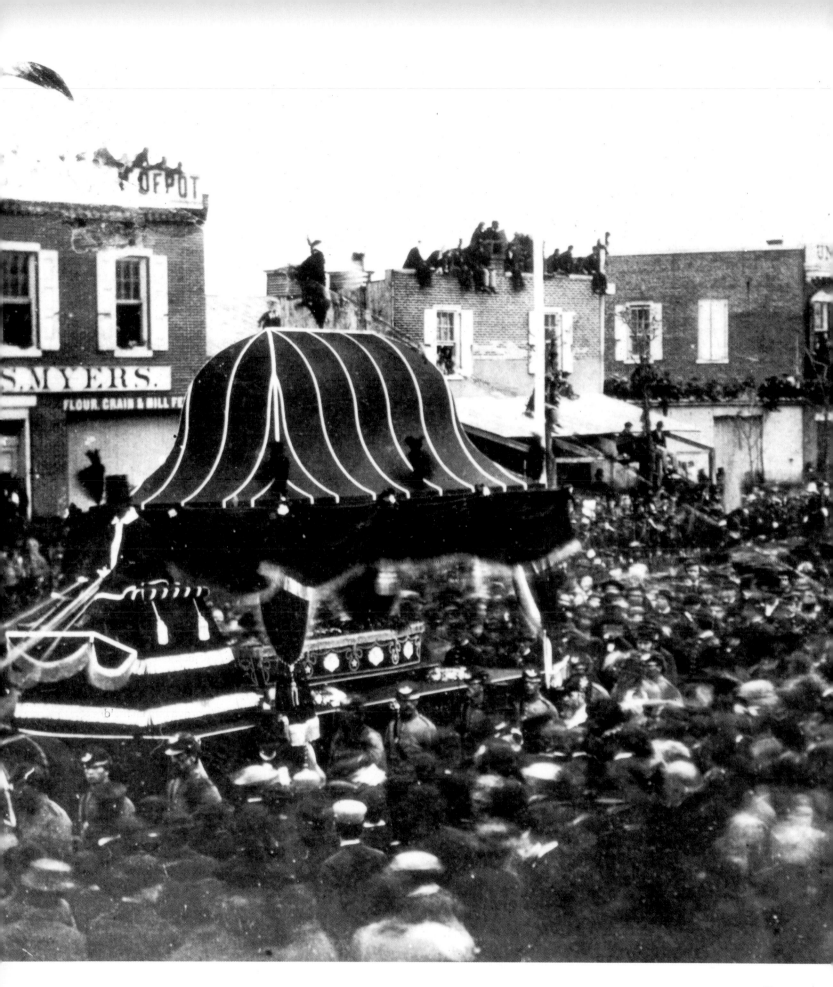

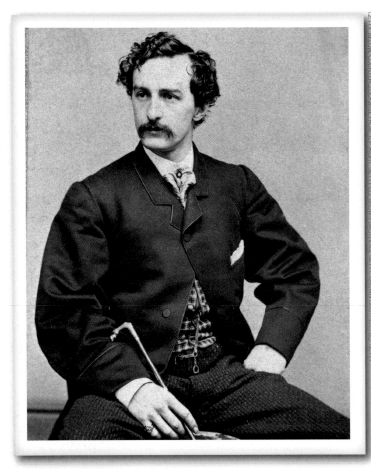

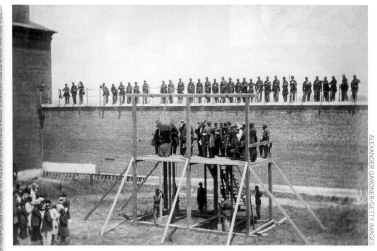

head. Booth tried to escape to the stage below but was temporarily blocked by Lincoln's guest, Major Henry Rathbone. The actor turned assassin wounded Rathbone with a dagger, then leaped from the box.

On July 7, 1865, Paine, Atzerodt, Herold and Surratt (who was accused of harboring the plotters at her tavern) are hanged. Opposite: A throng gathers in front of Lincoln's home in Springfield, Ill., on the day his casket arrives.

He became entangled in a flag, fell awkwardly and broke a bone in his left leg. He hobbled out the back door. Mounting a getaway horse, Booth rode into the shadows.

The desperate act was part of a larger conspiracy playing itself out less successfully beyond Ford's Theatre. Crosstown, Lewis Paine finagled his way into the residence of William Seward and stabbed the secretary of state several times (Seward would recover). Elsewhere, other planned assassinations—of Grant and Vice President Andrew Johnson—were abandoned for various reasons.

Booth fled south with fellow fugitive David Herold. Holed up in a barn in Virginia, they were discovered by Union troops on April 26. Herold gave himself up; Booth refused to surrender. The barn was set afire, but before the assassin could be captured, a bullet took his life. Soon after, Herold, Powell and two other plotters, Mary Surratt and George Atzerodt, were tried for murder and found guilty. All four were hanged on July 7.

It is said that after firing his fateful and fatal shot, Booth shouted, "Sic semper tyrannis"—Latin for "Thus always to tyrants." Perhaps this part of the legend is too convenient, for the infamous phrase, which happens to be the state motto of Virginia, is said to have originated with the real Brutus—the Roman senator who delivered the critical blow in the assassination of Julius Caesar. It all seems so pat.

But then again, perhaps Booth did hearken to Brutus from the Presidential Box. Only five months earlier, he had appeared alongside his brothers in a production of Shakespeare's *Julius Caesar*, so surely he would have known the phrase. And then there's this, written on the run, in a diary that was found on his body: "With every man's hand against me, I am here in despair. And why? For doing what Brutus was honored for.... So ends all."

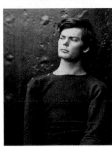
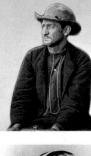
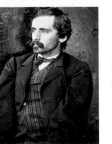
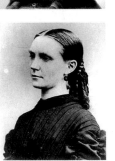
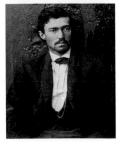

John Wilkes Booth (top) had plenty of assistance in carrying out his plot. His co-conspirators and accessories after the fact included (top row, left to right) Lewis Paine (also known as Lewis Powell); Edman Spangler, a Ford's Theatre stagehand who helped Booth escape; George Atzerodt, who failed to kill Vice President Andrew Johnson; (second row) Michael O'Laughlen; Mary Surratt; David Herold; and (bottom) Samuel Arnold.

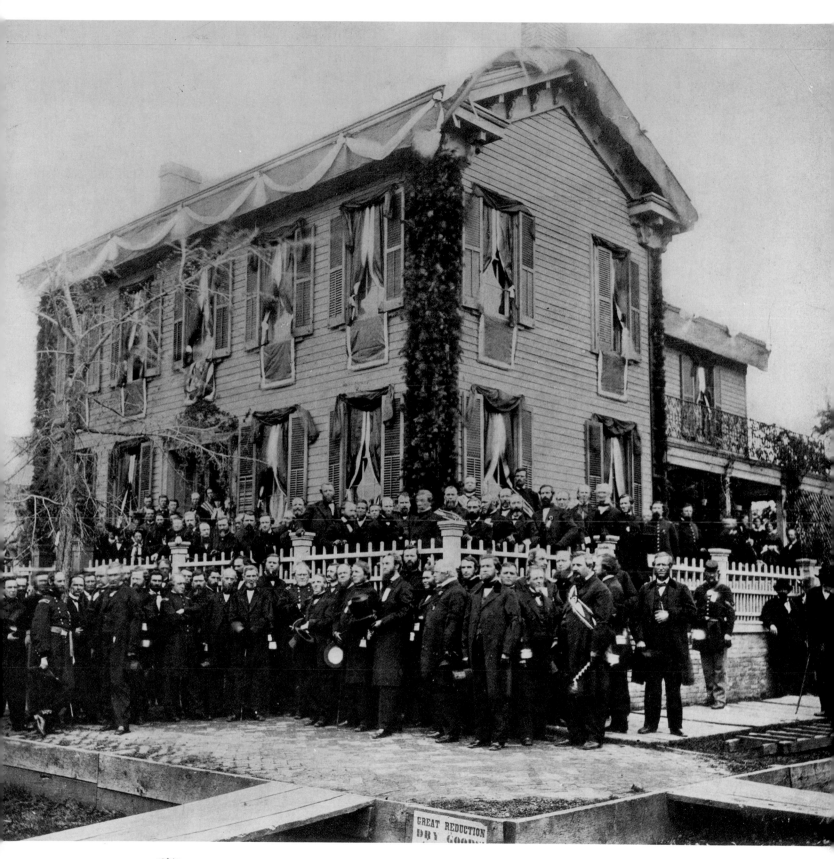

 He had just succeeded in rescuing the Union, which is
to say rescuing the United States of America.
And then he was struck down. He was taken from us.

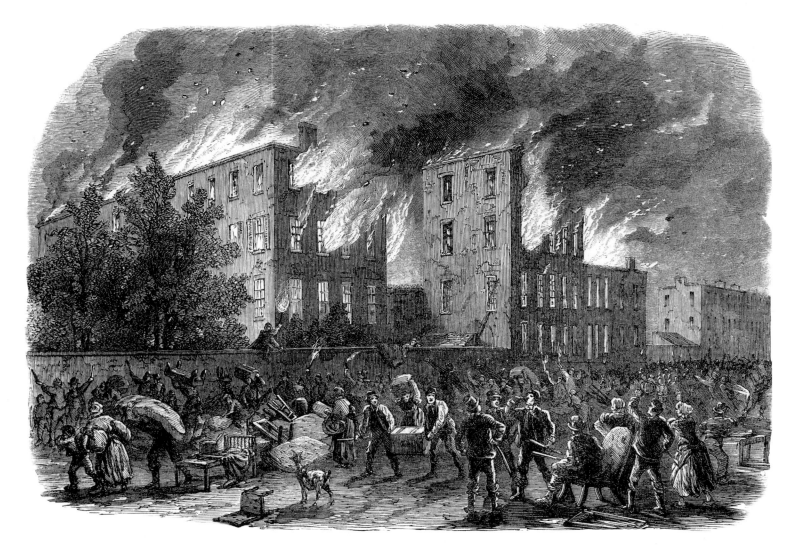

The Draft Riots

he philosophy and actions of people like John Wilkes Booth, as heinous as they were, can be understood—he was a proslavery Southern sympathizer and was committed to use whatever means necessary to help the South survive. In the North during the Civil War, many more complicated and conflicting emotions hung in the air, and several of them collided, like flint with stone, to ignite the Draft Riots of 1863 in New York City. The fierce violence included acts so wrongheaded—so vile—as to be utterly incomprehensible.

Although New York was an abolitionist bastion, it was also a city of many classes, interests and biases. Some of the uglier ones seeped to the surface soon after President Abraham Lincoln issued his Emancipation Proclamation, decreeing an end to slavery in the United States. In New York City, hate- and fearmongers warned that freed slaves would flee the South and compete for low-paying jobs.

Another piece of legislation further set the stage: In an effort to replace soldiers who had been lost at Gettysburg, as well as other battles, Congress hastily passed the Conscription Act of 1863. Targeting males ages 18 to 35, it was aimed squarely at family men, the only large source of manpower yet untapped by the Union. Under the provisions of the new draft, no man could claim an exemption on the grounds that he was the sole support of his wife and children.

The Conscription Act was met with strong resistance throughout the North, but nowhere was the resentment greater than among the immigrant Irish of New York City. These men were certain that while they were serving in the Army, former slaves would steal their jobs.

Moreover, they were incensed by a loophole in the law that allowed the rich to shirk their duty: A man could purchase exemption from military service for $300 (or by hiring a substitute for a lesser fee).

The first draft lottery took place on Saturday, July 11. On the following Monday, a protest was staged against the Conscription Act.

On that humid summer morning, demonstrators marched from Central Park toward the U.S. Provost Marshal's Office at Third Avenue and 47th Street. Along the way, some men broke into a hardware store and stole broad axes; others cut telegraph lines. Then a group of Irish women with crowbars began tearing up the Fourth Avenue railroad. The same was done to the Second and Third Avenue lines. The crowd was becoming a mob.

The Irish surged out of the Five Points, Mulberry Bend, Hell's Kitchen and the Upper West Side. They set forth to burn, loot and even kill. They attacked the draft offices, the *New York Tribune* building (looking to murder its liberal Republican editor Horace Greeley), the mansions on Lexington Avenue and, particularly, blacks—burning scores of black-owned stores and homes. Horrifically, they invaded the Colored Orphan Asylum on Fifth Avenue and 43rd Street; 237 black children were led out the back way as the rioters screamed "Burn the niggers' nests!" and set torches to the building.

Over the next four days, an estimated 50,000 men, women and children participated. Most were armed with primitive weapons: bricks, paving stones, clubs. They moved through the city in groups of up to 10,000; the sight of them swarming down a wide avenue—filling it wall to wall as far north as the eye could range—was frightening to authorities. Law enforcement detachments took cover in their station houses.

Federal troops, some fresh from Gettysburg, were called in. It took 6,000 soldiers, plus batteries of field artillery—lined up hub to hub, loaded with grapeshot and canister—to clear a bloody path through the rioters. The tide finally turned on that fourth day. Facing volleys fired by trained infantry, cavalry charges and artillery barrages, the dissidents gradually melted away.

The draft proceeded without further protest from the tenement districts, and New York was peaceable enough for the duration of the war. Thousands of men who had fought in the streets in July 1863 answered their summonses and fought in the Union Army later that same year.

The Draft Riots, which have been called the worst civil disturbance in U.S. history, can be seen as the progenitor of similar outbreaks in other urban settings—Watts, Newark, elsewhere. Each riot has its own backstory, but there are parallels. Upon the occasion of the 1992 violence in Los Angeles following the Rodney King verdict, journalist Pete Hamill looked back in time: "The Draft Riots make a point that must be underlined: Blacks don't riot, Latinos don't riot—the poor do. And if the poor are sufficiently brutalized, ignorant and alienated, they are capable of obscene atrocities. Many Irish Americans now grow huffy with self-righteousness at the riots in Los Angeles and other cities. They should read some history. The Draft Riots remind us of one large fact: No race, no nationality and no religion has a lock on virtue."

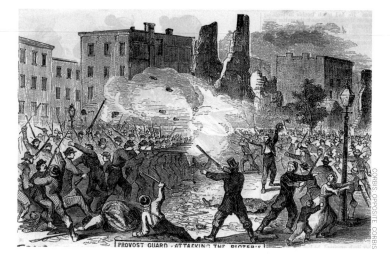

PROVOST GUARD · ATTACKING THE RIOTERS

Opposite: An engraving that ran in *The Illustrated London News* shows the destruction of the orphan asylum. Above: The provost guard attacks rioters. Below: Lieutenant Commander Richard Worsam Meade III, the naval officer who led the troops that finally suppressed the riots. His distinguished Civil War service included combat and blockade duty on the Mississippi River, the Atlantic Ocean and the Gulf of Mexico.

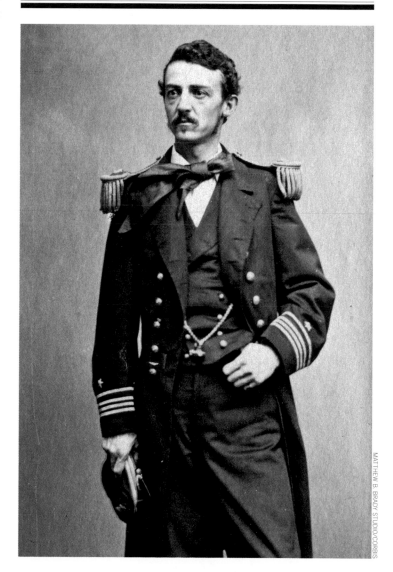

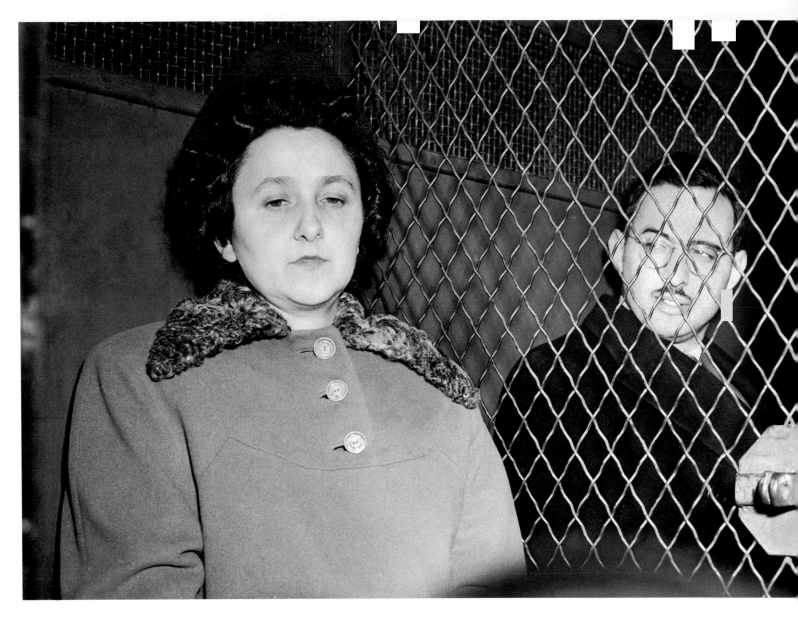

The Rosenberg Spy Case

The prevailing opinion in the United States [is that] they got what they deserved." So declared an editorial in *The New York Times* following the June 19, 1953, executions of Julius and Ethel Rosenberg. The newspaper was certainly right about the sentiment at that time, and all these years later, many still feel that Julius received precisely the penalty that fit his crime.

Ethel? Well, hers is another story.

Julius Rosenberg was born in New York City in 1918 and was already a member of the Young Communist League when he enrolled at the City College of New York in 1934. He split his time there earning a degree in electrical engineering, engaging in

radical politics and dating Ethel Greenglass, also a New Yorker and a card-carrying Communist. They married in 1939.

Julius's electronics expertise made him an ideal radar technician for the Army Signal Corps during World War II. He held that position until his Communist allegiance led to his dismissal in 1945.

The Army was right to boot him—more so than it had known. Julius had been recruited by a Soviet spy as early as 1942, when the U.S. and the USSR were war allies. Julius felt the USSR should have access to American technology and began passing confidential materials to them (including, at one point, technical information the Soviets later used to down the American U2 spy plane piloted by Francis Gary Power). Julius found another avenue to top-secret information when Ethel's brother, David Greenglass, was drafted into the Army and assigned to work as a machinist at the Los Alamos, N.M., laboratory, where the Manhattan Project was under way. More for money than idealism, Greenglass agreed to supply schematics and other atom-bomb data. The courier for Greenglass's booty was Harry Gold, who passed it off to Soviet KGB agent Anatoli Yakovlev.

The tenor of the times is crucial to this case: In 1948, the Good War was over, the Cold War had just begun. Our erstwhile allies in Moscow were now seen as the Red Menace. And on September 23, 1949, President Harry S. Truman announced that the Soviets had exploded an A-bomb.

By what means had they figured out how to build the bomb? How in the world had the Kremlin gotten its hands on what was thought to be

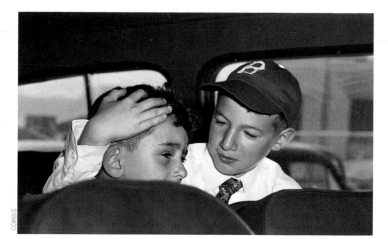

Above: Three days before his parents' execution, Michael Rosenberg, 10, comforts brother Robert, 6, after visiting Sing Sing Prison. Below: Ethel at home after Julius's arrest and before her own.

proprietary U.S. nuclear-weapons know-how? A fevered search for those answers was quickly launched. Nine months after the blast, Gold, the go-between, confessed to the FBI. Julius Rosenberg found out and made plans for his and his family's escape from the country; he urged Greenglass to flee as well. But the feds were better at persuading Greenglass, who had been fingered by Gold and fingered Julius and Ethel in turn. The Rosenbergs were seized, along with co-conspirator Morton Sobell, and the three went on trial on March 6, 1951. Twenty-three days later, the jury returned a guilty verdict. Federal Judge Irving Kaufman—who castigated the Rosenbergs as worse than murderers, villains who had "already caused . . . the Communist aggression in Korea" and doomed perhaps millions of victims—imposed the death penalty on the couple on April 5. (Sobell received a 30-year prison sentence.)

A two-year appeal process that went all the way to the Supreme Court bore no fruit, and on June 19, 1953, the electric chair nicknamed "Old Sparky" in New York's Sing Sing Prison was used once more. Julius was executed first; minutes later, Ethel survived four jolts but not the fifth.

The Rosenbergs' orphan sons, Michael and Robert, were adopted by a New York City songwriter. David Greenglass, who was sentenced to 15 years, served 10 and has since lived under an assumed name. He

Opposite: In April 1951, having received death sentences, the Rosenbergs are transported by police van. Below: Protesters seeking clemency are rained upon in Ossining, N.Y., after being stopped by police from reaching the prison.

cooperated on one of the many books that have been written about the Rosenbergs. In *The Brother,* published in 2001, he cast doubt on his sister's complicity, even though his testimony had helped convict her.

Ethel Rosenberg certainly knew of her husband's activities, but did she aid and abet him? In the chair, did she "get what she deserved"? That's a question that continues to be asked.

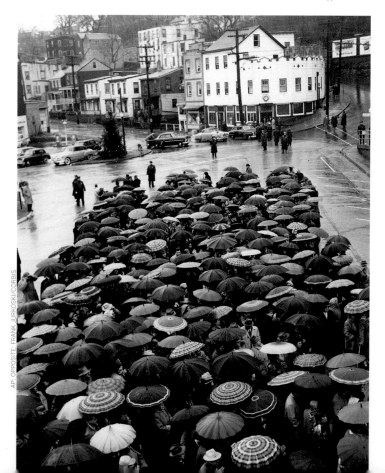

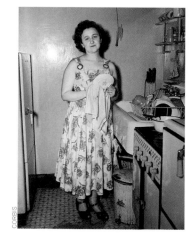

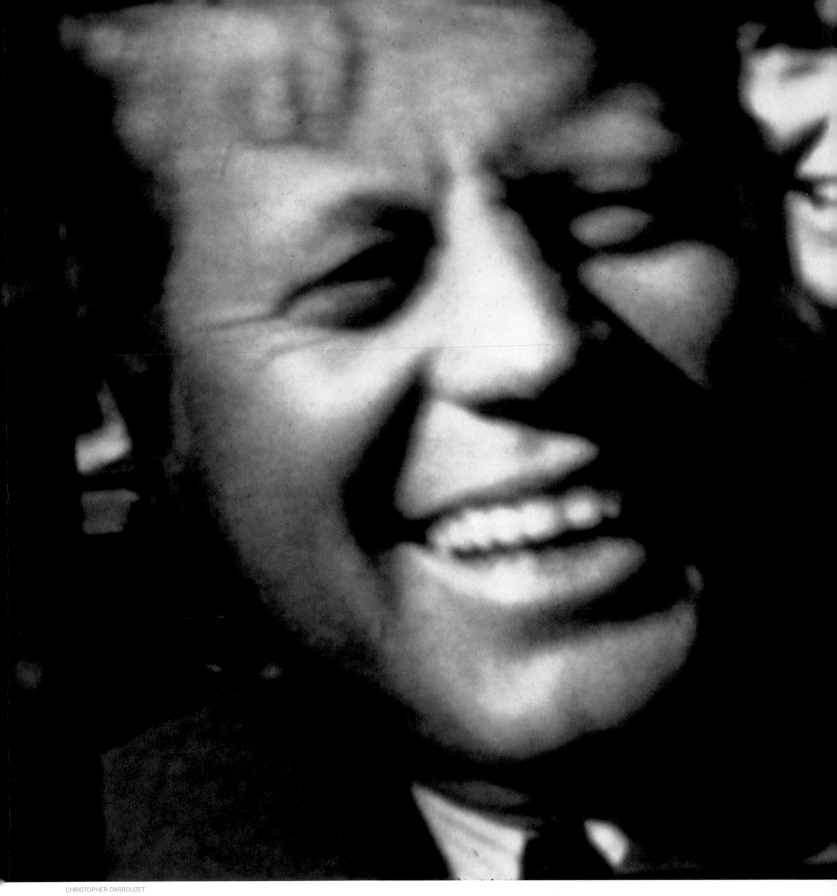

The President and First Lady are buoyant as they meet the people of Dallas—mere moments before JFK is shot.

The Assassination of JFK

Who killed President John Fitzgerald Kennedy on that November day in Dallas in 1963? It is a question that was answered many years ago, if you accept the Warren Commission's findings. And yet it is a question that lingers in our national consciousness, kept alive by conspiracy theorists, revisionist historians and even Hollywood movie directors.

What exactly happened on November 22, 1963?

Who was responsible for the murder of the 35th President of the United States?

Why did the assassin—or assassins—do it?

After 40-plus years of legwork by an investigative cottage industry devoted to analyzing forensic and anecdotal evidence, there is still no better answer than the official version: A 24-year-old ex-Marine named Lee Harvey Oswald was perched in an open window on the sixth floor of the Texas School Book Depository building that day, armed with a bolt-action rifle and bad intent.

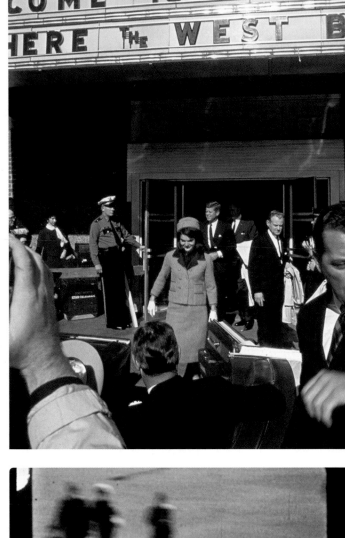

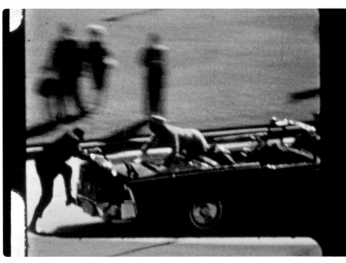

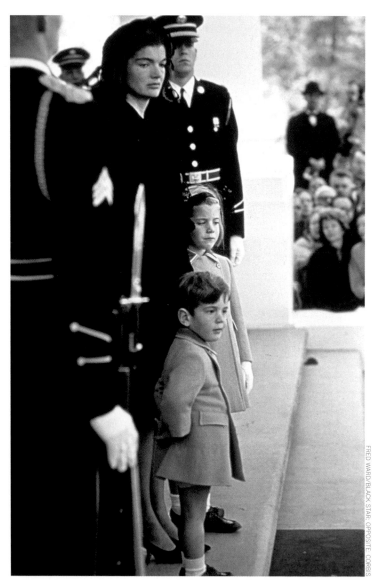

An odd existence led him to that pivotal place and point in time. Born on October 18, 1939, in New Orleans, and raised by a single mother, Oswald led a nomadic, often troubled childhood. He had lived at 22 different residences—mostly in Louisiana and Texas, though briefly in New York City. During his stay in New York, he underwent a psychiatric evaluation, which concluded that he harbored "schizoid features and passive-aggressive tendencies." That warning didn't keep him out of the U.S. Marine Corps, in which he served nearly three years, learning how to handle an M1 rifle and other weapons.

By then he had developed a fascination with Communism and talked about it openly. He was ostracized by his fellow leathernecks, some of whom taunted him with the nickname "Oswaldskovich." He studied rudimentary Russian and read Marxist literature.

Shortly after his discharge from the Corps in September 1959, Oswald went to Moscow, seeking to defect. Although his request for residency was denied, he was allowed to remain in the USSR. He moved to Minsk, where he worked in an electronics factory and met and married Marina Prusakova.

Top: Jacqueline Kennedy is characteristically resplendent in Texas. Above: A frame from the Zapruder film, which first appeared in LIFE and launched a thousand theories. Right: Jackie and her now-fatherless children—Caroline, 5, and John Jr., 3—are among 800,000 Americans who watch as six gray horses pull a wagon bearing JFK's casket to St. Matthew's Cathedral in Washington, D.C., on November 25. A riderless black horse trailed the coffin. Boston's Cardinal Cushing presided over the funeral Mass before the late President was interred at Arlington National Cemetery.

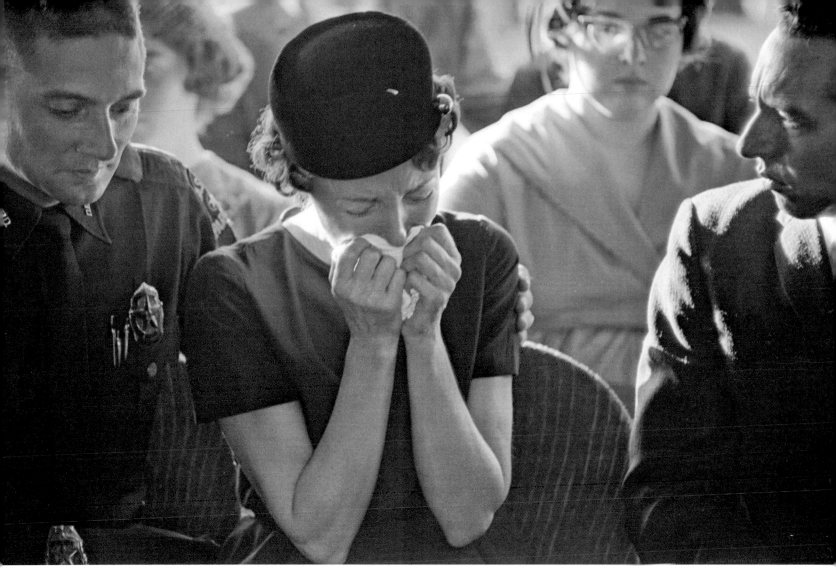

Oswald displayed a lifelong inability to settle. Perhaps disenchanted with the drabness of Soviet life, in June 1962 he moved with Marina and their young daughter back to the U.S.—to the Dallas area. Their marriage grew tempestuous (Marina has subsequently said that he physically abused her), and after bouncing between jobs, Oswald left for New Orleans in April 1963. He focused his interests on Cuba and Fidel Castro and wound up in Mexico City, where he applied for a visa to Cuba at both the Cuban and Soviet consulates. Frustrated by delays, he returned to Dallas and, in October, took a $1.25-an-hour job as an order filler at the book depository.

Earlier in the year, Oswald had placed a mail order for an Italian-made military rifle mounted with a four-power telescopic sight. On the morning of November 22, he arrived at work carrying a handmade paper bag that he told colleagues contained curtain rods.

President Kennedy's visit that day was an attempt to shore up support in a city that he did not carry in the 1960 election. Oswald, along with other readers of *The Dallas Morning News*, had seen the map of Kennedy's motorcade route printed in the paper. The entourage was scheduled to leave Love Field Airport, then head downtown and through Dealey Plaza, where the book depository was situated. With Kennedy in the Lincoln Continental convertible limousine, waving to the throngs that lined the roadways, were his wife, Jacqueline, Texas Governor John Connally and Connally's wife, Nellie.

At approximately 12:30 p.m. local time, the motorcade slowed as it passed the book depository. Seconds later, three shots rang out. One bullet struck Kennedy in the upper back and exited his throat, another missed its target and wounded a bystander far down the street and the third hit Kennedy in the back of the head and exited the top right side of his skull. The limo sped to nearby Parkland Memorial Hospital, where attempts were made to revive Kennedy, but he was already dead. Television anchor Walter Cronkite was overcome when he announced the news to the country.

Meanwhile, Oswald slipped out of the building. His absence was discovered by police, who were scouring the facility after a witness reported seeing someone with a rifle on the sixth floor. Dallas police officer J.D. Tippit heard the all-points bulletin on his patrol car's radio describing the suspected assassin. Spotting a probable match on the street, Tippit got out of the car to confront Oswald, who drew a .38-caliber pistol and shot the policeman dead. Oswald was then seen ducking into a movie theater. He was soon apprehended and charged with killing Tippit and Kennedy. "I'm just a patsy," he insisted to

reporters—the line that would spawn all those theories as to who, besides Oswald, might have been involved. Adding intrigue upon intrigue, two days after the assassination, Oswald himself was gunned down as officers were transporting him from Dallas police headquarters to the county jail. How had his assailant, Jack Ruby, a local strip-club owner, gotten past security? Was Ruby really acting out of personal anger, or was he in someone's employ, sent to silence Oswald?

Even as the nation grieved the loss of its popular, charismatic young leader, the rumors began to fly: *Oswald was in league with Castro, with anti-Castro forces, with the Mafia, with the FBI, the CIA, the KGB. A "lone gun-man" just couldn't have committed the murder.* A grassy knoll in Dallas was combed for clues; frames from a film taken by Abraham Zapruder, a local clothier and photo hobbyist, were pored over by amateur and professional sleuths after they appeared in LIFE.

Kennedy's successor, the Texan Lyndon Baines Johnson, quickly impaneled an investigatory unit to get to the facts, appointing Supreme Court Chief Justice Earl Warren as its head. After 10 months, the Warren Commission concluded that the assassination was the work of Lee Harvey Oswald alone. That decree has done little to quell suspicions in the decades since.

Of one thing we can be certain: The country changed that day. Camelot came to an end; our postwar pastoral was over. Jack Valenti, who would later gain renown as head of the Motion Picture Association of America, was, on that fateful day, an assistant to Lyndon Johnson. He was in the motorcade and summed up the events by quoting the poet William Butler Yeats: "The ceremony of innocence is drowned."

ALLAN GRANT, TOP LEFT: CORBIS (4)

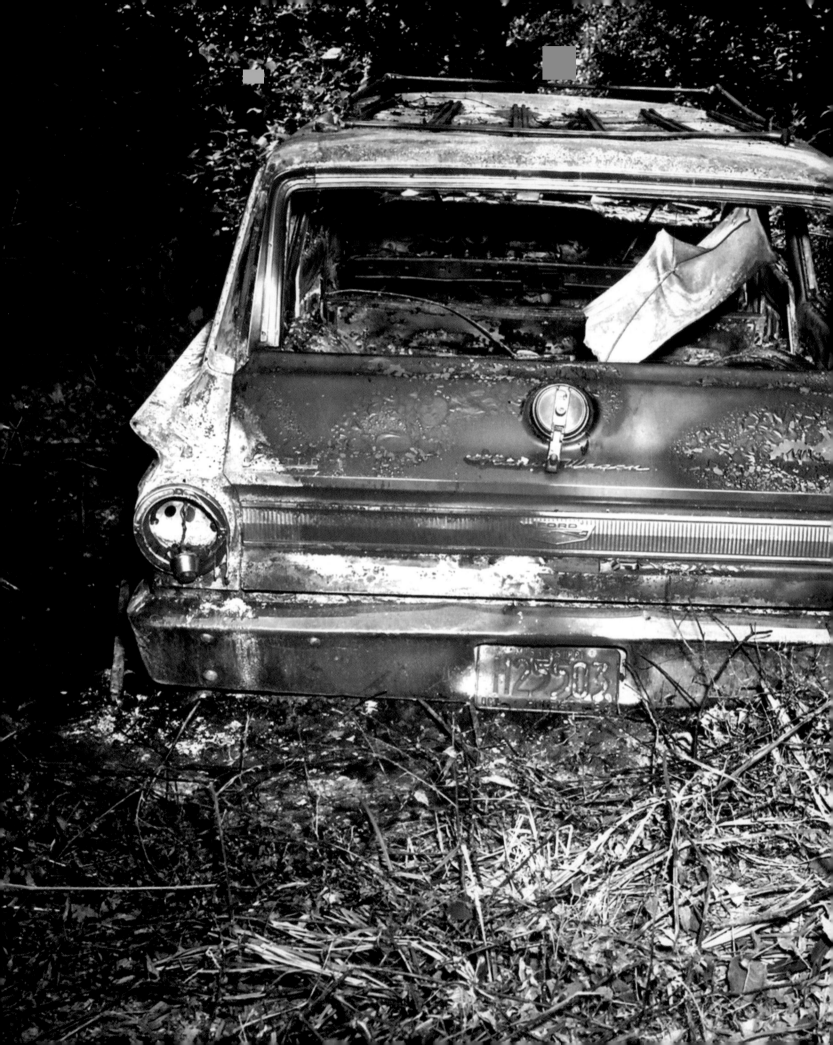

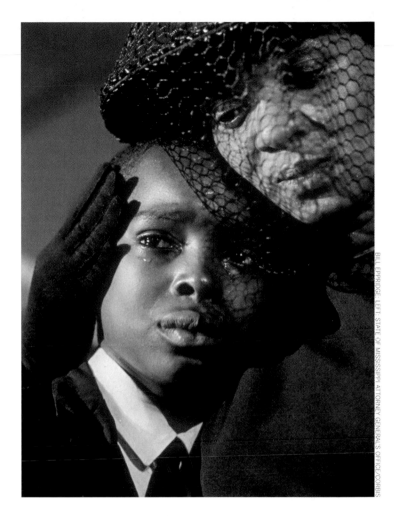

BILL EPPRIDGE. LEFT, STATE OF MISSISSIPPI ATTORNEY GENERAL'S OFFICE/CORBIS

Mississippi Burning

Murder is most foul when raw hate is the motive, and hate was in the air across eastern Mississippi's Neshoba County on the night of June 21, 1964. Fueled by racist rancor, a rabid pack of Klu Klux Klan members chased down a car carrying three young civil rights workers who had been set "free" from the local jail after being arrested. And then the killings began.

James Chaney, 21, a black man raised in Mississippi, and two white co-workers from New York, Michael Schwerner, 24, and Andrew Goodman, 20, were in Neshoba County to help register black voters as part of the Mississippi Summer Project. They were in an awful place at the worst possible moment, and they could see this clearly as they examined the remains of a black congregation's Mount Zion Methodist

Left: An FBI photograph of the burned-out station wagon taken in 1964 was used at the first trial, and then again more than four decades later. Above: The mother and brother of James Chaney grieve at his funeral in Meridian.

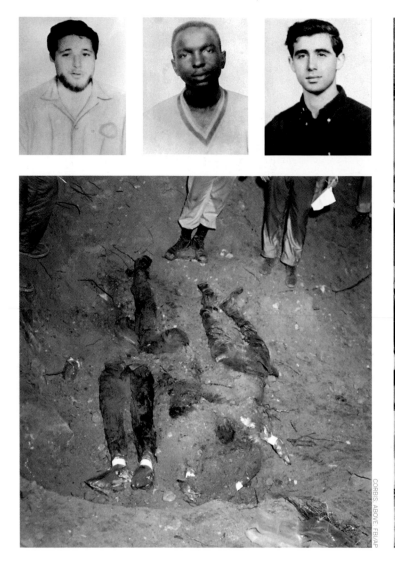

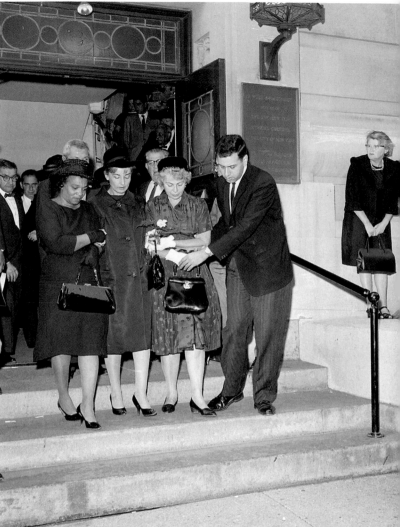

Church, which was still smoldering after having been torched only days earlier while its parishioners were beaten.

The first part of the fatal drama unfolded when the three were arrested by deputy sheriff Cecil Price on an alleged traffic violation. They were then released, but Price tracked their Ford station wagon and stopped them again. This time, he was joined by two carloads of Klansmen recruited by Edgar Ray Killen, a Klan leader and Baptist minister. The civil rights workers were stuffed into the back of Price's squad car and driven to a deserted spot on the unpaved Rock Cut Road.

Two of the Klan members, Wayne Roberts and Doyle Barnette, stepped forward with handguns and, from close range, summarily murdered their captives one by one. The first to die was Schwerner, who had gained virulent enemies in the area when he organized a black boycott of a white-owned business. For that, "Jew Boy" had been sentenced to death by Sam Bowers, the Imperial Wizard of the White Knights of the Ku Klux Klan of Mississippi. The next victim was Goodman, a college kid from a privileged background who had applied for the Mississippi Summer Project despite knowing the dangers. His murder ended what was his first full day on the job.

Top left, from left to right: Schwerner, Chaney and Goodman. Bottom left: Their bodies as discovered on August 4, 1964. Above: The mothers of Chaney, Goodman and Schwerner leave the Society of Ethical Culture building in New York City after a funeral service for Goodman. Opposite: Scenes from two Neshoba County trials, four decades apart. Price grins and Rainey fills his face with chewing tobacco In 1964 while the cops' pals have a laugh. Then, on January 7, 2005, Edgar Ray Killen, now 79, is led away after pleading not guilty to three counts of murder. He would be found guilty of man-slaughter—but observers felt that justice had been deferred for far too long.

Chaney went last, thus cutting short a life that had found a purpose. He had grown up in Meridian, not far from the site where he was executed. Asthma kept him out of the Army, and an apprenticeship as a plasterer didn't work out. As the civil rights movement gained momentum, he had become a reliable volunteer at the Council of Racial Equality (CORE) office in Meridian, working alongside Schwerner and Schwerner's wife, Rita.

Now he would be buried beside Schwerner and Goodman at the base of an earthen dam on a nearby farm.

When the civil rights workers failed to show up in Meridian as expected, CORE staffers called the FBI. Within days, hundreds of federal agents were swarming Neshoba and its neighboring counties,

interviewing residents and combing the backcountry for clues. They soon found the charred shell of the station wagon, but it wasn't until August 4 that an informant's tip led searchers to the decomposed bodies.

"I just didn't think we had people like that around," said one local of the ruthless killers. Even in what was a Deep South segregationist stronghold, where the Confederate flag proudly waved, shame and a desire for justice overcame racial bias; in fact, several Klansmen cooperated with federal investigators. On December 4, Price and his boss, sheriff Lawrence Rainey, were arrested, along with 17 others, and charged—not with murder but with conspiring to violate the civil rights of the three victims.

After years of legal wrangling, 18 of the defendants finally went on trial in Meridian on October 7, 1967. On the 20th of that month, the all-white jury found seven of them guilty, including Price and Bowers. Rainey and seven others were acquitted, and the jury deadlocked on the remaining three. Not until March 1970 did the seven convicted men enter prison.

One juror said afterward that she couldn't bring herself to vote against "Preacher" Killen, despite several witnesses' portrayals of the Klan organizer as the ringleader. And although the evidence appeared overwhelming, Mississippi prosecutors never brought murder charges against anyone—until January 2005, when Killen, at age 79, was indicted by a state grand jury. He was tried in June, found guilty of manslaughter and sentenced to three 20-year prison terms. The judge's decision came down precisely 41 years after the deed had been done.

The Assassination of Martin Luther King Jr.

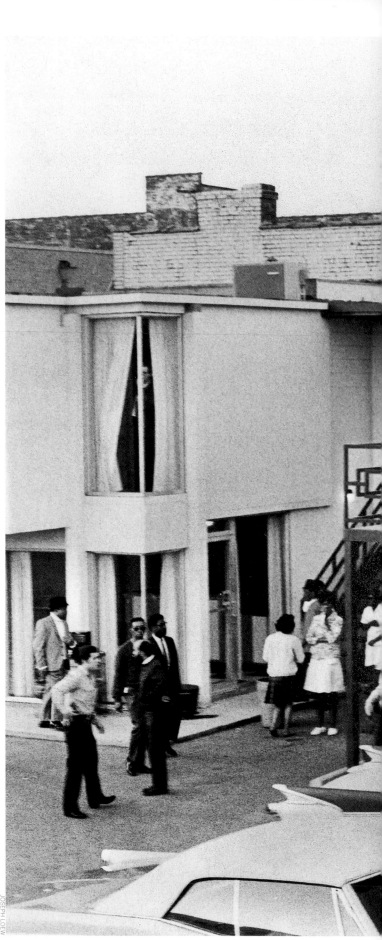

Abraham Lincoln issued the Emancipation Proclamation in 1862, abolishing slavery. Unfortunately, that hallowed decree failed to grant lasting rights to many freed slaves, leaving black Americans in the South to live under oppressive Jim Crow laws for nearly a century. Although the Supreme Court decision in *Brown v. the Board of Education* in 1954, followed a decade later by passage of the Civil Rights Act and then the Voting Rights Act, called for integration and equality, in reality, racism persisted and was practiced throughout the U.S.—but not without opposition.

Martin Luther King Jr. was born in Atlanta in 1929 and therefore witnessed inequities all his life. A devout boy, he sang in the church choir and determined to follow his grandfather's and father's path into the Baptist ministry. He entered Morehouse College at age 15, and after graduating, he matriculated at Crozer Theological Seminary in Pennsylvania.

After receiving his doctor of philosophy degree in systematic theology from Boston University, King was

King lies slain, as his aides point to where the shots rang out. Among those with King that day were Jesse Jackson and future Atlanta mayor Andrew Young.

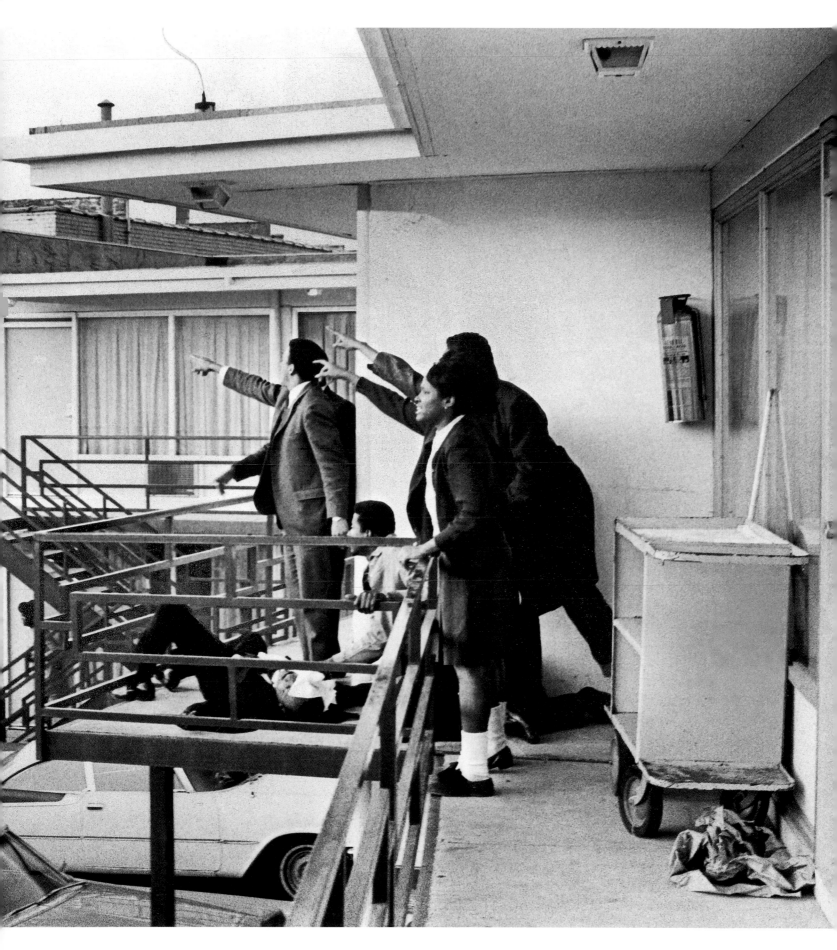

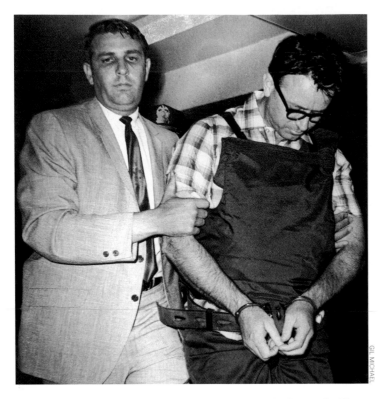

intellectually and spiritually armed for the road ahead. Most important, he was a powerful, charismatic orator—one of his era's greatest public speakers—and a peerless organizer. It was clear very early on that he would be a player in what was becoming known as the civil rights movement.

Above: Shelby County sheriff William N. Morris Jr., who would become the county's mayor, leads Ray after his arrest. Morris later said that Ray told him he regretted pleading guilty to the crime.

In 1954, at age 25, the ever-precocious King became the pastor of the Dexter Avenue Baptist Church in Montgomery, Ala. One year later, a local woman named Rosa Parks refused to give up her bus seat to a white man. Reverend King led the historic, yearlong bus boycott that was organized after Parks's arrest, and he suffered the consequences: He was arrested at one point, and his house was bombed at another. Ultimately, vindication came in the form of a Supreme Court decision outlawing segregation on public transportation, but King had learned that activism made him, in certain circles, a hated man—a target.

In 1957, King helped form the influential Southern Christian Leadership Conference, which promoted Gandhi's form of nonviolent protest. He became an outspoken critic not only of racial inequality but also of the war in Vietnam. He had discussions with socialist and Communist leaders about the issues of the day, drawing the ire of J. Edgar Hoover's FBI, which began wiretapping King. But he marched on: to Montgomery; to Washington, D.C., and 1963's famous "I have a dream" speech; to Stockholm, where he received the Nobel Peace Prize in 1964.

Traveling a dramatically different path through life was a man named James Earl Ray, a white career criminal. In 1967, not quite halfway through a 20-year sentence for a 1959 armed robbery, Ray escaped from the Missouri State Penitentiary and slipped away into Canada. There, he

either did or did not meet a mystery man known as "Raoul," whose existence became pivotal once Ray recrossed the border, drifted in and out of several cities and eventually ended up in Memphis on April 3, 1968. Among his few possessions was a high-powered rifle rigged with a scope.

King arrived in Memphis on the same day to organize a march in support of the city's mostly black sanitation workers. He and several aides checked into the Lorraine Motel. That day, he gave a speech, which included the prophetic words "I've been to the mountaintop . . . and I've seen the promised land." At 6:01 p.m. the next evening, King was standing on the balcony outside his motel room when a gun was fired from a rooming house across the street. The bullet struck King, passing through his chin and neck. He was pronounced dead at 7:05 p.m.

Police quickly found a rifle near the rooming house. Witnesses said they had seen a white man drop it before fleeing in a white Mustang. The FBI found the car in Atlanta days later and traced it to a man named Eric Starvo Gault. Fingerprints revealed Gault's true identity: James Earl Ray.

A two-month manhunt ended with Ray's arrest at London's Heathrow Airport on June 8. The evidence against Ray appeared incriminating, and Ray's lawyer told him that rather than risk the death penalty by going to trial, he should plead guilty. He did, received a 99-year sentence, then—three days later—recanted his confession. Raoul had been the mastermind, Ray now claimed. He himself was just Raoul's fall guy. Until the moment of his death at age 70 on April 23, 1998, Ray continued to ask for the trial he never had.

As with the assassination of President John F. Kennedy, conspiracy theories abounded in the aftermath of the King shooting. In addition to the phantomlike Raoul, the FBI, the CIA and the Mob have all, in one telling or another, done it.

Members of King's own family doubt Ray's guilt, and there are, perhaps, reasons for doubt. But a contributing factor to the speculation

Below, from left to right: Martin Luther King III, Dexter King, Coretta Scott King, Dora McDonald and Ralph D. Abernathy Jr. say farewell to the great man on April 7, 1968. Opposite: King in Atlanta.

must be that the scenario doesn't square with reality. How could a leader and philosopher of the magnitude of King have been brought down by a lowly drifter—a man so bereft of purpose as James Earl Ray?

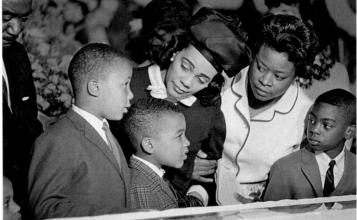

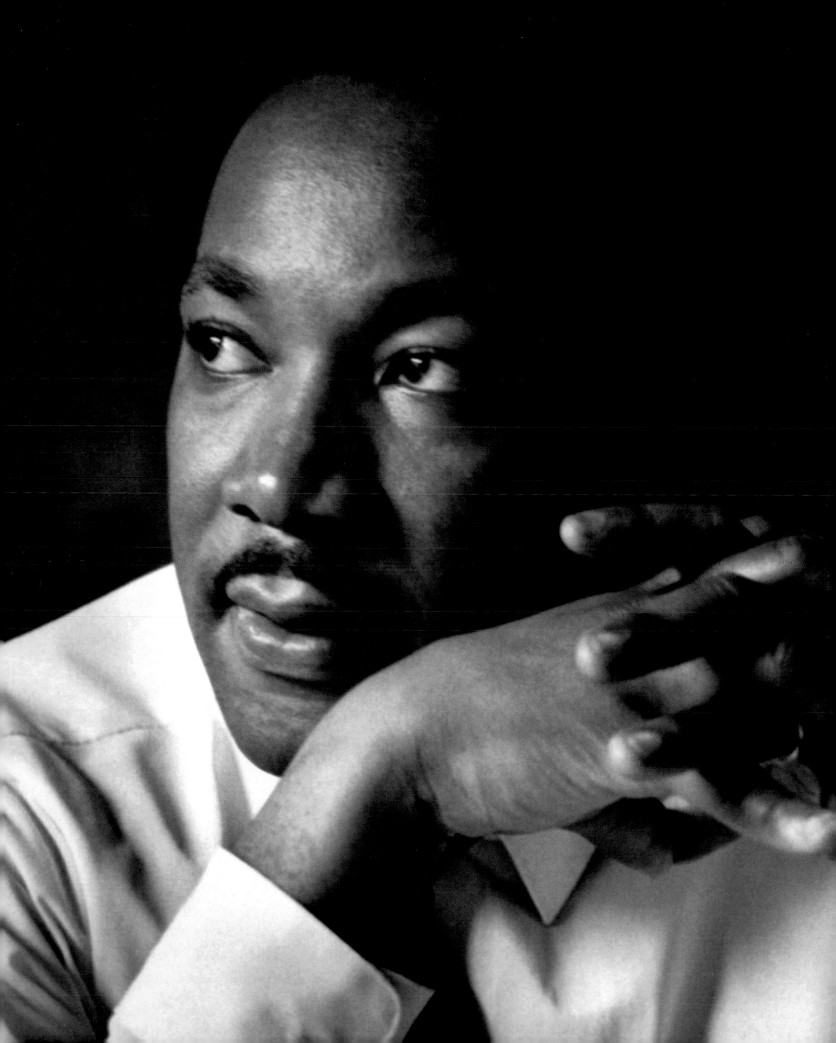

The Assassination of
Bobby Kennedy

Assassinations have been part of world history since the days of Caesar and beyond. But rarely, if ever, has a society—particularly a free and democratic one in which the citizenry has a voice—undergone a flurry of such murders as the United States suffered during the 1960s. Before Martin Luther King's assassination in 1968, civil rights leaders Medgar Evers and Malcolm X were both gunned down (in 1963 and '65, respectively). And then Robert Francis Kennedy shared the same ill fate as his brother John.

The seventh of nine children raised by Joseph and Rose, Bobby Kennedy had, in fact, entered politics in his brother's service. He had successfully run JFK's campaigns for the U.S. Senate in 1952 and the presidency in 1960, after which he was appointed U.S. Attorney General. As the nation's top cop, he went after organized crime figures and crooked union officials, most notably Teamster boss Jimmy Hoffa. RFK also championed civil rights. He made enemies through his crusades—enemies who would not be implicated in his death—and many friends. Bobby Kennedy's appeal to people, said *The New York Times,* was "as a symbol of hope and expectation who could understand their unspoken yearnings."

He was, of course, devastated by his brother's death but reluctantly agreed to stay on as Attorney General under Lyndon Johnson. For both men, it was an unworkable situation, and in early 1964, Kennedy left the administration to run for a U.S. Senate seat representing New York. He was elected and, in his new role, continued working on national issues, particularly civil rights. He was an officer of high rank in Johnson's War on Poverty. By 1968, though, he had split with the President over the Vietnam War. In March, he was a latecomer to the Democratic primary campaign but gained momentum when LBJ said he would not seek reelection. A crucial test loomed in the June 4 primary in delegate-rich California.

On that day, as thousands of citizens made their way to the polls, a slight, dark-haired 24-year-old signed in at the San Gabriel Valley Gun Club. He spent the next several hours at the club's shooting range firing a .22-caliber, eight-chamber revolver. Later, he showed up at the Ambassador Hotel in Los Angeles.

Kennedy had based his headquarters at the Ambassador, and that evening, he and his wife, Ethel, who was pregnant with their 11th child, monitored electoral returns from their suite. With victory apparent, the candidate made his way down to the ballroom where his supporters were reveling. He confirmed for them the good news and gave them the V sign, which in those days was coming to mean "peace" as well as "victory."

Kennedy exited the dais via the kitchen. His entourage paused while he greeted several workers. Suddenly, a man stepped out of the crowd and fired eight wildly aimed shots from a handgun. Kennedy fell; five others were hit (all would survive); the scene in that tight space was bedlam. Kennedy's associates that night included former pro-football lineman Roosevelt Grier and Olympic decathlete Rafer Johnson, who helped subdue the gunman.

Kennedy underwent several hours of neurosurgery at Good Samaritan Hospital. Meanwhile, the still-unidentified shooter was hustled off to jail and quickly charged with six counts of assault. The murder weapon was traced to someone who said that the man in custody was his brother, Sirhan Bishara Sirhan, a Palestine-born Jordanian living with his family in nearby Pasadena.

As Kennedy battled to survive and his countrymen held their collective breath, clues about Sirhan surfaced. Although raised a Christian, he had lately expressed hatred of Israel and sympathy for Palestinians displaced by the 1967 Arab-Israeli War. Kennedy was a strong supporter of Israel, and the rage this stoked in Sirhan was detailed in notebooks found in his bedroom: "My determination to eliminate RFK is becoming more [and] more of an unshakable obsession . . . RFK must die."

He did die—at 1:44 a.m., on June 6, at age 42. Sirhan was found guilty and sentenced to death, but California abolished capital punishment in 1972, and today, Sirhan Sirhan remains in state prison.

Bobby Kennedy rests 47 feet from John in Washington, D.C.'s Arlington National Cemetery—both martyrs of the madness that marked the darker side of the '60s.

Kennedy was shaking the hand of busboy Juan Romero before the shooting, who bent over the stricken senator, and said, "Come on, Mr. Kennedy, you can make it," and placed a rosary in Kennedy's hand. In this famous LIFE photo (opposite), Romero glances up.

The Kidnapping of
Patty Hearst

Remember "Tania"? For well over a year, she was the bizarre machine-gun–toting alter ego of heiress Patricia Campbell Hearst, granddaughter of press baron William Randolph Hearst—a man who had been the real-life model for Orson Welles's mythic protagonist in *Citizen Kane*. Parsing the Hearsts' real, fictive and alter ego personae can make for an interesting parlor game.

Which is in no way intended to make light of the strange-but-true saga of Patricia Hearst. On the night of February 4, 1974, the 19-year-old was kidnapped from her Berkeley, Calif., apartment by three armed members of a leftist revolutionary "family," who stuffed

Throughout 1974 friends of Hearst on both sides of the law would release photographs that might argue their case in the public forum. Some were of a fresh-faced young Patty (left); others depicted the proud, tough Tania (opposite).

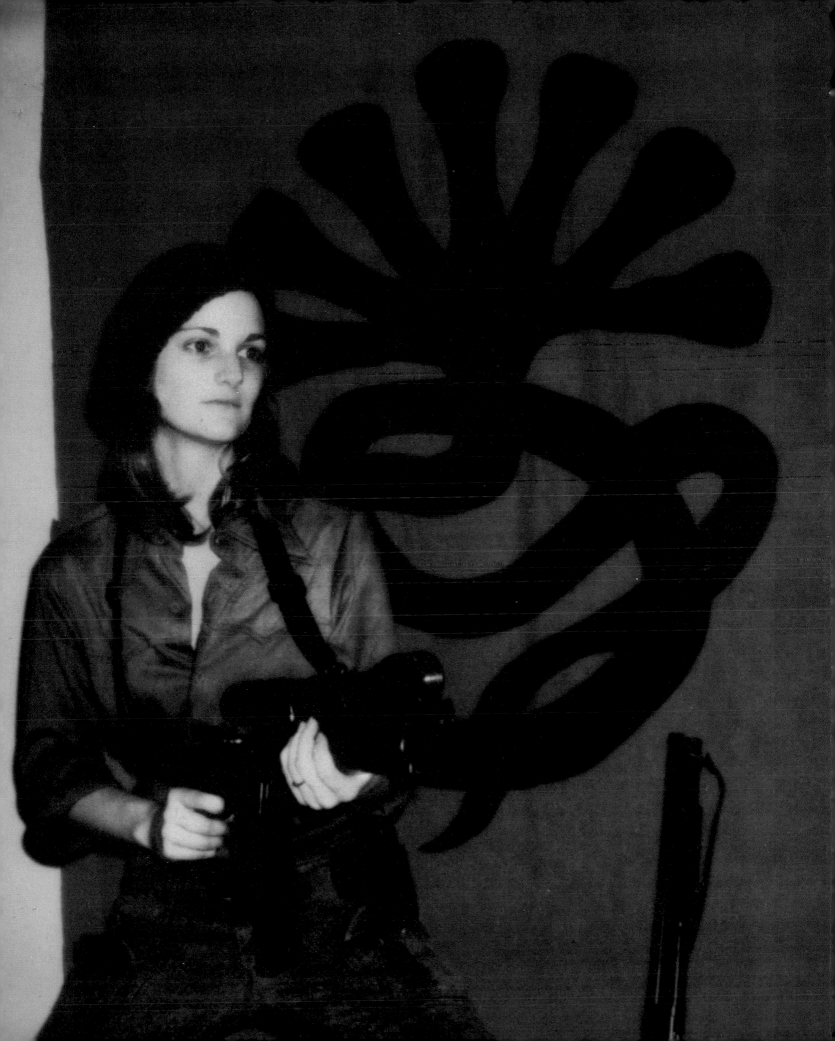

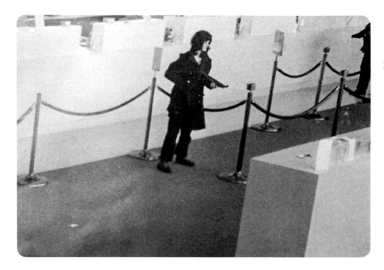

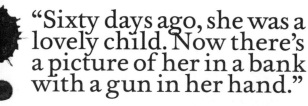

"Sixty days ago, she was a lovely child. Now there's a picture of her in a bank with a gun in her hand."

WANTED BY THE FBI

NATIONAL FIREARMS ACT

William Taylor Harris
Date photographs taken unknown
FBI No.: 308,668 L5
Aliases: Mike Andrews, Richard Frank Dennis, William Kinder, Jonathan Maris, Jonathan Mark Salamone, Teko
Age: 30, born January 22, 1945, Fort Sill, Oklahoma (not supported by birth records)
Height: 5'7" **Eyes:** Hazel
Weight: 145 pounds **Complexion:** Medium
Build: Medium **Race:** White
Hair: Brown, short **Nationality:** American
Occupation: Postal clerk
Remarks: Reportedly wears Fu Manchu type mustache, may wear glasses, upper right center tooth may be chipped, reportedly jogs, swims and rides bicycle for exercise, was last seen wearing army type boots and dark jacket
Social Security Numbers Used: 315-46-2467; 555-27-8400; 359-48-5467
Fingerprint Classification: 20 1, 1 At 12
 S 1 Ut

Emily Montague Harris
Date photographs taken unknown
FBI No.: 325,801 L2
Aliases: Mrs. William Taylor Harris, Mary Hensley, Jeanne James, Anna Lindenberg, Cynthia Sue Mankins, Dorothy Ann Petri, Emily Montague Schwartz, Mary Schwartz, Yolanda
Age: 28, born February 11, 1947, Baltimore, Maryland (not supported by birth records)
Height: 5'3" **Eyes:** Blue
Weight: 115 pounds **Complexion:** Fair
Build: Small **Race:** White
Hair: Blonde **Nationality:** American
Occupations: Secretary, teacher
Remarks: Hair may be worn one inch below ear level, may wear glasses or contact lenses; reportedly has partial upper plate, pierced ears, is a natural food faddist, exercises by jogging, swimming and bicycle riding, usually wears slacks or street length dresses, was last seen wearing jeans and waist length shiny black leather coat; may wear wigs
Social Security Numbers Used: 327-42-2356; 429-42-8003

NATIONAL FIREARMS ACT; BANK ROBBERY
Patricia Campbell Hearst
FBI No.: 325,805 L10
Aliases: Tania, Susan
Age: 21, born February 20, 1954, San Francisco, California
Height: 5'3" **Eyes:** Brown
Weight: 110 pounds **Complexion:** Fair
Build: Small **Race:** White
Hair: Light brown, may be dyed blonde and cut short
Scars and Marks: Mole on lower right corner of mouth, scar near right ankle
Remarks: Hair naturally light brown, straight and worn about three inches below shoulders in length, however, may wear wigs, including Afro style, dark brown of medium length; was last seen wearing black sweater, plaid slacks, brown hiking boots and carrying a knife in her belt

Feb., 1972 Dec., 1973 April, 1974 (artist conception) Summer 1974

THE ABOVE INDIVIDUALS ARE SELF-PROCLAIMED MEMBERS OF THE SYMBIONESE LIBERATION ARMY AND REPORTEDLY HAVE BEEN IN POSSESSION OF NUMEROUS FIREARMS INCLUDING AUTOMATIC WEAPONS. WILLIAM HARRIS AND PATRICIA HEARST ALLEGEDLY HAVE USED GUNS TO AVOID ARREST. ALL THREE SHOULD BE CONSIDERED ARMED AND VERY DANGEROUS.

Federal warrants were issued on May 20, 1974, at Los Angeles, California, charging the Harrises and Hearst with violation of the National Firearms Act. Hearst was also indicted by a Federal Grand Jury on June 6, 1974, at San Francisco, California, for bank robbery and use of a weapon during a felony.

her—half naked and blindfolded— into the trunk of a car. They sped away, leaving behind Hearst's brutally beaten fiancé, Steven Weed. Two days later, a letter arrived at KPFA, a radio station in Berkeley. It stated that Hearst was a prisoner of the Symbionese Liberation Army (SLA), a radical Bay Area group that had been implicated in the assassination of Oakland's superintendent of schools Dr. Marcus Foster the previous year.

The letter was followed by a series of taped messages from Hearst and SLA leader Donald DeFreeze, then known as "General Field Marshal Cinque." The tapes were filled with the SLA's antiestablishment rhetoric and included a demand that Randolph A. Hearst—Patty's father and chairman of the Hearst publishing empire—buy millions of dollars' worth of food and distribute it among the poor.

The media was already going wild with the story when, on April 3, a rambling communiqué arrived in which Hearst herself denounced her bourgeois parents and declared that she had willingly "chosen to stay and fight" for the SLA. "I have been given the name of Tania after a comrade who fought alongside Che" Guevara, a Communist guerrilla leader.

On April 15, the SLA pulled a stickup. At 9:40 a.m., a black man and four white women burst into a San Francisco branch of the Hibernia Bank, brandishing carbines. "Get on the floor," the man screamed. One of the gun-toting molls announced, "This is Tania Hearst!" It was she, a bank guard later testified, who shouted the threat: "Lie down or I'll shoot your [expletive] heads off!" The grainy black-and-white footage of Tania/Patty, cradling a rifle in her arms, nervously standing guard while her cohorts/captors netted $10,960 in cash, is arguably the most famous surveillance snippet of all time; today, it can still be seen on YouTube. The heist lasted about five minutes, and then the members of the gang sped off. Their diversionary gunshots wounded two bystanders.

"It's terrible," a perplexed Randolph Hearst told reporters who had camped outside his home in the San Francisco suburb of Hillsborough. "Sixty days ago, she was a lovely child. Now there's a picture of her in a

The video footage (above) from the Hibernia Bank heist was shown ad infinitum in 1974—and has found a second life on YouTube. Other extraordinary images from that time include the heiress's pretty face on an FBI wanted poster (right), just below those of her partners in crime, the Harrises.

bank with a gun in her hand." A public debate raged around him and his family: Patty Hearst, victim or villain?

The bank footage revealed the identities of the four other SLA bandits, including that of Field Marshall Cinque. DeFreeze, 30, was a career criminal who had escaped in 1973 from California's Soledad Prison, where he espoused militant politics. After his jailbreak, he cofounded the SLA. Within days of the Hibernia heist, the FBI issued wanted posters featuring mug shots of all five perpetrators—including Hearst.

The fugitives fled to Los Angeles, where, on May 16, there was another very public, violent incident. Hearst sprayed submachine-gun bullets across the storefront of Mel's Sporting Goods to assist the escape of SLA husband-and-wife team William and Emily Harris—a.k.a. Teko and Yolanda—who were being detained for shoplifting. Police worked fast this time, determined the location of the gang's hideout and, on May 17, surrounded it. A fierce shootout left the building engulfed in flames and six SLA members, including DeFreeze, dead. Hearst was not at the hideout but instead watched live TV coverage of the confrontation from a motel room near Disneyland, where she and the Harrises were holing up.

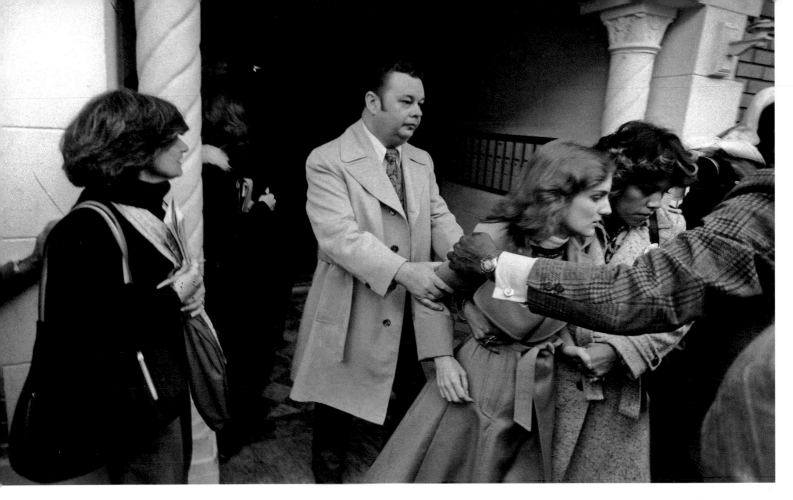

Hearst and the Harrises were able to elude the authorities. Following a final communiqué in early June—in which Hearst eulogized her fallen comrades—the trio laid low for months and contemplated their future.

By the early summer of 1975, they had crisscrossed the country gathering new followers and scheming more crimes. On April 21, with Hearst manning the getaway car, a band of masked SLA members robbed the Crocker National Bank in Carmichael, Calif., near Sacramento, and killed Myrna Opsahl, a 42-year-old mother of four who was depositing her church's collection money. Any sympathy the public felt over Hearst's captivity was pretty much erased by this murder, and the manhunt for the SLA intensified. Finally, on September 18, 1975, the running came to an end. The remnants of the SLA had returned to San Francisco and were sequestered in two different apartments—both of which were under surveillance by the FBI. "Are you Patty Hearst?" the agent shouted, guns trained on the wan heiress and her comrade in crime, Berkeley radical Wendy Yoshimura. "Don't shoot," said Hearst, "I'll go with you." Earlier, the Harrises had been arrested at a separate location.

On February 4, 1976—exactly two years after she had been kidnapped—Patty Hearst, a few weeks shy of 22, went on trial for the armed robbery of the Hibernia Bank. She arrived at the San Francisco courthouse with

Top: On February 16, 1976, during her trial, Hearst revisits the SLA hideout where she had once been held captive in a closet. Inset: Her engagement to Steven Weed just a memory, Hearst weds Bernard Shaw, on April 1, 1979.

her family, wearing a beige pantsuit, hardly looking like the "urban guerrilla" she had listed as her occupation when she was booked. Indeed, Hearst appeared pale and fragile—to some, a sympathetic figure. Over the next nine emotion-packed weeks, while the prosecution portrayed her as a victim turned willful accomplice, her superstar defense lawyer, F. Lee Bailey, argued that she had been brainwashed and threatened throughout her ordeal. No sale: The jury of seven women and five men deliberated for only 12 hours before returning a guilty verdict. Hearst was sentenced to seven years but served only 21 months before her term was commuted by President Jimmy Carter in February of 1979. In January 2001, just hours before turning the White House over to George W. Bush, President Bill Clinton pardoned Hearst.

Today, living in suburban Connecticut with her husband and two daughters, the occasional actress Patty Hearst is well—and remains perhaps the only person on the planet with any understanding of what happened during her 19 months with the SLA.

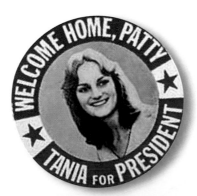

WELCOME HOME, PATTY · TANIA FOR PRESIDENT

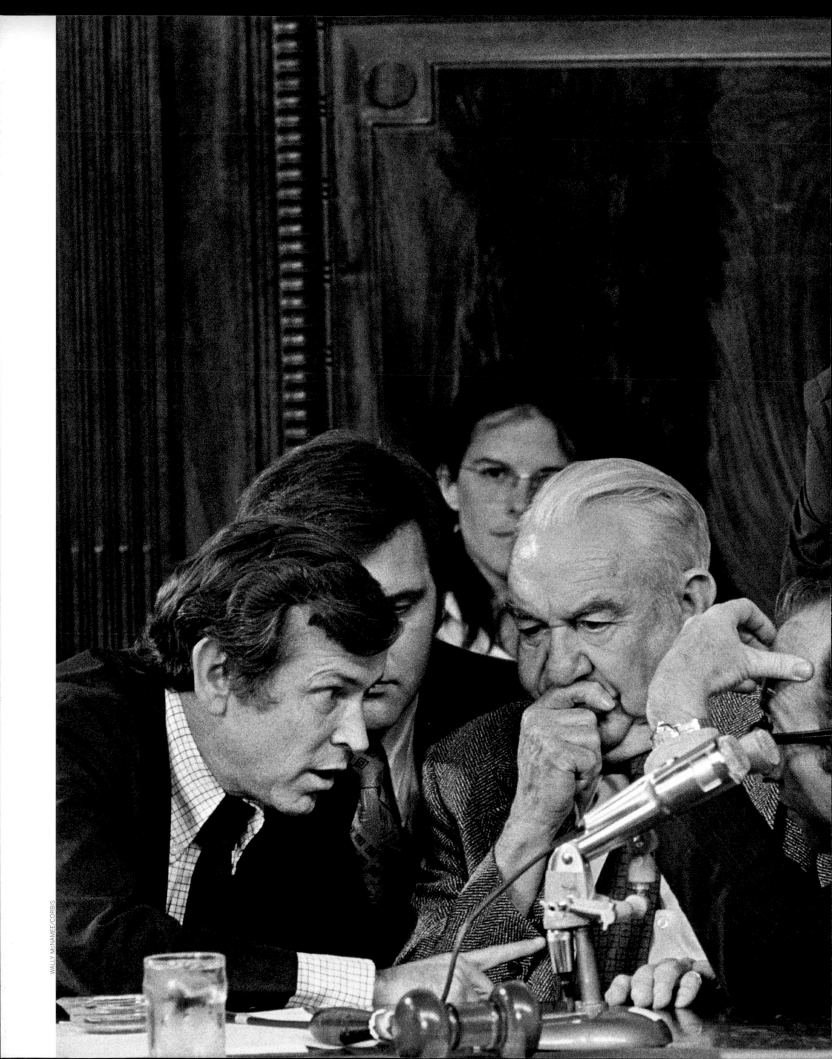

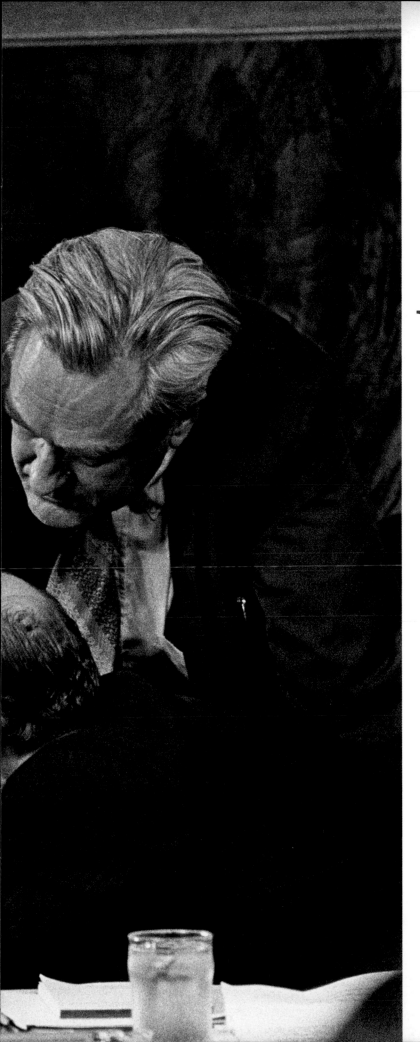

Watergate

I t really was a dark and stormy night.

And it was on this night—well, the early morning of June 17, 1972—when a security guard named Frank Wills peered into an office suite, discovering therein a most curious crew of burglars. News of the bungled break-in made the front page of *The Washington Post*: "Five men, one of whom said he is a former employee of the Central Intelligence Agency, were arrested at 2:30 a.m. yesterday in what authorities described as an elaborate plot to bug the offices of the Democratic National Committee here."

It wouldn't be the last time an article about this incident would appear prominently on the front page of that newspaper.

The caper had unfolded at the Watergate, which would become an infamous edifice in the annals of crime but theretofore known only as a ritzy Washington, D.C., hotel. The Watergate affair was a smarmy little stunt from the get-go. The Republican Party's Committee to Re-elect the President—officially known as CRP, but which could and would be wonderfully rendered as CREEP—was dedicated beyond all reason to the continued tenure of Richard M. Nixon at 1600 Pennsylvania Avenue. Dirty tricks were de rigueur for Tricky Dicky's gang, and in their world, they were above the law.

The Watergate burglars worked for a CRP-financed "plumbers" unit, which was

Senator Sam Ervin of North Carolina (center), head of the Senate Select Committee on Presidential Campaign Activities (better known as the Senate Watergate Committee), confers with Senators Howard Baker (left) and Sam Dash (right).

39

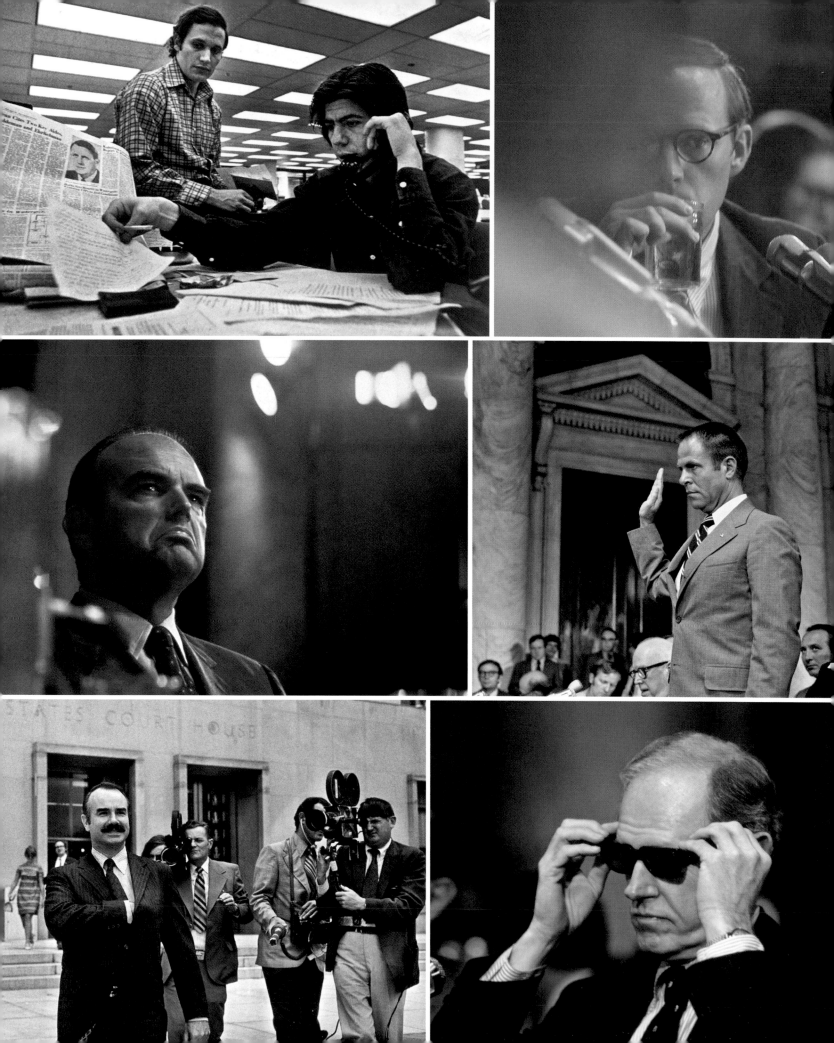

charged with throwing a monkey wrench into the Democrats' election machinery. Their arrest unleashed a pack of media bloodhounds, none of whom would prove more dogged than two young *Post* reporters, Bob Woodward and Carl Bernstein. They sniffed out a trail of misdemeanors and then high crimes that led all the way back to the White House.

Clockwise from top left: Reporters Woodward and Bernstein of *The Washington Post;* former White House Counsel Dean; former presidential adviser Haldeman; convicted conspirator E. Howard Hunt, a co-leader of the "plumbers" unit; Hunt's fellow mastermind G. Gordon Liddy; former White House aide Ehrlichman.

"Woodstein" had a well-connected source, Deep Throat. This shadowy figure supplied incriminating evidence not just of the break-in but of the subsequent cover-up.

Nixon, as we all know, won the 1972 election in a landslide over South Dakota Senator George McGovern. What we might have forgotten is that only days after Nixon's second inauguration, the burglars were convicted, and among them was James W. McCord Jr., who wrote a note to Judge John J. Sirica that pointed to a conspiracy involving administration heavyweights. On April 30, 1973, Attorney General Richard Kleindienst and the President's two closest advisers, H.R. "Bob" Haldeman and John Ehrlichman, resigned (they were all later convicted). Then Kleindienst's replacement, Elliot Richardson, appointed a special prosecutor, Archibald Cox, to oversee an independent inquiry, while Nixon fired White House Counsel John Dean, who would soon become a star witness in the special committee hearings convened by the Senate.

During the summer of '73, those televised proceedings became must-see TV of the highest order. In June, Dean testified that he repeatedly talked with Nixon about the cover-up and warned his boss of a potentially lethal "cancer growing on the presidency." A few weeks later, another former insider, Alexander Butterfield, stunned the committee with the revelation that Nixon secretly tape-recorded conversations in the Oval Office. The President's refusal to turn over pertinent tapes to either Cox or the Senate panel set the stage for the so-called Saturday Night Massacre of October 20. Nixon fired special prosecutor Cox and forced the resignations of Richardson and his deputy, William Ruckelshaus.

The President's brinkmanship only inflamed the situation, and the fight for the tapes grew fiercer. Finally, the White House reluctantly agreed to release edited transcripts of the recordings but drew more Congressional ire when a critical 18-and-a-half-minute gap couldn't be satisfactorily explained. As the stonewalling mounted, so did indictments of key Nixon figures and an erosion of public and political support. An enormous blow came in July 1974 when the Supreme Court ordered Nixon to turn over the tapes, which included the "smoking gun" reel made days after the break-in. On it, for all to hear, were the plans to cover up the crime. By month's end, the House passed articles of impeachment, meaning a Senate trial—and Nixon's probable conviction—was imminent. The front-page *Post* article of August 9, 1974, read in part:

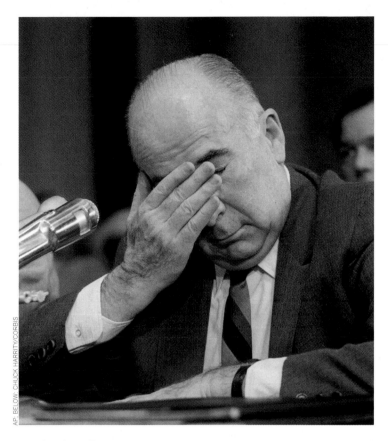

"Richard Milhous Nixon announced last night that he will resign as the 37th President of the United States at noon today."

In an address on his last day in office, Nixon said, "I regret deeply any injuries that may have been done in the course of the events that led to this decision." The next day, his successor, Gerald Ford, declared, "Our long national nightmare is over."

Yes, but there would be at least two postscripts.

Only a month into his term, Ford ended any speculation about Nixon's fate by granting him a full pardon.

And in 2005, W. Mark Felt, the former No. 2 man at the FBI, revealed that he had been Deep Throat.

Above: On July 11, 1973, former Attorney General John Mitchell wipes his eyes during testimony before the Senate panel. Below: A year later, former President Nixon bids farewell to the White House.

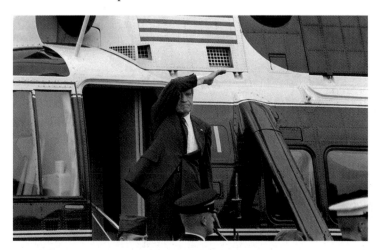

The Shooting of
Ronald Reagan

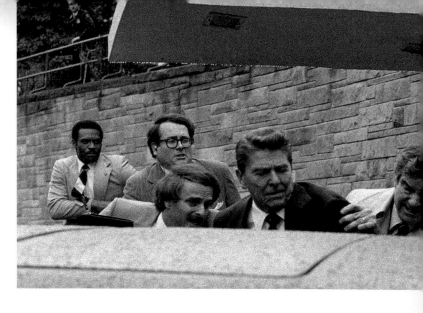

An ex–movie actor who was perhaps the most famous person in the world and an unknown but soon-to-be-infamous young man with a sick fixation on a movie actress were drawn together in a drama that unfolded in Washington, D.C., on March 30, 1981. The hero barely survived, and the villain was caught. It seemed like fodder for a Hollywood script, but tragically, it was real.

Born February 6, 1911, in Tampico, Ill., Ronald Wilson Reagan spent his life embodying the America Dream. He found quick success as an entertainer: first as a radio broadcaster, next as a movie and TV actor of considerable renown. He then parlayed his communication skills, good looks and popularity among conservatives into a long political career. A two-term governor of California, he became, at 69 in 1980, the nation's oldest President-Elect. There were concerns about his age, but no one could foresee the event that would nearly end his presidency in its second month.

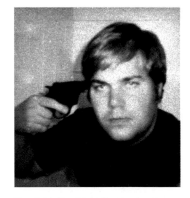

Having addressed a luncheon audience at a Hilton Hotel, the President headed along the sidewalk toward his limousine. From the crowd of onlookers, a 25-year-old man called out, "President Reagan!" then dropped into a marksman's crouch and fired six shots in about three seconds.

The shooter was quickly subdued, while a Secret Service agent grabbed Reagan and shoved him into the limo, which whisked the President away. At first, it was thought that he had escaped unscathed, but soon he complained of pain and started coughing up

Top right: President Reagan has been shot, but even he is unaware of the serious nature of his wound. Right: In the moments immediately after the shooting, a barrage of Secret Service agents leaps into action, tending to the wounded and forcing Hinckley to the ground. Above: In a Polaroid self-portrait that was part of the trial evidence, the state of the shooter's mind is made plain.

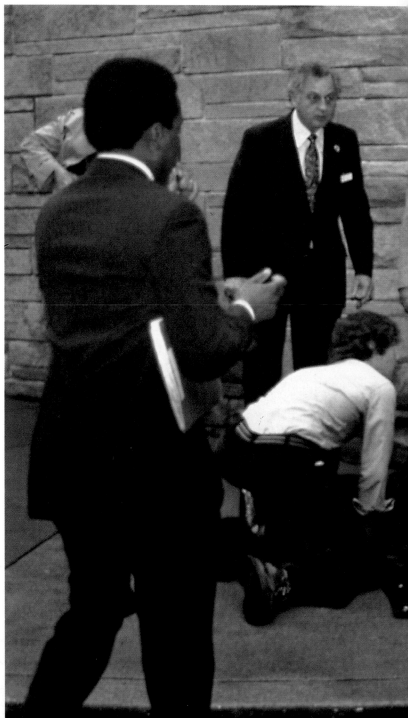

blood. A wound was found under his armpit, and the car sped to the hospital, where surgeons were able to save his life.

The gunman was identified as John Warnock Hinckley Jr. He had grown up in affluence, in Texas, and, by accounts, had been a stable youngster. But something went wrong. During the late 1970s, he became increasingly disturbed. He fixated on the movie *Taxi Driver;* he reportedly saw it 15 times. The film's antihero, Travis Bickle, thinks he can win over a pretty campaign worker by assassinating the presidential candidate she's canvassing for. When that scheme is thwarted, he turns his obsession toward an adolescent prostitute, played by then–13-year-old Jodie Foster. Bickle "rescues" the girl by murdering her pimp.

In September 1980, Hinckley headed to Connecticut, where Foster was enrolled at Yale University. He spoke with her twice by phone and sent her creepy love letters. She rebuffed him, of course, and the spurned Hinckley, now armed, began stalking President Jimmy Carter on the campaign trail. At one point, he was arrested at Nashville's airport for carrying concealed handguns.

Reagan was President by the time Hinckley drifted into Washington, D.C. He wrote one last letter to Foster before pulling the trigger: "I would abandon this idea of getting Reagan in a second if I could only win your heart and live out the rest of my life with you."

That is hardly how he will live out his life: Hinckley, found not guilty by reason of insanity, is institutionalized. It should be noted that he wounded three others. A policeman and a Secret Service agent both recovered, but Reagan's press secretary, James Brady, was left paralyzed—a reminder that real life, as opposed to a movie, involves real pain.

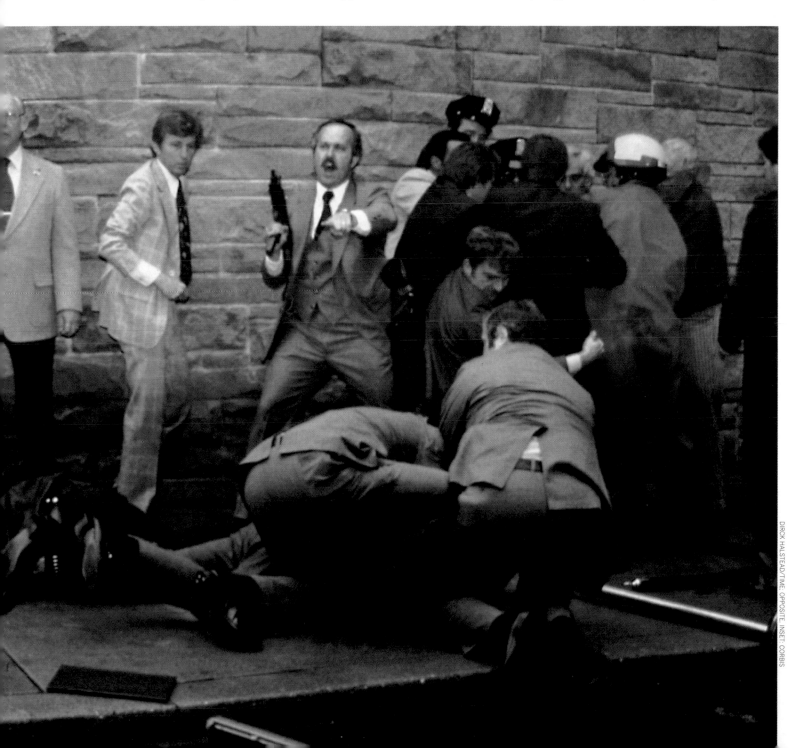

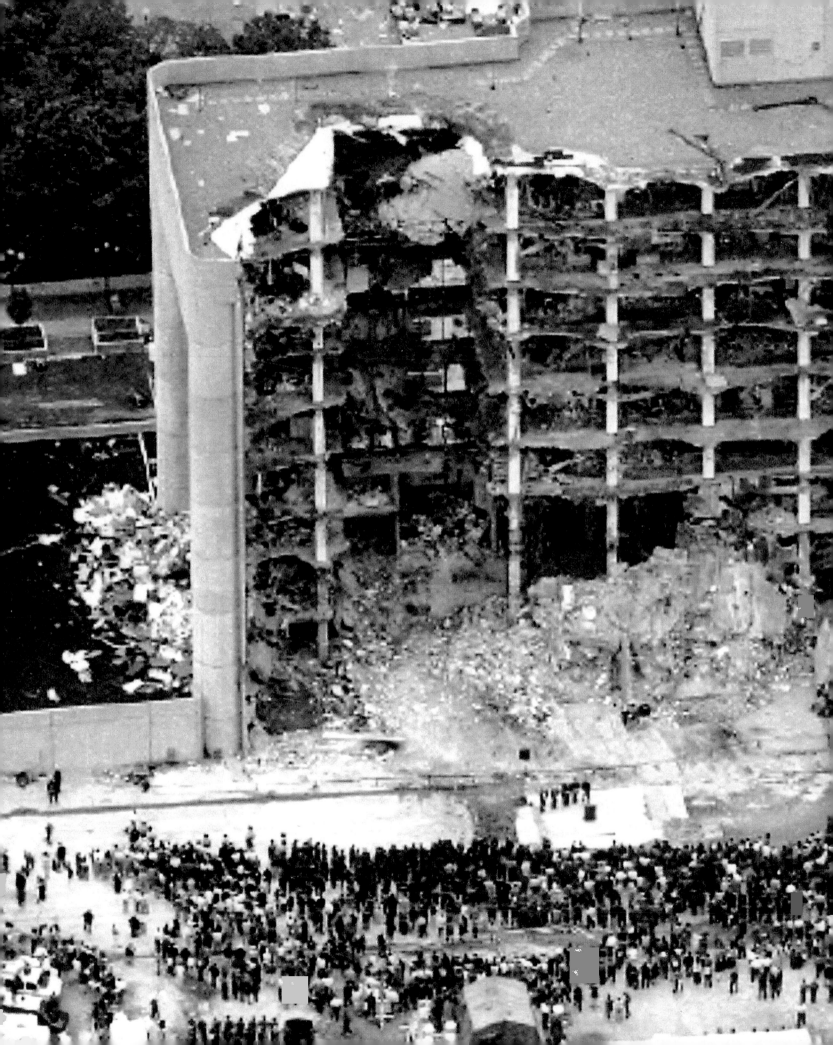

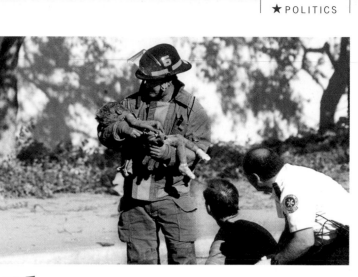

The Oklahoma City Bombing

Timothy McVeigh, once a bright kid who grew up near Buffalo, N.Y., went from earning a Bronze Star in the Army to plotting the government's destruction. After federal agents laid siege to the Branch Davidian compound in Waco, Tex., in 1993—culminating in a fire that destroyed the compound and took the lives of more than 70 men, women and children—McVeigh swore revenge. In April 1995, he drove a truck filled with up to two and a half tons of homemade explosives to Oklahoma City. He parked it in front of the Alfred P. Murrah Federal Building, believing that the agents responsible for Waco worked there. The explosion shattered the structure, leaving 168 dead, including 16 children in a daycare center, and more than 800 injured.

McVeigh, 33, was put to death by lethal injection on June 11, 2001. He no doubt felt he was a martyr, and the date of his fatal deed sheds light on his fanaticism. Oklahoma City happened on April 19; Waco burned on April 19. And on April 19, 1775, in Massachusetts, the shot heard round the world was fired, igniting the Revolutionary War. We remember the start of our national saga as Patriots Day. More than two centuries later, someone's tragically twisted idea of patriotism led to the mass murder of innocents.

Two signature images: The massive destruction (opposite) and firefighter Chris Fields carrying a dying Baylee Almon (above) from the scene. Almon had turned one year old only the day before.

45

The Olympic Park Bombing

Bad guys know that with the whole world watching, the Olympics provide a perfect stage from which to send a message. Ever since the 1972 Summer Games in Munich, Germany, when Palestinian terrorists killed 11 Israeli athletes and coaches in the athletes' village, security has been a top priority of organizers. For their part, the planners of the 1996 Atlanta Games brought in 30,000 law enforcement officers and 11,000 National Guard and active-duty military personnel, including 500 Delta Force and SEAL-Team 6 commandos, airmen from the Army's 160th Special Operations Aviation Regiment and specially trained U.S. Army Rangers. The organizers hoped this would be enough.

As the seventh day of competition came to a close, the congregants at Centennial Olympic Park were enjoying a free concert by Jack Mack and the Heart Attack. Shortly after one a.m. on Saturday, July 27, a vigilant security guard alerted an agent of the Georgia Bureau of Investigation that he had found a suspicious-looking, unattended backpack under a bench near a stage. Around the same time, a local 911 operator received a bomb threat. The security guard and police hastily tried to clear people from the area; a bomb squad rushed to the scene. But the flurry of activity proved too late: At 1:21, the bag exploded. A shower of nails and screws flew indiscriminately through the air. Victims were hit from as far as a football field away. When the chaos subsided, Alice S. Hawthorne, 44, of Albany, Ga., was dead. One hundred eleven people were injured.

The FBI quickly determined that the three crude pipe bombs hidden inside the pack had been planted by homegrown, not foreign, terrorists; the agency called the bombing a "Bubba job."

But that didn't mean the culprit was immediately found. In fact, the earliest theories proved disastrously wrongheaded. The alert security guard, Richard Jewell, who had instantly been hailed as a lifesaver, soon became a prime suspect. The media painted him as a frustrated, attention-seeking loser who had put others in harm's way so that he might look the hero. Even though there was zero evidence of Jewell's guilt, he wouldn't be cleared of suspicion until October. U.S. Attorney General Janet Reno would later apologize to Jewell, who agreed to out-of-court settlements for libel suits he had brought against several media outlets.

The case went cold until, in early 1997, investigators made a connection between the Olympic Park episode and two other Atlanta-area bombings—at an abortion clinic and a lesbian nightclub. Nearly a year later, these three crimes were tied to yet another bombing at an abortion clinic in Birmingham, Ala., in which a policeman had been killed. The license plate of a car fleeing the scene was traced to Eric Robert Rudolph, a 31-year-old carpenter from North Carolina. Feeling the heat, Rudolph escaped into the wilderness of his home state, where he evaded pursuers for more than five years.

On May 31, 2003, Rudolph was scrounging for food behind a grocery store in Murphy, N.C., when he was finally nabbed. His statement of confession was defiant. Because the law of the land sanctioned abortion rights, wrote Rudolph, "the agents of this government . . . are legitimate targets."

How that explained what happened in Atlanta is unfathomable. Regardless, Rudolph, now imprisoned for life, is remembered not for his philosophy but for killing an innocent woman who was trying to have fun at the Olympic Games.

Opposite: Sports fans who had come to join in the Olympics merriment react with shock at Centennial Olympic Park, while ambulances rush the wounded to the hospital. Above: Rudolph is finally taken into custody.

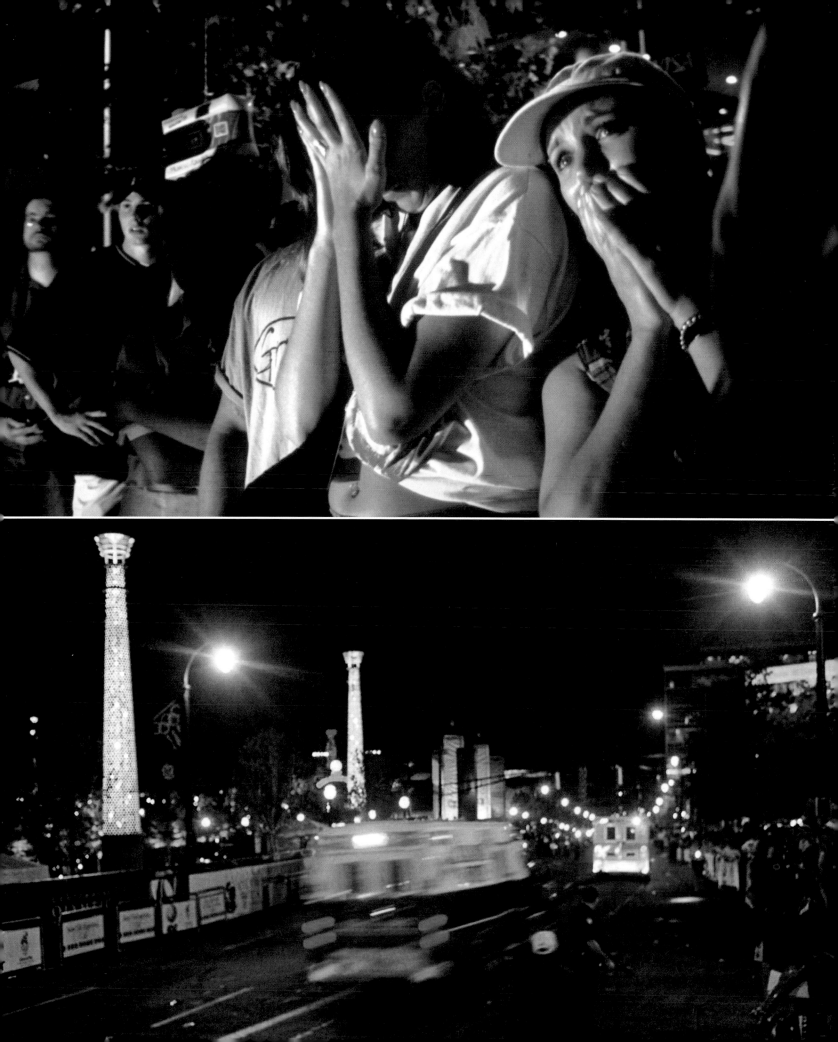

Passion

They killed for love or were killed by lovers. Throughout history, the allure of people like Evelyn Nesbit has been fatal.

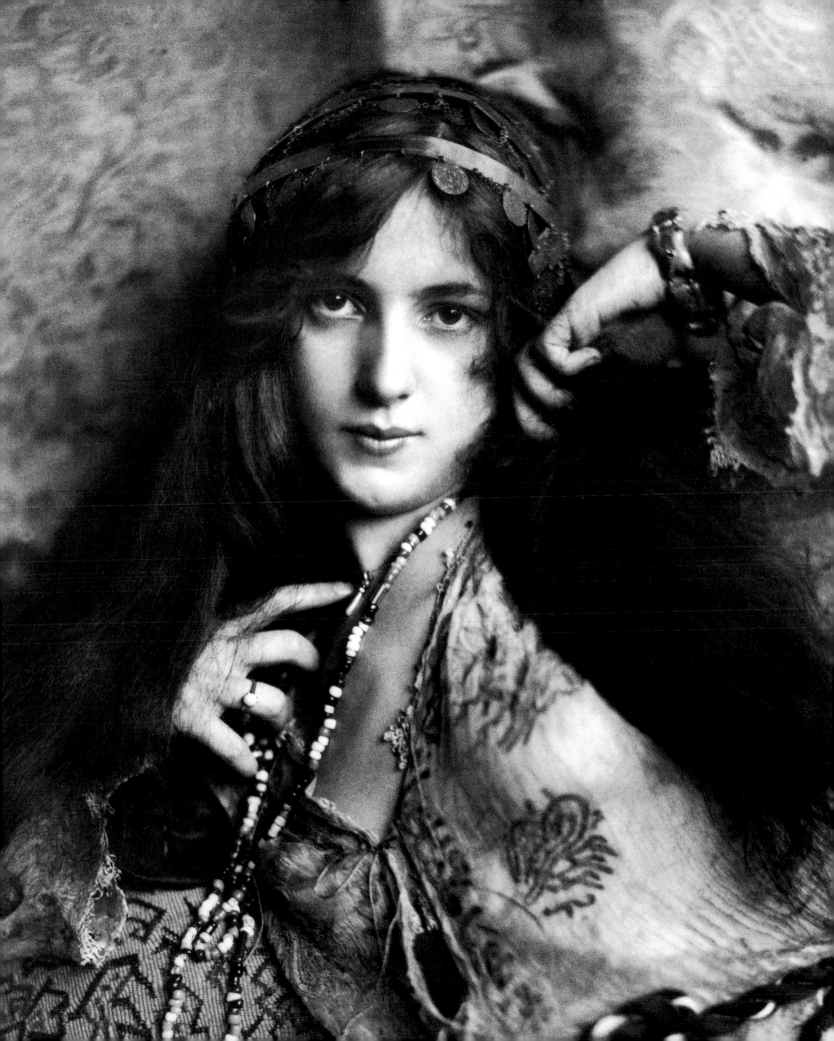

An American Tragedy

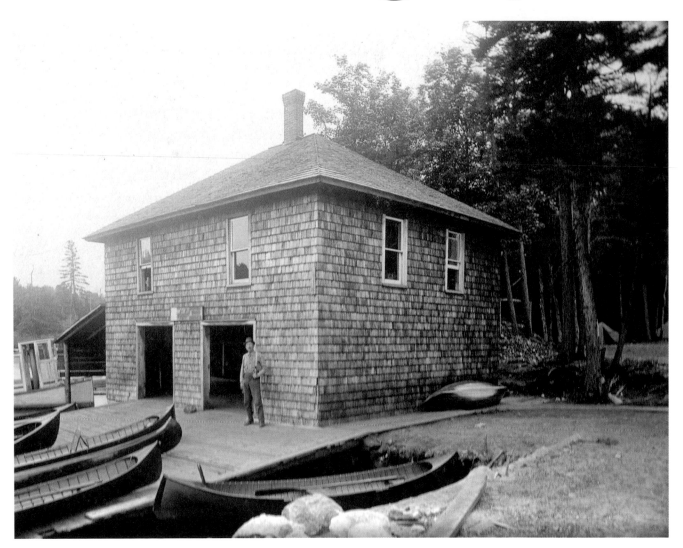

t is a safe bet that on the night *A Place in the Sun* won six Academy Awards in 1952, the names Chester Gillette and Grace Brown were unknown to most of the Hollywood crowd and probably long since forgotten by many Americans. The audience perhaps knew George Eastman, the character played by Montgomery Clift, and Angela Vickers, as portrayed by Elizabeth Taylor. And they probably knew that Eastman and Vickers were the original protagonists of Theodore Dreiser's classic 1925 novel, *An American Tragedy,* upon which the movie was based. But few would have reached back to 1908 when Gillette, the real-life prototype for

Eastman, was executed for the murder of Brown in the denouement of what was, at the time, one of the most sensational murder cases in American history.

Chester Gillette and Grace Brown met in 1905 while working at the Gillette Skirt Factory, owned by Gillette's rich uncle. Gillette was 21. Brown was an attractive 19-year-old from a local farming family near Cortland, the small city in south central New York where the factory was located. The handsome Gillette had a reputation as a playboy, so Brown's family was less than thrilled when the two young people started dating that summer.

The relationship took a dramatic turn when Brown became pregnant in the spring of 1906. She kept her condition secret, hoping to break the news after Gillette proposed marriage, as she was sure he would. But Gillette kept putting Brown off, rebuffing the emotional outpourings of letters she wrote to him after returning to her parents' home. "Oh, please come and take me away," she pleaded. He wouldn't, and Brown grew desperate. She threatened to reveal Gillette as the father of her soon-to-be child, forcing his hand but certainly not as she had hoped to.

They rendezvoused at a hotel in DeRuyter, a small town east of Cortland, on July 8, 1906. With a suitcase and a tennis racket in hand, he registered as Charles George. The next day, the couple took a train to Utica, where he signed them into a hotel as Charles Gordon and wife, of New York City. Their fateful journey continued northward to the Adirondack Mountains, a favorite upstate getaway. They checked into a hotel in Tupper Lake on July 10 as Charles George and wife.

Opposite: From this boathouse near the Glenmore Inn, Gillette rented a 17-foot-long wooden rowboat for the fateful, fatal trip on Big Moose Lake. Above: The young lovers and one of Brown's anguished letters.

Gillette rented a rowboat for a sojourn on Big Moose Lake the following afternoon. This time, he registered at the lakeside Glenmore Inn as Carl Grahm, of Albany, while signing in Brown under her real name. For reasons known only to Gillette, he brought his suitcase and racket on the boat. By the next morning, they hadn't returned. A search party discovered the capsized boat and subsequently located Brown's body at the bottom of the lake. Gillette was nowhere to be found.

It didn't take long for authorities to suspect foul play, figure out Carl Grahm's true identity and start looking for Gillette. Three days later, he was arrested at the Arrowhead Hotel in Inlet, a few miles from the lake. He still had the suitcase. The tennis racket had disappeared.

District Attorney George Ward entered the packed Herkimer County Courthouse with a sheaf of circumstantial evidence, highlighted by the couple's correspondence and Gillette's trail of aliases. With reporters from every major newspaper in the land listening raptly, the prosecutor read excerpts from Brown's letters, effectively giving her a voice from the grave. He contended that rather than marry the mother of his unborn child, the heartless defendant beat her with the tennis racket and dumped her overboard. On the stand, Gillette insisted he had been unable to stop the suicidal Brown from flinging herself into the lake. After attempts to save her failed, he swam to shore and hiked to Inlet, burying the tennis racket along the way for fear it could be mistakenly linked to her death.

The jury didn't buy it. On December 4—with no eyewitnesses, no direct proof, no confession—they declared Gillette guilty of first-degree murder. His appeal and his mother's pleas for leniency couldn't save him from Auburn Prison's electric chair, where he died on March 30, 1908.

Dreiser took it from there. And then Hollywood. Fade to black.

The Shooting of Stanford White

The public's hunger for celebrity scandal and tabloid titillation is hardly a recent phenomenon. A century ago, the media may have lacked the reach and speed it commands today but certainly not the enthusiasm. Cutthroat competition among newspapers—notably New York City's *World Journal* and *Morning Journal*—led to yellow journalism's heyday. Whatever sold copies was far more important to the publishers than actual news.

Against that backdrop try to imagine the circus that attended this incident in the summer of 1906: Harry K. Thaw, the filthy-rich husband of sex goddess Evelyn Nesbit, calmly walked up to bon vivant architect Stanford White and, at point-blank range, shot him dead while White was attending a show in the rooftop cabaret of a showcase Manhattan building that he himself had designed. William Randolph Hearst set a tone in the *Morning Journal*: "It is not a mere murder. The flash of that pistol lighted up depths of degradation, an abyss of moral turpitude that the people must think of, because it reveals some of the hidden features of powerful, reckless, openly flaunted wealth."

Most of the deadly sins were represented in this one. You had lust, jealousy, pride, greed, drugs and violence, and all of this was on vibrant display during a courtroom drama that never skimped on sordid details.

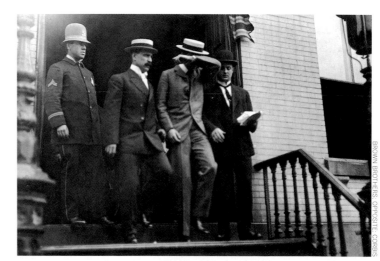

This tale begins in 1901, when White, at 47 a leading American architect and a well-known, fabulously wealthy connoisseur of showgirls, attended the popular Broadway review *Florodora*. He couldn't divert his licentious eyes from the stunning 16-year-old redhead in the chorus—Florence Evelyn Nesbit. White learned that Nesbit hailed from a dirt-poor Pennsylvania family. Her exquisite beauty, paired with destitution, had been the impetus

Thaw (above) chooses to remain anonymous on the morning after White's murder, while, later, Nesbit (opposite) makes her best attempt to appear demure as she testifies at Thaw's trial.

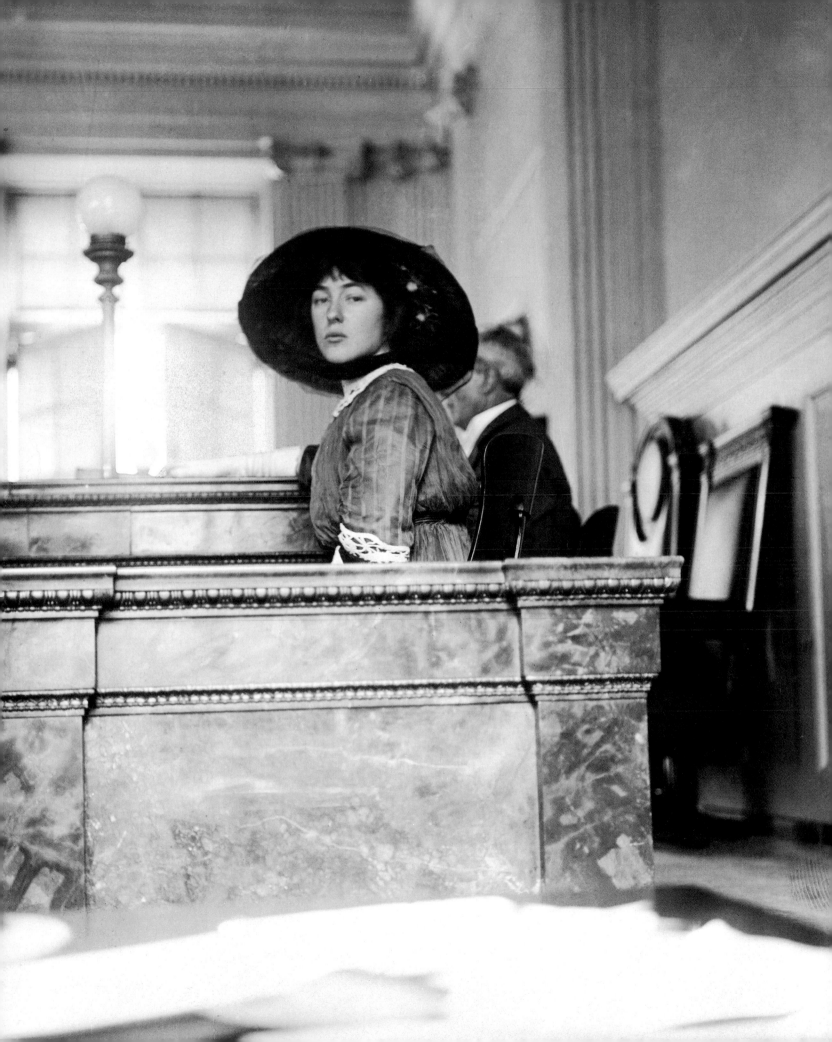

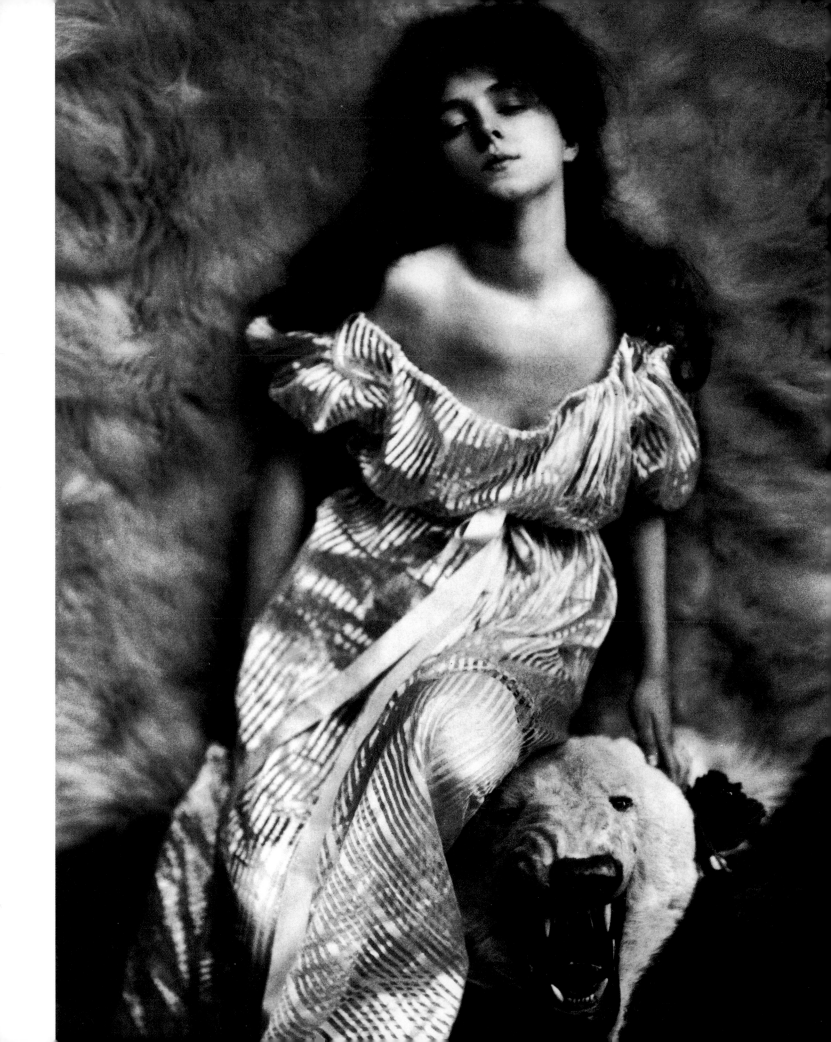

Most of the deadly sins were represented in this case. You had lust, jealousy, pride, greed, drugs and violence— all of it on vibrant display during a trial that never skimped on sordid details.

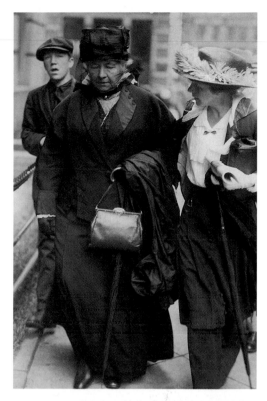

for her modeling career. Breaking into the industry in Philadelphia when she was just 14, she was soon in New York, earning enough to support her mother and younger brother. And then came *Florodora*.

White, a married man, maintained a lavish pied-à-terre—replete with a fabled red velvet swing—atop Madison Square Garden. It was, in a word, a lair. Like many a starlet before her, Nesbit visited White in his apartment often, at first with chaperones, then without. When he and the teenager were alone one night, he allegedly slipped her a sedative and defiled her. Whether or not Nesbit was White's willing lover that night, she subsequently became his concubine.

One so ravishing and celebrated as Nesbit naturally attracted other suitors. Among them was the rising actor John Barrymore. Rumors spread that their intimate relationship had resulted in Nesbit, then 17, becoming pregnant. White arranged for her to attend an all-girls academy in New Jersey, where she had a medical procedure for "appendicitis."

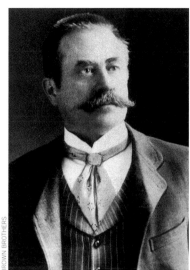

Opposite: The teenage Nesbit in 1901, the year she met White. Clockwise from top left: The debonair debaucher himself; Thaw's mother, Mrs. Copley Thaw, and sister Alice, the countess of Yarmouth, at the trial; Thaw at an elegant breakfast table in his cell.

But the great Barrymore was only a bit player in this drama. Enter Thaw, of Pittsburgh, whose millions weren't earned but inherited. His job, as he saw it, was to spend the fortune gallivanting in Europe. Along the way, he picked up a cocaine habit and a predilection for whipping his lady friends.

Thaw presumptuously saw himself as White's rival for social status (and showgirls) even before he vied for Nesbit's affections. His initial overtures to the young beauty were in the form of mystery gifts from a "Mr. Monroe." Thaw eventually revealed himself and—ignoring White's disapproval—persisted in wooing Nesbit, heaping largesse on her and her mother. During a European tour with Nesbit, Thaw learned that White had deflowered her, and in a rage, he beat her.

Despite all, Nesbit became Thaw's bride, and in the summer of 1906, the couple headed out from Pittsburgh on another globe-trotting trip. First stop, New York—thus setting the stage for White's final curtain.

At the sensational murder trial, the legendarily aberrant Thaw and his defense team figured he was a cinch for an insanity plea. After all, wasn't White's wicked lifestyle—especially his vile theft of Nesbit's virginity—enough to drive any good man crazy? The first jury deadlocked over that question, but 10 months later, a second jury answered yes. Thaw was sent to an asylum north of New York City. He escaped to

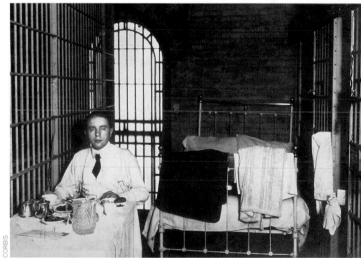

Canada in 1913 but was caught. For two years, his lawyers fought to keep him free, and in 1915, the courts relented, declaring him sane.

As one might expect, there would be no happy ending for either Thaw or Nesbit, who divorced him after his exoneration. The ever-depraved Thaw was sent back to the asylum for six years in 1916 after he whipped a teenage boy. In 1947, he died of a heart attack at age 76.

Nesbit had a son, who might have been Thaw's, but devoted more attention to drugs, booze and other forms of dissolution than to parenting. Before she died in 1967, at age 82, she was portrayed in the movie *The Girl in the Red Velvet Swing*. Her life and times also informed E.L. Doctorow's great novel *Ragtime*, which went on to stage and screen. But none of the fictive treatments of Nesbit, Thaw and White can quite equal the real thing—especially as duly recorded in the lurid accounts of the day.

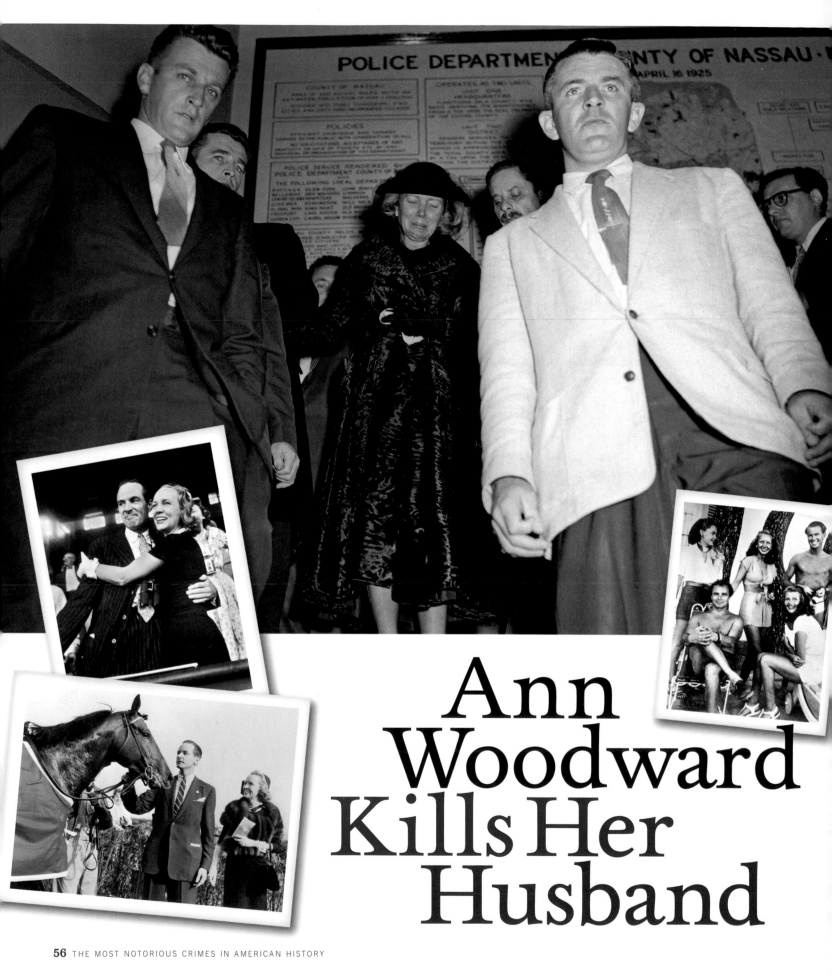

Ann Woodward Kills Her Husband

Technically, this one's not a crime, but it's just too irresistible—and, at the time, created too large a sensation (LIFE called it "the shooting of the century")—to keep out of a book like ours. And actually, there was a crime committed that night: Someone did trespass on private property. So perhaps this fact gives us dispensation.

We begin our tale with William Woodward Jr., a character out of an F. Scott Fitzgerald novel and, in the 1950s, one of America's preeminent sportsmen and social lions. A third-generation, old-money, Harvard-educated New York City banking bigwig, Billy preferred investing his time—after distinguishing himself in the Navy during World War II—in pursuit of fine wines, fine women and glory at the horse track. His family farm was the renowned Belair Stud in Maryland, which had already produced two Triple Crown winners, Gallant Fox (in 1930) and Omaha (in 1935), and was now known as home of the great Nashua.

Evangeline Crowell's background was nothing like Billy's. Her family's farm in Kansas was meager, and the girl knew early on that she wanted out. In 1937, she changed her name to Ann Eden and headed for New York City, her blonde loveliness being her principal calling card. She became a model with the John Robert Powers agency, then won stage roles, a radio gig and a job moonlighting as a showgirl at FeFe's Monte Carlo nightclub.

Opposite: Snapshots from happier days include the Woodwards posing with Nashua and hugging as he wins. Ann, who adored glitterati, stands in the center of a scene that includes Prince Ali Khan and Rita Hayworth.

Ensign Woodward met Miss Eden and fell hard, marrying her in 1943. While Billy was off gallantly fighting in the South Pacific, Ann was gallivanting in New York, where she was considered by many in high society, including Billy's grande dame mother, Elsie Woodward, as a pariah. After the war, Billy joined Ann in glamorous public cavorting—and, unfortunately, in dubious private behavior. The Woodwards engaged in love affairs and domestic dustups that sometimes devolved into fisticuffs. They hired private eyes to spy on each other. The marriage was a mess, yet they persevered—mostly, it was thought, for the sake of their two young sons.

On October 29, 1955, the Woodwards attended a party in honor of the Duchess of Windsor, which was being thrown not far from their estate on Long Island's exclusive North Shore. They returned home and prepared for bed, which involved a little bit more than brushing their teeth due to the recent wave of break-ins in the area. Billy stashed a revolver in a bedside nightstand. In her own bedroom, Ann checked her double-barreled 12-gauge shotgun.

At around three a.m., Ann awoke to the family dog's barking. "I saw a figure, which I failed to recognize," she later told police. No stranger to firearms (a seasoned hunter, she had once bagged a Bengal tiger), Ann

emptied both barrels. The pellets from one caught Billy in the head, killing him instantly at age 35. Ann's physician would testify: "When Mrs. Woodward was startled by the noise, grabbing the shotgun and shooting was a conditioned response." A grand jury bought that argument, not in the least because a serial burglar had been caught and had admitted to being on the premises that night, and Ann was exonerated.

But she and what remained of her family were never really set free. Son Jimmy attended a private school in Switzerland and served in Vietnam, then sunk into a life of substance abuse and mental illness. He committed suicide in 1976. Son Woody followed in his dad's footsteps at Harvard and eventually became a wealthy, influential journalist, publisher and politician in New York City. But he could never exorcise his personal demons, and in 1999, he, too, killed himself.

Ann (opposite) weeps after three hours of questioning in November 1955. That same month, Woody and Jimmy (below) after visiting their mom.

Ann received a relative pittance of Billy's fortune, which she spent during the considerable amount of time she lived abroad in the years after her trial. In 1975, she learned that *Answered*

HAL MATHEWSON/NEW YORK DAILY NEWS

Prayers, Truman Capote's ruthless look at society's elite, featuring a thinly veiled version of her story (including a claim that Billy had learned she was a bigamist), was to be excerpted in *Esquire.* Just before the magazine hit the stands, Ann, then 60, ate enough cyanide to end her life.

"Well, that's that," Ann's mother-in-law was quoted as saying. "She shot my son, and Truman has just murdered her, and so now I suppose we don't have to worry about that anymore."

Sorry, Elsie, but a tale so torrid will continue to be told, as this one was in Dominick Dunne's best-selling novel *The Two Mrs. Grenvilles,* then in a 1987 TV movie—and now in this book.

The Death of Johnny Stompanato

The crimes committed here, as we interpret the jury's decision in this case, were largely Johnny Stompanato's own: His loudly issued threats and his uncontrollable rage made his violent death on the night of April 4, 1958, not only a thing to be expected but also a thing that could be justified. The villain was the victim.

But Stompanato wasn't the real star of this drama; if he were, he would have been forgotten long ago. The girlfriend in question was Lana Turner, the seven-times-married screen siren who paused between husbands four and five for an ill-advised romance with an olive-skinned,

Above: Police officer Kenneth O. McKuin plays his part in a classically noir L.A. crime photo by helpfully lifting Stompanato's shirt. Opposite: Crane, after the stabbing and just before being booked, in Los Angeles County Juvenile Hall.

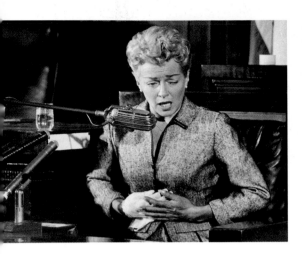

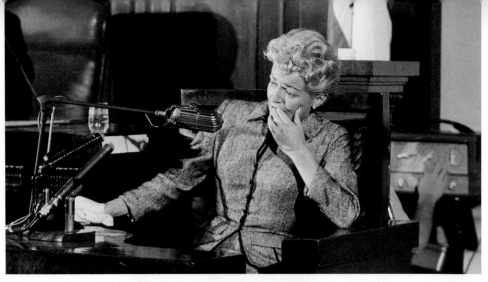

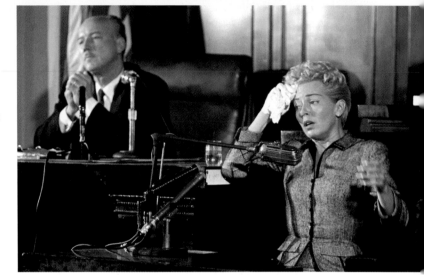

Left: Turner portrays Stompanato clutching his abdomen. Above and right: During Turner's hour-long testimony—which some called the performance of her life—the anguish is her own. Opposite: At day's end she is in tears beside defense attorney Jerry Geisler.

dark-haired ex-Marine. Stompanato was good-looking, but he was not at all good. Among other things, he was a fraud. In 1957, when he began courting Turner, he presented himself as John Steele and lied that he was 32, five years older than she; he was actually four years younger. He also failed to mention at least three previous marriages and divorces, or his reputation as a gigolo, or his association with the Los Angeles gangster Mickey Cohen.

This last item was most disturbing to Turner. One more boyfriend could hardly damage her public image, but running around with a known hoodlum certainly could.

Still, Lana had developed a taste for Stompanato and spent lots of time with him, even though she avoided being seen around town in his company. This state of affairs was much to the macho man's chagrin, and Stompanato grew possessive, then verbally and physically abusive. Representative of several incidents was the outburst on Oscar night in 1958. Turner, who was expecting a best actress statuette for *Peyton Place* (she wouldn't win it), insisted that Stompanato stay home. He didn't want to, of course, and later that night, he erupted, raving at Turner and slapping her around.

Witnessing this was Cheryl Crane, the 14-year-old daughter from Turner's second marriage and her only child. The incident obviously loomed large in the teen's consciousness one week later when Stompanato blew yet another gasket. It was the night of Good Friday at the Turner mansion, and Stompanato was in full fury when Crane decided her mother had suffered enough. She ran to the kitchen and grabbed an eight-inch carving knife. She made her way to Turner's bedroom. "I walked into the room, and I said, 'You don't have to take that, Mother,'" she would later testify. "Then I pushed the knife into his stomach with all my might."

That was the end of Stompanato and the beginning of a fast-paced tabloid spectacular. Crane escaped the immediate glare first in jail, then in a juvenile detention center as she awaited her day in court, which came

quickly. On April 11, exactly one week after the killing, a jury, convened for a coroner's inquest, heard evidence. While a live television audience gawked, an impeccably dressed and coiffed Turner sobbed on the witness stand as she recalled the abuse she suffered at the hands of Stompanato. Crane's vivid recollection of the night confirmed her mother's testimony: "I heard him say, 'I'll get you if it takes a day, a week or a year. I'll cut your face up. I'll stomp you.'" Then Crane's deposition, in which she admitted that she had "stuck him with the knife," was read back.

In the end, the jury declared that the daughter had committed "justifiable homicide." The district attorney agreed, concluding, "It would not be my inclination to prosecute her."

Turner went on from that courtroom to more men, more movies, more tabloid headlines, a starring role in TV's *Falcon Crest* and Hollywood legend status that she retained until her death in 1995 at age 74. Crane, who became a ward of the state, spent time in a reformatory and escaped on one occasion. She became a successful businesswoman and now lives in the San Francisco area. In 1988, she wrote a memoir in which she discussed not only the killing but also the sexual abuse that she had suffered at the hands of Turner's fourth husband, actor Lex Barker.

As for Johnny Stompanato, he became a memory—a fascinating footnote in the ever amazing annals of Tinseltown.

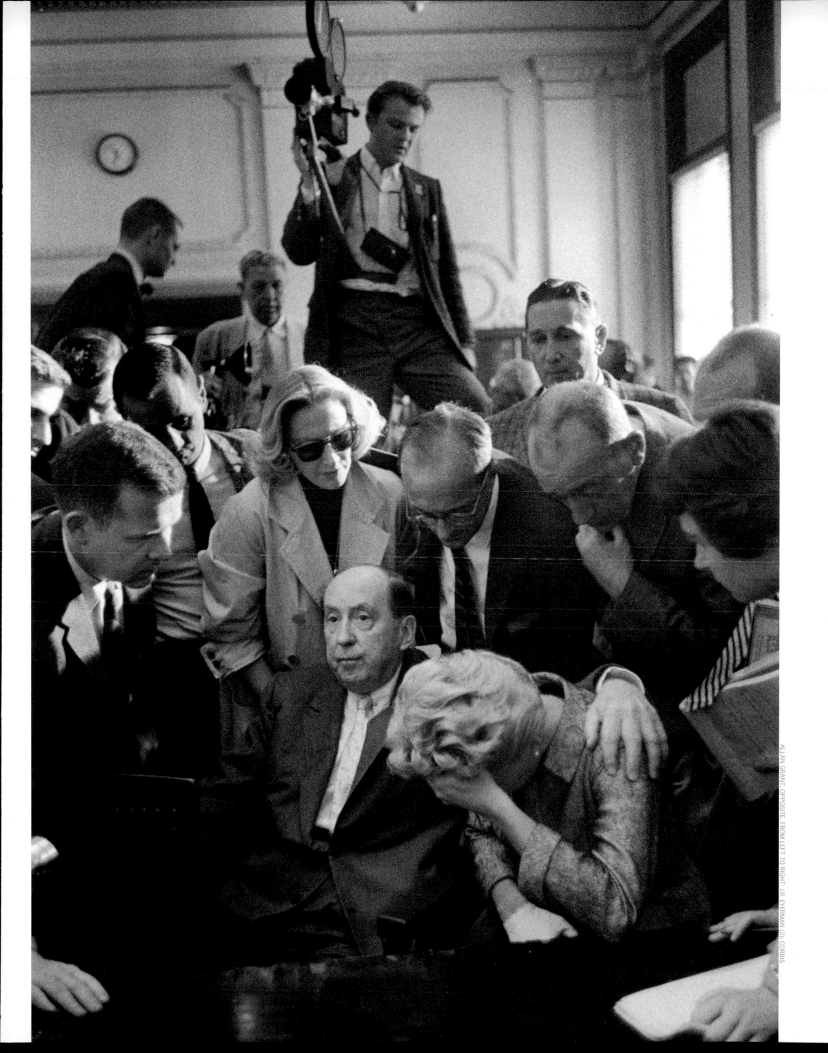

The Deaths of Sid & Nancy

They say there's someone for everyone. The brief, intense romance of Sid Vicious and Nancy Spungen seemed to affirm that adage—in a terribly sad way. And the spectacle of Sid and Nancy as they sped along a downward spiral in the late 1970s served to support another rule of thumb: The public cannot help but watch, open eyes covered by splayed fingers, as celebrities' lives crash and burn.

The setting for this psychodrama was the punk rock scene in New York and London. Bands like the Ramones, the Clash and the Damned were proud to be loud and rude—but the kings of outrage were the Sex Pistols. Dressed in tatters held together by safety pins, their hair dyed and spiked, they were the epitome of British working-class nihilism. The group's lead singer was John Lydon, better and much more appropriately known by his stage name, Johnny Rotten. In 1976, their first single, "Anarchy in the U.K.," led to a raucous, obscenity-laced TV appearance, decried by the *Daily Mirror* in the headline THE FILTH AND THE FURY. The episode propelled them to fame in their homeland, where they were revered and vilified in equal measure.

John Simon Ritchie, a 19-year-old Londoner, was an old friend of Lydon's. So when the Pistols lost bassist Glen Matlock in 1977, Lydon brought in Ritchie and rechristened him Sid Vicious, which was also the name of the Lydon family's hamster. Sid wasn't much of a musician, but his grungy looks and belligerent attitude worked well onstage. He further endeared himself to fans with what *The New York Times* felicitously called a "particularly rabid series of offstage carryings-on." The 19-year-old American Nancy Spungen became part of said shenanigans soon after meeting Sid. A problem child "almost from birth" (as her mother would later write in a memoir), Nancy left the family's suburban Philadelphia home and became a heroin addict and sometime stripper. She went to England hoping to hook into the punk scene. Sid was her ticket to ride.

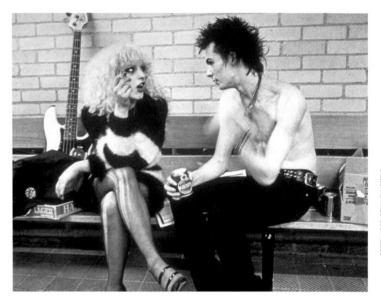

But that ride was about to veer off course. In January 1978, the Sex Pistols essentially disintegrated during a two-week U.S. tour that was marked by constant infighting and regular disappearances by Sid. At the final gig in San Francisco, Lydon quit the Pistols. The band's tour manager, Nils Stevenson, said that in this period Sid grew to "dislike everything—except heroin and Nancy." By the summer of that ill-fated year, the lovers had shacked up at New York's fabled Chelsea Hotel, the eternal bohemian haunt of everyone from Mark Twain to Janis Joplin.

For Sid and Nancy, the Chelsea became a house of horrors. As both sank deeper into drug dependency, Sid turned violent, to the point where, according to a fellow resident, he beat Nancy with a guitar on more than one occasion. Not only did she stay with Sid, she bought him little tokens of her love—like a knife she gave him to fend off thugs.

On October 12, police were summoned to the Chelsea after someone reported trouble in Room 100. They discovered Nancy, drenched in blood,

KE

As the two fell deeper into drug dependency, Sid turned violent. On more than one occasion, according to another resident of the Chelsea, Sid beat Nancy—with his guitar.

under the bathroom sink, a fatal knife wound in her abdomen. Sid was found wandering the halls in a drugged stupor when he was arrested for murder.

Out a day later on $50,000 bail, his already-miserable life came completely undone. His mother's arrival from London and methadone treatments for his addiction couldn't keep Sid from several suicide attempts. "I want to be with my Nancy!" he reportedly screamed after the first try.

In December, he landed back in jail after attacking rocker Patti Smith's brother with a broken bottle. On February 1, 1979, he was again out on bail and reunited with Mum. It has been alleged that to celebrate his freedom, she bought him some heroin. About 13 hours after his release, the 21-year-old was dead from an overdose. The medical examiner ruled it an "inadvertent death."

It certainly seems, in retrospect, an unavoidable one. The story of Sid and Nancy was a tragedy from hello and doomed to end viciously.

Opposite: Nancy chats with Sid. Left: With blood on his hands, Sid exits the Chelsea Hotel after Nancy's death, then (above) enters the morgue after his own.

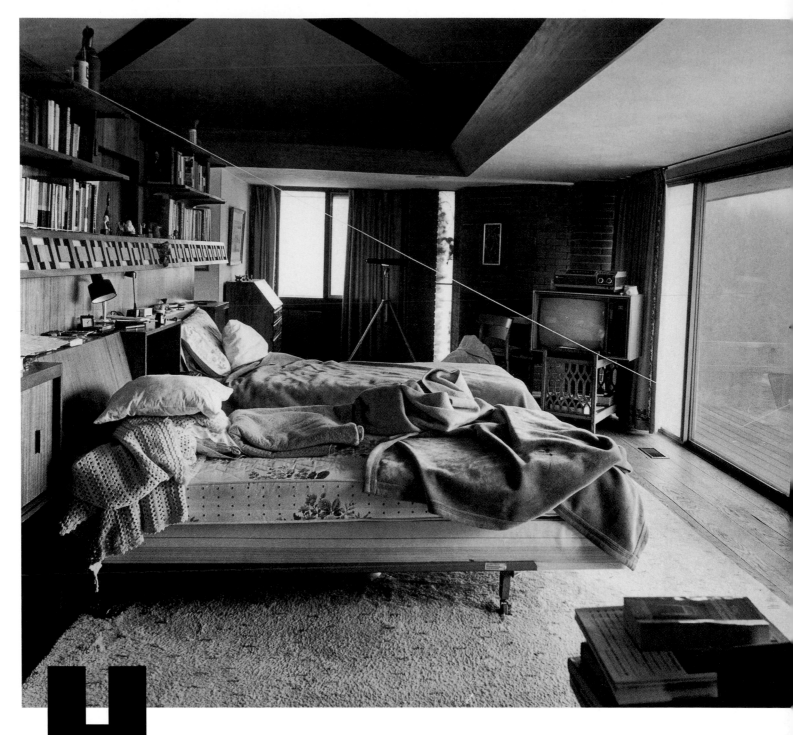

The Scarsdale Diet Doc Murder

H e will have to tread carefully," wrote *Time* magazine's Walter Isaacson in 1981, regarding the prosecutor's approach in the trial of the murderer of the doctor who had created the then-popular Scarsdale Diet, "lest the jury forget that Herman Tarnower, not poor Jean Harris, was the victim." Yet even today, Harris, who was found guilty of shooting Tarnower and went to prison for almost a dozen years before her release in 1993, is widely regarded as the sympathetic character in this sensational case.

Born in Cleveland in 1923, Jean Struven doesn't fit the profile of a killer. A bright child, she graduated from prestigious Smith College in 1945 and soon after married Jim Harris. Nineteen years and two sons later, their marriage had simply run its course, and they divorced.

Already an experienced educator, she landed a job as the director of the Thomas School in Rowayton, Conn. In 1966, she met Tarnower, not yet a famous author but already a successful cardiologist in the affluent New York City suburb of Scarsdale. They began a long-distance relationship that continued even after Harris landed the headmistress position at the exclusive all-girls Madeira School in McLean, Va., in 1977. Her style of governance there earned her the nickname "Integrity Harris."

In 1979, Tarnower became a bona fide celebrity with the success of *The Complete Scarsdale Medical Diet,* which is why the events that would soon unfold are remembered today. If an anonymous school headmistress had murdered an anonymous two-timing Westchester County heart doctor back then, it wouldn't have created a stir. But she murdered the "Diet Doc."

Tarnower was a confirmed bachelor and ladies' man; Harris, his most constant companion, tolerated this—until Tarnower began to dally with his longtime but much-younger blonde office assistant, Lynne Tryforos. Harris grew terribly jealous and increasingly depressed. She confronted Tarnower and her rival, which gained Harris nothing but more heartache and despair. Finally, these emotions festered into rage.

On the rainy night of March 10, 1980, Tryforos was among a handful of dinner guests at Tarnower's posh estate in the hamlet of Purchase. Harris, meanwhile, was desperately driving north for an unannounced visit. The dinner guests left around nine p.m., and Harris arrived two hours later, bearing a load of confusion and a .32-caliber revolver.

She surprised Tarnower in his bedroom. She wanted to talk; he didn't. She freaked out when she found another woman's nightgown in the bathroom. An argument led to a scuffle and four gunshots. By sunrise, the 69-year-old Tarnower had been pronounced dead, and Harris, 57, was in jail for second-degree murder.

Harris told police she had intended to use the gun for her own suicide, but it had accidentally misfired. She stuck to this story during the exhausting 14-week trial, which was capped by her star turn on the stand. Sobbing, she admitted shooting Tarnower, but only after he had hit her—and she insisted he wasn't the target. "Hit me again, Hy. Make it hard enough to kill me!" Harris said she had screamed as she grabbed the revolver. "Never mind, I'll do it myself." They grappled over the gun. It went off. "There was an instant where I thought I felt the muzzle of the gun in my stomach. I pulled the trigger. I thought, 'My God, that didn't hurt at all. I should have died a long time ago.'"

Dodging the "poor Jean" dilemma, the prosecutor's trump card was a bizarre letter Harris had sent to Tarnower shortly before that fatal night. In it, she called Tryforos a "vicious, adulterous psychotic" and accused her of slashing some of Harris's clothes and stealing her jewelry.

The jury deliberated for eight long days before delivering a guilty verdict on February 24, 1981. Later, Harris was sentenced to a minimum of 15 years to life in prison.

From top: Harris in the late '70s, when she was headmistress at the Madeira School in Virginia; Tarnower and Harris relax in Florida, in December 1978; Tryforos goes about her work while Tarnower enjoys a healthful lunch. Opposite: The crime scene shortly after the murder.

The case had an immediate afterlife through books and a made-for-TV movie. In prison, Harris quickly devoted herself to teaching fellow inmates, especially young mothers, and went on to write three books about her trial and life behind bars. Beyond the institution's walls, a corps of supporters, including her grown sons, mounted unsuccessful appeals, and then sent clemency petitions to New York Governor Mario Cuomo. On the fourth request, Harris was granted clemency—just hours before undergoing bypass surgery following a third heart attack—on December 29, 1992. She was freed a month later and has led a quiet life in relative seclusion. To her belongs the calm final chapter in this tumultuous story.

The Pamela Smart Murder Case

All these years later, it's still hard to say why Pamela Smart had her husband, Greg, killed. If she was angry with or bored by him, she could have simply divorced him. But then again, we know she feared that in the settlement her husband might have gotten the couple's dog.

The sound track to this story is meant to be played loud. Pamela Ann Wojas, who was the "Maiden of Metal" on a weekly radio show at Florida State University, met Greg Smart at a New Year's Eve party in 1986 and found that he shared her passion for ear-splitting tunes. With his guitar and his long hair, he reminded her of Jon Bon Jovi. What was not to love? So they married in 1989 and moved into a condo in Derry, N.H. During this happy time, the couple bought a Shih Tzu puppy and named it Halen—as in the band Van Halen.

This blissful period proved all too brief. Within a year, Greg—minus the mane since becoming an insurance salesman—admitted he was having an affair. Pam, who was in charge of the media services department at Minnacunnet High School in Hampton, N.H., soon had a dalliance of her own—a dangerous one. The 22-year-old's attractiveness and taste in music made her a favorite among the kids, particularly the boys and especially 15-year-old sophomore Billy Flynn. In March 1990, when Greg was out of town, Pam invited Flynn to her condo. While viewing the sexy film *9½ Weeks*, Pam slipped into lacy lingerie and seduced the underage virgin, touching off a series of encounters and Flynn's deepening infatuation.

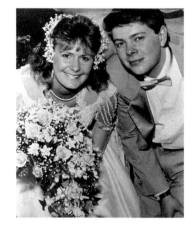

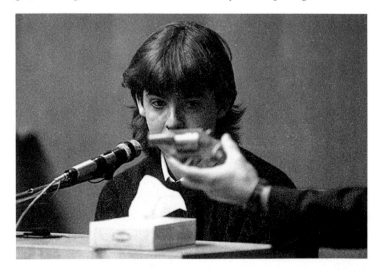

Above: Pam and Greg as happy young newlyweds. Left: On his 17th birthday in 1991, Flynn is shown the gun he used in the crime. Opposite: Pam strikes a beguiling pose in a photo she asked a friend to take. She then gave the film to Flynn to be developed.

Pam expressed one wish to Flynn: She wanted Greg dead. "If you loved me, you'd do this," she said. If he didn't do it, she added, then no more sex. Flynn agreed to play his part, and Pam picked a date—May 1. Flynn and a friend entered the Smarts' home through a door that Pam had left unlocked. Per her orders, they safely stashed Halen in the basement, ransacked the place to suggest a burglary and waited for Greg's return. The boys jumped him when he came in the front door. "God, forgive me," Flynn said as he fired a single bullet, killing the 24-year-old Greg.

From the start, detective Daniel Pelletier didn't like the look of things. A bungled burglary with an execution-style killing? And Pam, said Pelletier, "wasn't acting the grieving widow."

In mid-June, the police received an anonymous tip that Cecelia Pierce, Pam's intern, knew something. Pierce cooperated with authorities, was wired for sound and taped two damning conversations with Pam about Greg's murder. Then Flynn's friends started talking, and police had enough evidence to arrest the widow Smart and her co-conspirators.

"It's replaced the soap operas," remarked a Derry store owner as the 12-day trial—carried live on local TV—neared its close in late winter 1991. Flynn had already pleaded guilty to his part in the plot and testified against Pam. On March 22, the jury declared her guilty, and she was sentenced to life without the possibility of parole. Flynn, serving a 40-year term, is eligible for parole in 2018. The town of Derry has returned to normal.

Amy Fisher
and the
Buttafuocos

In the early 1990s, theirs was a seamy, triangulated story of underage lust, adultery and attempted murder. On the radar screen of the American public, one day they were nobodies—and the next, the very biggest thing.

Amy Fisher grew up in a middle-class family on Long Island. In May 1991, the attractive 16-year-old student at John F. Kennedy High School in Bellmore, N.Y., panicked when she damaged her car. To avoid her father's wrath, she decided to get the car fixed quick. That was Fisher's plan when she drove to Complete Auto Body & Fender. But that plan changed when she and the owner of the garage, 35-year-old Joey Buttafuoco, laid eyes on each other.

Before long, the two of them, ignoring the fact that she was underage and he was married and had children, were having sex—at the shop and at local no-tell motels. Fisher, who meanwhile started turning tricks for an escort service to earn money (Joey set that up for her), asked Joey to leave his wife, Mary Jo. But he was enjoying the status quo and wouldn't budge.

On May 19, 1992, Fisher, now 17 and nearing the end of her senior year, decided to take matters into her own hands. At around 11:30 that morning, she rang the doorbell at the Buttafuocos' house in Massapequa. Mary Jo answered and, for the next few minutes, listened to Fisher's odd tale about Joey having an affair with some other young girl. Finally, Mary Jo heard enough, but when she turned to go back inside, Fisher whipped out a .25-caliber semiautomatic pistol and shot Mary Jo in the head.

Fisher's scheme to bump off the wife and have Joey to herself backfired. Although critically wounded, Mary Jo survived and gave police a description of her assailant. Joey then identified Fisher, but only as a wacko customer. Within days, Fisher was behind bars, charged with attempted murder and unable to post the astronomical $2 million bail—unable, until she agreed to tell her story for the same amount. That fee speaks volumes about how hot this story starring the "Long Island Lolita" was at the time.

Fisher confessed that she and Joey had been having a torrid affair but claimed that the gun fired accidentally when she went to bop Mary Jo on the head. Joey said Fisher's story about their relationship was nonsense. But if Fisher was in trouble, Joey wasn't doing very well, either—especially when his signature was discovered on local motel registers.

MARC ASNIN/REDUX; BELOW: MARY MCLAUGHLIN; OPPOSITE: PAUL DeMARIA/NEW YORK DAILY NEWS

Above: Members of the media, including Geraldo Rivera (right), engulf Joey. Left: The big guy plants a very public kiss on Mary Jo as she returns from the hospital. Opposite: Fisher is led away in handcuffs.

Finally, Fisher copped a plea, admitting to reckless assault and pledging to cooperate in the investigation of Joey's role. Fisher got a 5-to-15-year sentence; Joey got six months for statutory rape. After Fisher served seven years, she was paroled in 1999 and became a columnist for a local newspaper. She authored a tell-all book, married in 2003 and had two kids.

In 2006, Fisher and Mary Jo confronted each other on TV—part of the healing process, you see—then Fisher and Joey hooked up for the coin toss at the Lingerie Bowl, a racy Super Bowl halftime alternative. The topper came in May 2007, when Fisher, having left her husband, and Joey, divorced since 2003, reportedly went on a date. They were either talking things out or discussing the possibility of a reality TV series. Stay tuned.

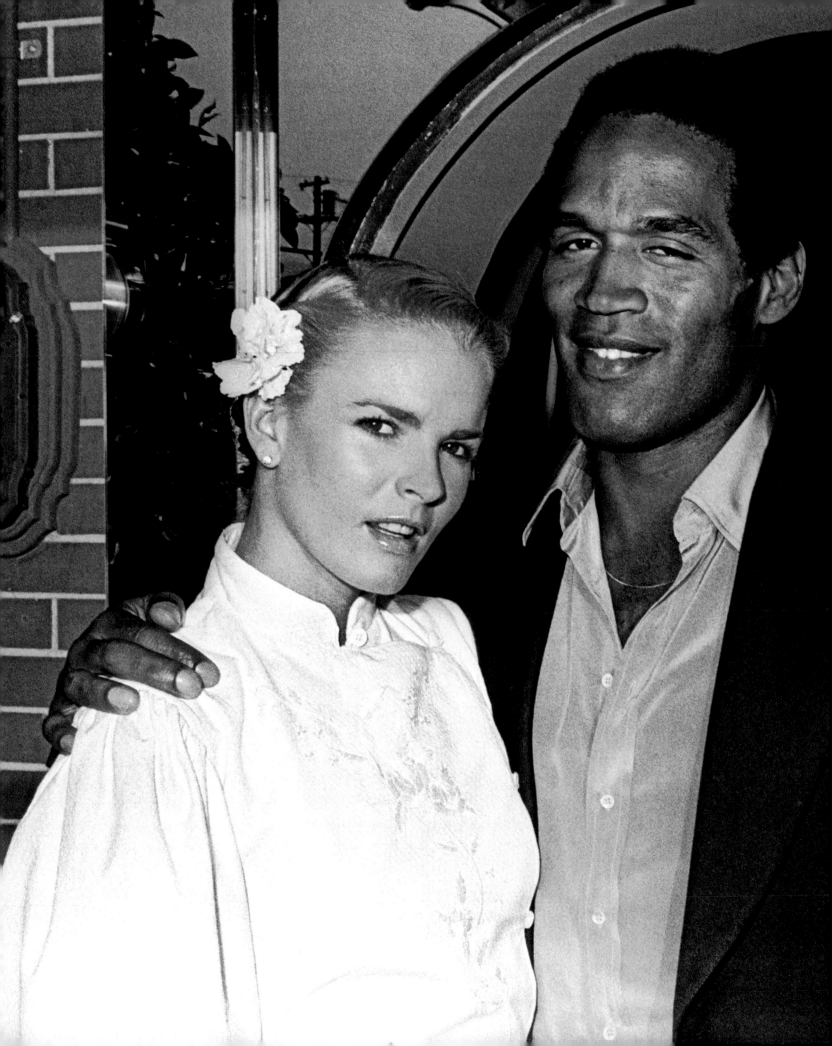

The Murder of O.J. Simpson's Wife

Agruesome double murder took place on the night of June 12, 1994, in the ritzy Brentwood section of Los Angeles. It occurred in a dark walkway leading to a luxury condominium where someone brutally knifed a man and a woman. From that shocking scene unfurled a long, ultra-high-profile case that became the latest seeking to claim the Trial of the Century title—because one of the victims was the gorgeous former wife of a very rich and famous American sports hero turned movie actor.

Orenthal James "O.J." Simpson was one of the greatest running backs in the history of football. The 1968 Heisman Trophy winner was among the best-ever college players, and his years with the Buffalo Bills earned him a spot in the Pro Football Hall of Fame. Then he headed to Hollywood, where "Juice" became an action hero with a surprising and disarming sense of humor. Through his work as a commentator on *Monday Night Football* and a series of funny Hertz commercials, America's vast TV audience came to know and like O.J. Simpson.

Opposite: Nicole and O.J. in L.A. in 1980, three years after they had started dating and five years before they wed. They divorced in 1992, and she was killed in '94.

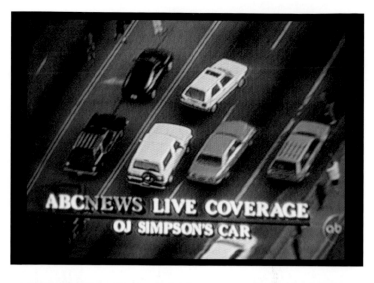

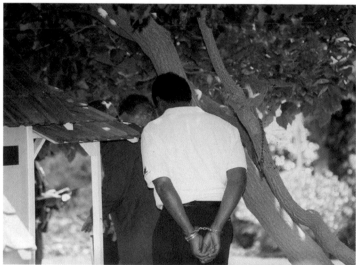

beautiful blonde wife divorced in 1992? Was it true that during their seven-year marriage, this superstar athlete beat her?

After O.J. and others interviewed by police couldn't concur on his whereabouts at the time of the killings, a judge issued a warrant for O.J.'s arrest on June 17. When he did not turn himself in as promised, an already wild story became surreal. The police went to take O.J. into custody, but he wasn't home. That evening, a white Bronco was spotted heading south on the freeway. This SUV belonged to O.J.'s close friend and former teammate Al Cowlings, who warned police that a distraught O.J. was pointing a gun at his own head. Minutes later, millions of TV viewers witnessed live coverage, beamed from a swarm of news helicopters, of a bizarre slow-speed police chase. Eventually, the posse followed the Bronco to O.J.'s home, where he surrendered.

Over the next six months, the L.A. district attorney's office and a "dream team" of defense lawyers prepared their cases. The prosecution, led by Marcia Clark and Christopher Darden, compiled a mountain of evidence to prove that Nicole was a battered wife, butchered by a jealous ex-husband whose murderous rage also fell upon Goldman—a guy who was in the wrong place at the wrong time. Lead defense lawyer Johnnie Cochran, meanwhile, was preparing to show that O.J. was framed

The TV tabloid shows went into overdrive, and in the way they phrased their questions, the racial overtones that shadowed the case became clear.

So, many felt great and immediate sympathy for him when they learned that 35-year-old Nicole Brown Simpson, O.J.'s second ex-wife and the mother of two of his children, had been killed outside her home, along with Ron Goldman, a 25-year-old friend of hers.

But in a murder investigation, the spouse or former spouse is always a suspect, and once O.J. became a target of the investigation, the case was off and running with the speed that he had shown on the gridiron. Detectives swarmed the crime scene, gathering evidence that included bloody footprints and a bloody glove. Searching O.J.'s house nearby, they discovered more bloodstains—on his driveway, his white Ford Bronco and a pair of socks in his bedroom. An officer picked up what appeared to be the matching glove behind the house.

The TV tabloid shows went into overdrive, and in the way they phrased their questions, the racial overtones that shadowed the case became clear: Why exactly had this African American man and his

Above: Police cruisers follow O.J. on the freeway, then officers cuff him at his home. Right: Highlights of the prosecution's case included these photos, a desperate 911 call from Nicole after O.J. had beat her and DNA evidence indicating that blood found at the murder scene and at his house belonged to him.

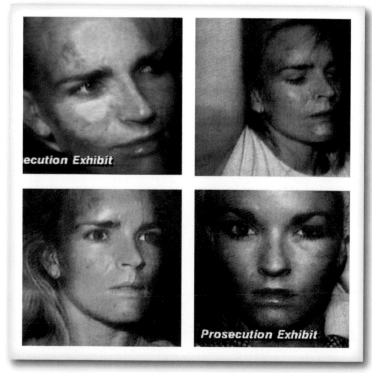

ecution Exhibit

Prosecution Exhibit

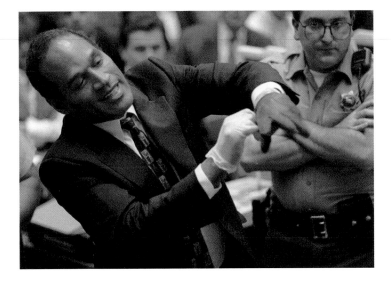

by a racist cop. He also lined up experts who would cast reasonable doubt on the prosecution's DNA evidence.

From the selection of the predominantly black jury to the stunning verdict it rendered 10 months later, the O.J. trial captivated America. Televised live, it was endlessly analyzed by TV talking heads. The case provided an unprecedented journey inside the U.S. justice system.

Above: When O.J. struggled with the glove, Cochran was presented with the signature line for his closing argument: "If it doesn't fit, you must acquit." The jury did, and Simpson walked—and not for the last time. Below: He beats a road-rage rap in 2001.

O.J. never testified, though he did play a crucial role in a sensational episode: Darden asked the defendant to try on one of the bloody gloves, but it didn't fit.

In October 1995, the jury deliberated for less than four hours before finding O.J. not guilty. The reaction, which was split largely but not exclusively along racial lines, ranged from joy to horror; to this day, most Americans can recall where they were when they heard of O.J.'s acquittal. But few can remember when O.J. lost the civil case brought by Goldman's and Brown's families for the wrongful death of Ron and battery against both Ron and Nicole. The "preponderance of evidence" directive to the jury facilitated the deliverance of a guilty verdict and a $33.5 million judgment against O.J. in 1997. Because of the former football star's financial arrangements, only a fraction of the money has been paid to the families.

In November 2006, it was announced that O.J. would publish *If I Did It*, an account of how he might have committed the murders. The public outcry that met this news caused the project to be shelved.

To the surprise of few, no other suspect has been charged in this case.

Mary Kay Letourneau

Was it true love, as Mary Kay Letourneau has claimed often and vociferously over the years, when she—at 34, a married mother of four and a grade-school teacher—had sex with 12-year-old student Vili Fualaau? Was it for love that she bore his daughter? Was it even deeper love that drove Letourneau, who was on parole after serving two and a half months in prison for the statutory rape of Fualaau, to take up with him again? And could it have grown deeper still when, back in the slammer for a second time, she gave birth to the couple's second child? Certainly it was for love that she married him, right?

None of this could have been predicted for Mary Katherine Schmitz, born in 1962 and raised in an ultraconservative Roman Catholic household in Southern California. She attended college at Arizona State University where, having become pregnant, she married fellow student Steve Letourneau in 1984. The young family settled into the Seattle suburb of Burien, where he worked as a cargo specialist for Alaska Airlines and she became an admired public school teacher.

Letourneau first met Fualaau in her second-grade class at Shorewood Elementary School. She was struck by the eight-year-old's artistic talent. "There was a bonding that was pretty instantaneous," she would later tell *The Seattle Times*. Fualaau became her student again in the sixth grade, and by then, "he was my best friend," Letourneau claimed. "We just walked together in the same rhythm."

In June 1996, just before Fualaau's 13th birthday, the couple had sex for the first time. A few months later, Letourneau was pregnant; Audrey Lokelani Fualaau was born on May 23, 1997, and placed in the care of Fualaau's mother.

When their romance went public, it set off an interesting debate. Cases

Below: Letourneau and Fualaau in a yearbook photo. A lot of parents fought to get their kids into her class, and at first many felt she had been falsely accused.

involving adult male teachers having sex with underage female students seemed clear-cut crimes. But Letourneau insisted that her relationship with Fualaau was consensual, and some observers,

Left: The happy couple in 2004, after her release from prison. Above: Mary Claire, the oldest daughter from Letourneau's first marriage, performs maid-of-honor duties at Mom's wedding to Fualaau in 2005.

including the boy's mother and Letourneau's soon-to-be ex-husband, argued that the punishment for her role in the affair should be lenient. The judge agreed and sentenced Letourneau to seven and a half years but reduced her time to six months, contingent upon a pledge that she undergo sex-offender treatment, take medication for bipolar disorder and keep her hands off the kid. "I give you my word," Letourneau said.

Just a month after her release from prison, police busted Letourneau again, having found her and Fualaau in a compromising position inside a steamed-up car. Pregnant once more, Letourneau was sent back to jail. There, she delivered Alexis Georgia.

Letourneau left prison for the last time on August 4, 2004. While incarcerated, she had tutored fellow inmates, sung in the choir and rarely missed Mass. She had also remained in contact with Fualaau—even collaborating on a book, *Only One Crime, Love* (which was published in France in 1998). Fualaau turned 21 just before Letourneau was freed, and he petitioned the court to lift the no-contact order. It did, and as supporters had predicted and detractors feared, the couple got married on May 20, 2005, selling the TV rights to their wedding for a six-figure payoff.

Today, the Fualaaus live in Normandy Park, Wash., where their household sometimes includes not just their two kids but the four from Mary Kay's previous marriage: a nice big nuclear family that has been through a positively nuclear experience.

The Murder of Laci Peterson

From the moment Scott Peterson spoke to the cops on Christmas Eve 2002, something about him didn't seem quite right. His wife, Laci, was missing from their Modesto, Calif., home, Scott told police. The 30-year-old fertilizer salesman said good-bye to her early that morning as he was leaving for an all-day solo fishing trip in the waters off Berkeley. Laci, 27 and eight months pregnant with the couple's first child, was taking their golden retriever for a walk when he had last seen her.

"I had a gut feeling," Modesto police detective Al Brocchini would later tell *People* magazine. "When we questioned him a couple of hours after he got home, he didn't know what he was fishing for or what bait he was using." Added Stanislaus County prosecutor Rick Distaso: "I'm a fisherman. I could tell you what I was fishing for three years ago."

Scott and Laci, both good-looking, athletic California kids, had met in 1995 when they were undergrads at California Polytechnic State University in San Luis Obispo. They wed in 1998 and moved to Modesto to be closer to her family. When Laci became pregnant in the spring of 2002, a sonogram showed she was carrying a boy, whom they named Conner. Everything was going great. And then Laci disappeared.

Amber Frey, a 27-year-old massage therapist in Fresno, was shocked when she saw the news about the disappearance of Scott's wife. She called the Modesto police immediately and said, "Scott's my boyfriend." For more than a month, she had been dating him, she claimed, and he had told her—among other lies—that he was single.

Realizing her sticky role in the mystery, Frey agreed to tape-record phone conversations with Scott. While police continued to follow up various leads to no avail, their eyes remained fixed on Scott, who, the authorities now knew, had purchased a $250,000 life insurance policy on his wife. On April 13, the remains of a tiny human body washed ashore in San Francisco Bay less than five miles from where Scott had supposedly gone fishing. A day later, a woman's body was found nearby. On April 18, officials arrested Scott—who had lightened his hair and grown a goatee—near his parents' home in San Diego. He was about 30 miles from the Mexican border and carrying $15,000 in cash, as well as his brother's driver's license. When DNA evidence

confirmed that the bodies were those of Laci and Conner, Scott was charged with two counts of murder.

Several months of highly publicized investigation and legal wrangling preceded the opening gavel on June 1, 2004. Over the next five months, Distaso's team argued that Scott had either strangled or smothered Laci at home, loaded her body in his truck and dumped it in the bay.

Even the defense team, led by celebrity litigator Mark Geragos, admitted that Scott was a "14-carat a--hole" for cheating on his pregnant wife but insisted there was a lack of direct evidence proving Scott's guilt. Geragos pointed to a satanic cult, burglars and even Laci's relatives as possible suspects, concluding that the prosecutors "have not proved that Scott Peterson did anything except lie."

Above: Scott and a pregnant Laci appear very happy during the 2002 Christmas season, but she would not live to see the holiday. Opposite: The search for her body intensifies.

The jury deliberated for nine days before returning its verdict on November 12. As people across the country watched a live broadcast and hundreds outside the San Mateo courthouse listened to an audio feed, the six men and six women declared Scott guilty of the first-degree murder of Laci and the second-degree murder of Conner. A month later, the same jury said execution was warranted, and on March 16, 2005, Judge Alfred Delucchi sentenced Scott to die by lethal injection. Still insisting upon his innocence, he remains on death row at San Quentin. "Peterson will never confess," Distaso has said. "That will never happen."

The promise of a payoff always puts a spring in the step of ne'er-do-wells like the Dapper Don, John Gotti.

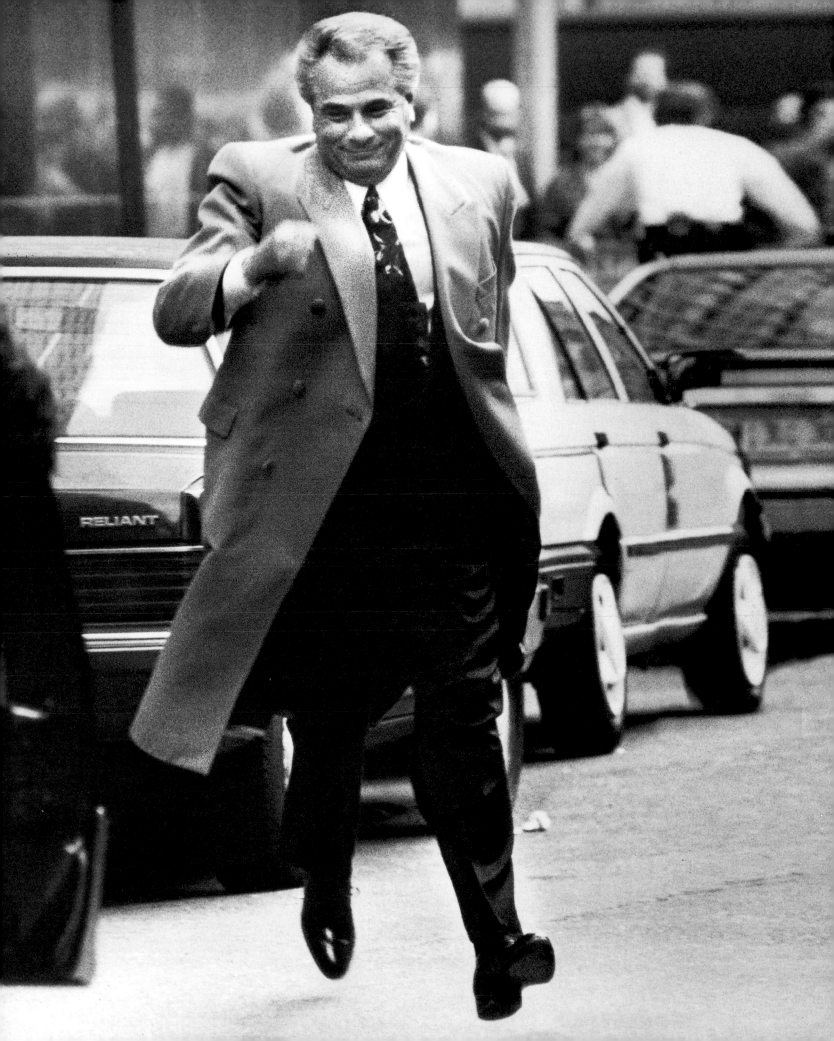

Sacco and Vanzetti

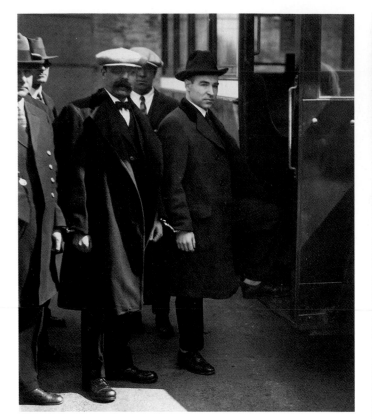

The true spirit of our democracy requires that our judicial system operate free from the political biases that can prejudice and threaten the fair treatment of the accused. The politically charged atmosphere surrounding the trial of Nicola Sacco and Bartolomeo Vanzetti severely put that cornerstone to the test during much of the 1920s. The case of these two Italian immigrants—whether they perpetrated the crime or not—raised questions about civil rights, ethnic bigotry, patriotism and capital punishment.

The crime itself was brazen. On April 15, 1920, outside the Slater & Morrill shoe factory in South Braintree, Mass., two men ambushed paymaster Frederick Parmenter and guard Alessandro Berardelli as they were about to deliver nearly $16,000 in payroll money. Parmenter and Berardelli were shot and lay dying as the robbers sped off in a getaway car.

Sacco and Vanzetti were local laborers. Sacco, a married father of one son, worked at a shoe factory in Stoughton. Vanzetti, a bachelor, toiled as a fish peddler on the streets of Plymouth. They had come to America sharing not only a strong work ethic but also a distrust of big government and an attraction to the radical philosophy of the Italian anarchist Luigi Galleani. Indeed, their mutual support of Galleani's militant activities, which included a rash of bombings, brought them together in 1917. They had joined a group of fellow anarchists who fled to Mexico to avoid the draft during World War I. Needless to say, these actions curried no favor with the authorities, who linked evidence from the shoe factory shooting to Sacco and Vanzetti. They were arrested on May 5, 1920, although neither had ever been convicted of a crime before.

Jury selection began on May 31, 1921, and once the members were chosen, district attorney Frederick Katzmann started to play upon a fear that many Americans harbored. Socialism and Communism were spreading west, fueled by the Russian Revolution of 1917, the recent

Above: The mustachioed Vanzetti and his fellow anarchist Sacco are dapper and composed—and shackled together—as they await their fate. Below: Sacco's wife (left) and Vanzetti's sister leave the courthouse. Opposite: The two men's funeral procession draws some 15,000 supporters to a narrow Boston street.

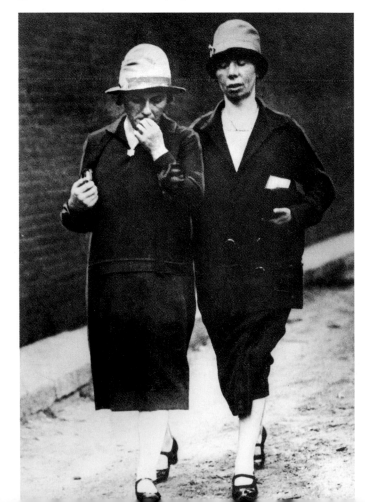

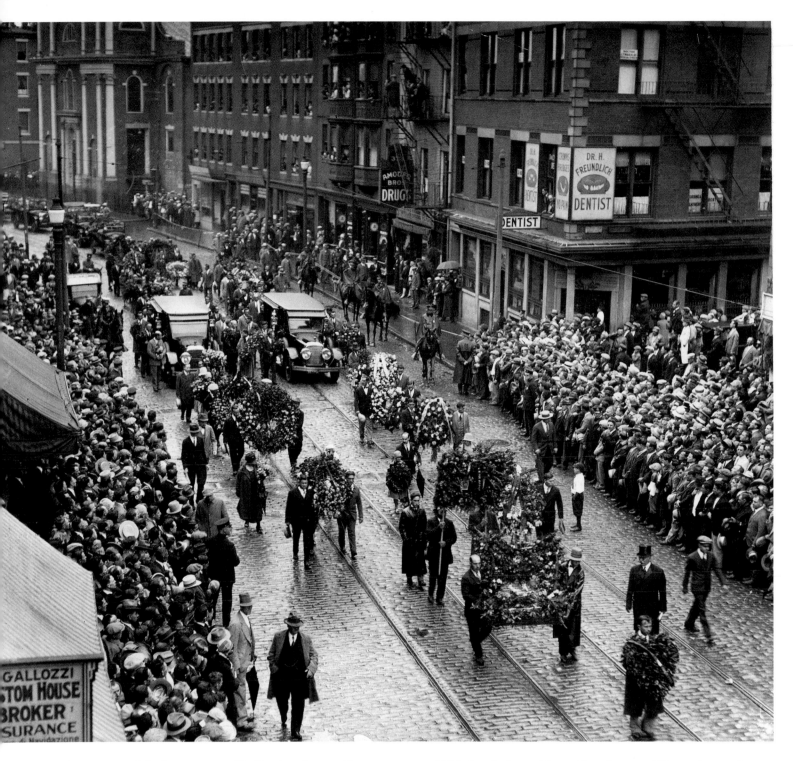

war in Europe and the latest surge of Italian immigrants. Katzmann portrayed Sacco and Vanzetti as seditious, draft-dodging aliens with dubious alibis. Despite contradictions in eyewitness testimony and questionable ballistics evidence, the jury returned guilty verdicts.

For more than six years, a series of appeals kept the destiny of Sacco and Vanzetti in the public eye. Across the U.S. and around the world, their plight as victims of an unfair trial sparked protests. The outcry eventually forced Massachusetts Governor Alvan Fuller to empanel an investigatory commission, which upheld the jury's decision.

With the whole world watching, Sacco and Vanzetti were electrocuted on August 23, 1927. "Long live anarchy," Sacco proclaimed before the switch was thrown. Prior to shaking hands with the warden, Vanzetti said: "I have never done a crime, some sins, but never any crime. I now wish to forgive some people for what they are doing to me."

Numerous books and exhaustive legal reviews of the trial have since largely confirmed Sacco's guilt while broadly questioning Vanzetti's.

A last note: This case is remembered for its political overtones, but we placed it in our Profit section because, at the outset, it was a robbery.

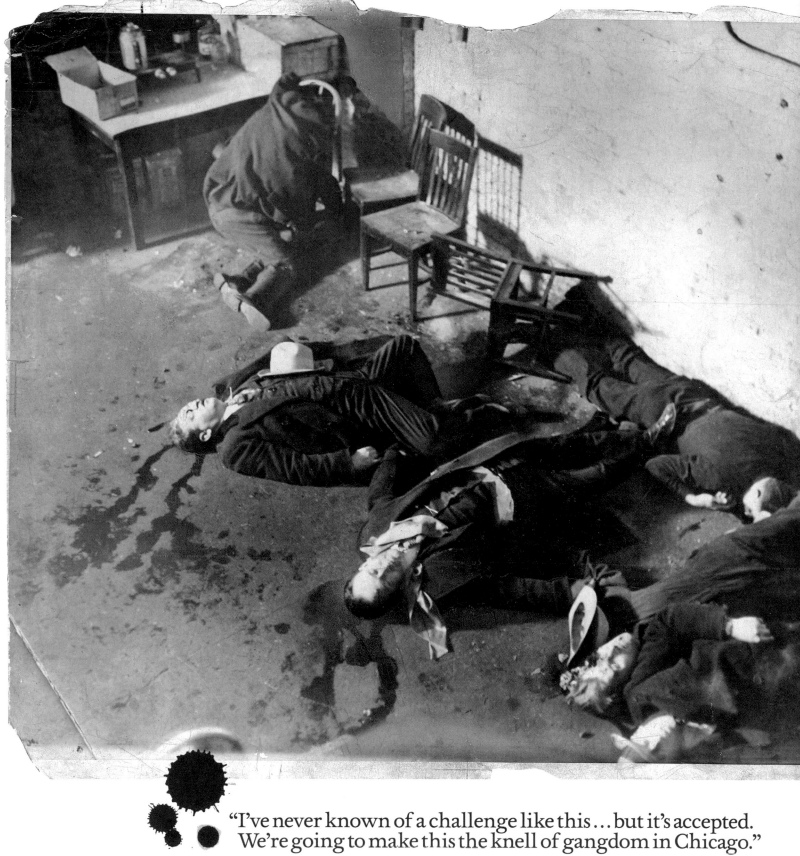

"I've never known of a challenge like this … but it's accepted. We're going to make this the knell of gangdom in Chicago."

The Saint Valentine's Day Massacre

In 1920, America outlawed the manufacture, sale and transportation of liquor, a ban that lasted 13 years. Even though Prohibition pleased the temperance folks, it hardly corked the bottle. Bootlegging—the illegal trade in alcohol—became rampant, slaking the public's undiminished thirst and triggering an organized-crime wave the law found nearly impossible to oppose.

Chicago, the Midwest's bootlegging capital, was dominated by the crime syndicates of legendary gangsters Alphonse "Scarface Al" Capone and his personal enemy No. 1, George "Bugs" Moran. Their vicious rivalry—pitting Capone's largely Italian South Side crew against Moran's North Side Irishmen and Germans—came to a stunning crescendo on the freezing morning of February 14, 1929.

One of Capone's top lieutenants, Jack "Machine Gun" McGurn, was steamed that Moran's goons had twice tried to kill him. McGurn got Capone's okay to arrange a Valentine's Day surprise for Bugs and his men. The ruse came in the form of an offer to buy cheap whiskey, supposedly from a trustworthy bootlegger. The oxymoron notwithstanding, Moran accepted.

The deal was scheduled to go down at around 10:30 a.m. inside a brick-walled garage at 2122 North Clark Street, where Moran ran the S-M-C Cartage Company. Six of his henchmen (plus an unfortunate hanger-on) were enjoying coffee and crackers as they waited. Moran himself was, by some accounts, simply late for the rendezvous. Other reports claimed that he saw a cop car pull up to the garage, so he laid low. As the front door of the garage opened, two men wearing police uniforms entered, followed by two others in street clothes. The former were armed with submachine guns, the latter with sawed-off shotguns.

Above: Scarface was in Florida, but nothing happened in Chicago's underworld back then without his say-so. Moran said of the rubout, "Only Capone kills like that!" Opposite: Six of the seven victims.

McGurn's clever plot, right down to the stolen police car and uniforms, made the charade look like a legitimate raid to any passerby. It seemed that way to the seven men inside, too, who were peeved but compliant. They followed orders to line up and spread 'em against the wall, palms pressed to the brick, their backs to the cops. "Then, it is believed, came the order to 'give it to them,' and the roar of the shotguns mingled with the rat-a-tat of the machine gun, a clatter like that of a gigantic typewriter," *The New York Times* evocatively reported.

After the ferocious fusillade stopped, the shooters continued their playacting. The phony flatfoots marched their cohorts, arms up, out of the garage at gunpoint. Onlookers who had been drawn by the cacophony of gunfire assumed this was the last chapter of the raid. In actuality, they were witnessing the final moments of what would soon be widely known as the Saint Valentine's Day Massacre, Chicago's worst gangland killing to that point and still one of the most notorious incidents in the history of organized crime.

When the real cops arrived, they estimated that more than 100 shots had found their mark. Incredibly, one of the victims, "Tight Lips" Gusenberg, survived for a short while, during which he stalwartly refused to rat out his assailants.

Affronted by the audacity of the faux booze bust, police commissioner William Russell declared a "war to the finish" on Chi-Town's underworld. "I've never known of a challenge like this—the killers posing as policemen—but now the challenge has been made, it's accepted. We're going to make this the knell of gangdom in Chicago."

Given that the ambush was clearly intended to take out Moran, Capone's complicity was instantly suspected, even though his alibi—he was in Florida—seemed airtight. No one was ever convicted of the executions, but Russell was resolute in turning up the heat on his city's mobsters. Capone finally fell in 1931. What took him down? Tax evasion, for which he drew an 11-year sentence—out with a whimper, not a bang.

The Lindbergh Baby Kidnapping

This case was among the 20th century's earliest Crime of the Century candidates. On March 1, 1932, Charles Augustus Lindbergh Jr., the 20-month-old firstborn of Lucky Lindy, one of the world's most famous and popular figures, was kidnapped. Although the century had 68 years yet to go, headline writers were sure this would be the ultimate titlist.

Its status reflected the magnitude of Lindbergh senior's heroic public image. On May 21, 1927, he had landed his single-engine airplane at Le Bourget Aerodrome in Paris, thus becoming, at age 25, the first to fly solo nonstop across the Atlantic. Lindbergh's derring-do aboard *The Spirit of St. Louis* earned him not only the $25,000 Orteig Prize but also the French Legion of Honor and America's Congressional Medal of Honor—as well as a ticker tape parade down Fifth Avenue.

Lindbergh, his wife, Anne, and the entire nation celebrated the birth of Charles junior on June 22, 1930. Less than two years later, everyone was aghast when the toddler's nurse, Betty Gow, discovered him missing from the second-floor nursery of the family home near Hopewell, N.J. Lindbergh immediately phoned the state police,

Charles A. Lindbergh Jr.'s delicate, curly-haired visage came to haunt the American public and fostered a collective hatred for whoever had done the deed.

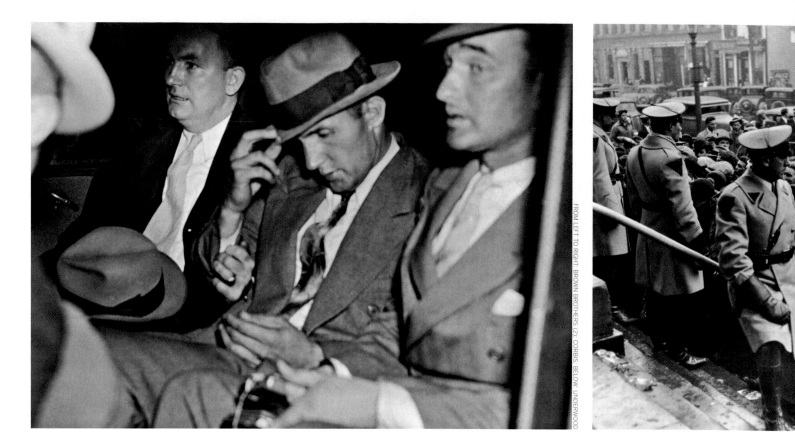

FROM LEFT TO RIGHT: BROWN BROTHERS (2), CORBIS; BELOW: UNDERWOOD

whose commander, H. Norman Schwarzkopf (the father of the future leader of 1991's Operation Desert Storm), took control. That night, a handmade, partially broken ladder was discovered. There was a trace of mud in the room and footprints leading away from the house.

Lindbergh found a ransom note resting on the windowsill. It demanded $50,000 in two to four days. Misspellings indicated that English might be the kidnapper's second language: "We warn you for making anyding public or for notify the Polise. The child is in gut care."

A second note arrived in the mail on March 6, upping the ransom to $70,000. Two days later, an eccentric 72-year-old retired school teacher, John F. Condon, wrote a letter to the *Bronx Home News*, offering to act as a go-between and add $1,000 of his own money to the ransom. Lindbergh agreed, which set the stage for a bizarre string of further missives and two anxious meetings in Woodlawn Cemetery between Condon and "John," as his mysterious contact with a German accent called himself. Meanwhile, thousands of other tips sent investigators on wild-goose chases that would eventually stretch as far as Austria.

At the second graveyard rendezvous, on April 2, Condon handed over $50,000 to "John," in return for a note that claimed the Lindbergh baby could be found aboard a boat, *Nelly*, which was moored off the southern tip of Martha's Vineyard, Mass. An agonizing search turned up neither the boat nor the missing child.

Above: Hauptmann after his arrest in New York City. Everything was stacked against him, including the fact that he fought for the other side in the First World War. **Below:** The Lindbergh house in New Jersey and the ladder reaching into Charles junior's room.

Several weeks later, on May 13, *The New York Times* reported: "The baby son of Colonel Charles A. Lindbergh was found dead yesterday afternoon. The child had been murdered." The remains of the child, who had sustained two fractures to his skull, were discovered in woods less than five miles from the house. The *Times* continued: "The condition of the body indicated that the child has been dead at least two months, and there was a strong possibility that he had been killed on the very night of the kidnapping."

Now the state police, the Bureau of Investigation (precursor to the FBI) and other agencies began to follow the trail of the ransom money. Forty thousand dollars of it consisted of marked gold certificates. Banks, grocery stores, post offices and other frequently visited businesses were put on the lookout. In September 1934, an alert gas station attendant jotted down the license plate number of a car driven by a man who paid in gold certificates. This diligence paid off on September 19, when police arrested Bruno Richard Hauptmann, 35, at his home in the Bronx.

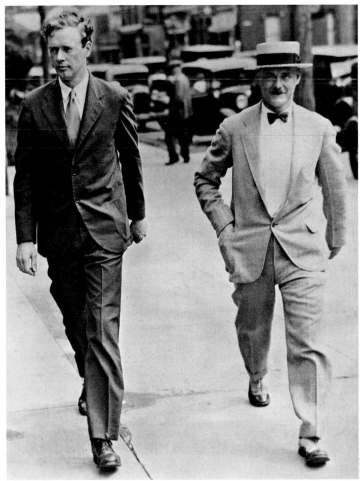

Top left: Guards keep the throngs—the likes of which the town of Flemington, N.J., had never known—away from the courthouse. Top right: Tasteless souvenirs for sale. Left: America's hero arrives to testify.

The German-born carpenter, who had fought against the U.S. during World War I before immigrating to the States, was hoarding $13,750 of the Lindbergh ransom in his garage. Condon made a "partial" identification of him as "John," and the handwriting on the notes appeared to match Hauptmann's. A week after his arrest, he was indicted for extortion; on October 10, a New Jersey grand jury indicted him for murder and kidnapping—both punishable by death.

Starting on January 3, 1935, the eyes of the world rested on the courthouse of the small New Jersey town of Flemington, where the five-and-a-half-week trial was held. Journalist H.L. Mencken called the case "the greatest story since the Resurrection." Hauptmann's high-profile attorney, Edward J. Reilly, was powerless in the face of the forensic evidence against his vilified client. There was the money, Condon's identification of him, the handwriting and expert testimony that matched the lumber from Hauptmann's home to that of the ladder used in the crime. On February 13, the jury returned a guilty verdict. His lawyers appealed the conviction to no avail, and Hauptmann was electrocuted on April 3, 1936.

To this day, some insist that Hauptmann was unfairly convicted, that evidence was suppressed, that there was a rush to convict because the aggrieved parent was an American hero. Others have speculated that Gow took part in an "inside job" or that Condon was somehow involved. Such theories seem to always attend a case this big—a case big enough to be a candidate for Crime of the Century.

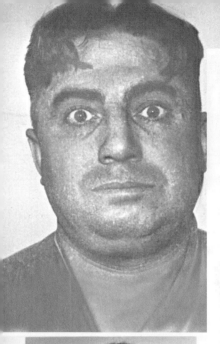

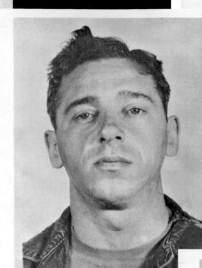

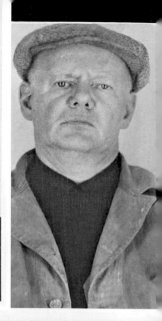

A

D

HENRY BAKER

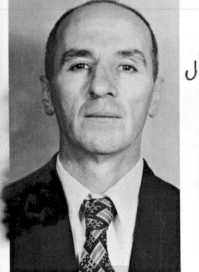

J

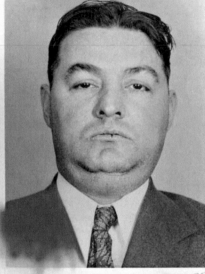

B

JOSEPH SYLVESTER BANFIELD

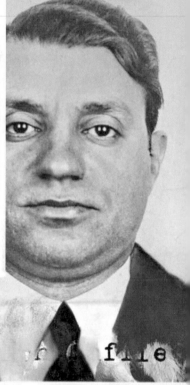

JOSEPH JAMES O'KEEFE

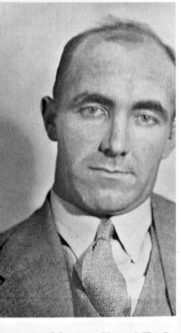

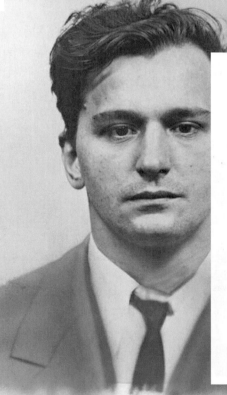

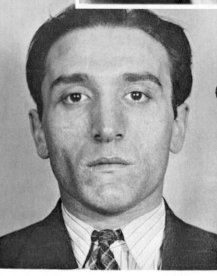

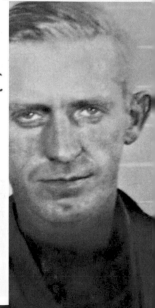

C

MICHAEL GEAGA

VINCENT COSTA

The Great Brink's Robbery

On January 17, 1950, $2,775,395.12—a stunning sum at the time—was stolen by a gang of 11 robbers in a crime that smacked of great planning, execution and audacity. It was followed by a dogged, if often frustrating, pursuit of the crooks. They evaded authorities for six years, but when they were finally caught, thanks to a double-crosser within their ranks, much of the loot was nowhere to be found. To this day, it has yet to surface.

On a wintry Tuesday evening shortly before seven p.m., a group of seven men entered the Boston headquarters of the Brink's Company, a security firm renowned for transporting large amounts of cash. To look like Brink's guards, the men wore peacoats, gloves and chauffeur's caps. They also wore soft-soled shoes or rubbers to muffle their footsteps and hid their faces behind Halloween masks. Each was armed with a revolver.

The mastermind of the operation, which had been meticulously plotted over nearly 18 months, was a Sicilian immigrant named Anthony "Fats" Pino. He and each of his associates—Joseph "Specs" O'Keefe, Joseph "Big Joe" McGinnis, Stanley "Gus" Gusciora, Vincent Costa, Michael Vincent Geagan, Thomas Francis Richardson, Adolph "Jazz" Maffie, Henry Baker, James Ignatius Faherty and Joseph Sylvester Banfield—had come to know everything about the Brink's building by sneaking into it after hours on several occasions. During their reconnaissances, they removed the lock cylinders from five doors, including the one leading to the second-floor room where the currency was processed nightly. They temporarily replaced the cylinders with look-alikes, had a locksmith quickly fashion keys and then reinstalled the originals. Pino observed when money shipments came and went and when workers' shifts ended. He rehearsed his team often so they would be ready for the big night.

And then it arrived. The crew gathered in the Boston neighborhood of Roxbury. Their transport that night was a green 1949 Ford truck that had been stolen from a local car dealer weeks earlier. Seven men—O'Keefe, Baker, Faherty, Maffie, Gusciora, Geagan and Richardson—slipped into their "uniforms" during the ride to the target. Costa, perched on a rooftop nearby, gave the go signal, and one of the most lucrative heists in U.S. history began.

The seven made their way to the second floor with alacrity, then bound and gagged five Brink's money-counters. They stuffed $1,218,211.29 in cash and $1,557,183.83 in checks, money orders and securities into burlap sacks, which they hauled to the truck. It was all over in about 20 minutes, after which they drove to the home of Maffie's parents in Roxbury. They divvied up some of the money and stashed the rest. The crew scattered, each with a plan to establish an alibi.

It didn't take long for the Beantown police and the FBI to zero in on several usual suspects among the city's criminal element, including ringleader Pino as well as McGinnis, O'Keefe and Gusciora. But it still took almost six years of work—requestioning gang members, following up on hundreds of leads, searching for the booty—before indictments were handed out against all 11 robbers on January 13, 1956. The big break had come a few days earlier when O'Keefe, who had run afoul of his erstwhile mates and survived three rubout attempts, finally sang to the feds.

Banfield and Gusciora died before the trial, and O'Keefe pleaded guilty, so eight men faced the jury. All were convicted and given life sentences.

More than a half century later, there remains that intriguing postscript: Where is the missing $1,150,000? Will we ever know?

Pino meticulously planned the robbery, as seen on this page from the manual (right) drawn up for the heist. It was so well executed that some cops suspected an inside job.

In Cold Blood

I n the late 1950s at the Kansas State Penitentiary in Lansing, a criminal named Richard Hickock was sharing a cell with Floyd Wells, who told Hickock how years earlier he had worked for a farmer named Herbert Clutter. Wells said Clutter was wealthy and kept a lot of cash in a safe in the office of his house—a bit of info Hickock would harbor.

Clutter was indeed well-to-do: He owned the prosperous River Valley Farm near the tiny west Kansas village of Holcomb. He shared a comfortable life with his wife, Bonnie, and their kids in a two-story house that he had built himself in 1948.

When Hickock was paroled in August 1959, he couldn't have cared less about Herb Clutter's nice life or that his family attended services every Sunday morning at the local Methodist church. What obsessed Hickock was Clutter's safe, and when another prison pal, Perry Smith, a robber who had been paroled in June, came to visit him at his parents' place in Olathe, Kan., that fall, the two hatched a plan.

They traveled in Hickock's 10-year-old Chevy about 400 miles west to Holcomb, stopping along the way to buy rubber gloves, cord and duct tape. They also had a flashlight, a hunting knife and a 12-gauge Savage Model 300 shotgun on hand.

A little past midnight on November 15, Hickock and Smith parked the Chevy outside the Clutters' house. Asleep inside were Mr. and Mrs. Clutter, their daughter Nancy, 16, and son Kenyon, 15 (daughters Beverly, 20, and Eveanna, 23, no longer lived at home). The thieves headed straight for the office, but there was no safe. So they roused Mr. Clutter and grew increasingly frustrated when he swore he didn't have a safe, just the money in his wallet. Convinced that a treasure existed somewhere in the house, they awakened the rest of the family. No one knew of any safe. Smith and Hickock then split the Clutters apart—binding the father and son in the basement and the mother and daughter in their respective rooms. Then the murdering began. Smith slit Herb Clutter's throat, held the 12-gauge near the 48-year-old man's head and pulled the trigger. Soon after, Smith

walked into the adjoining room, where Kenyon trembled, and shot him dead, too. Hickock grabbed the gun, went up to Nancy's room and killed her. Finally, Bonnie, 45, was executed.

With no witnesses, scant forensic evidence and a mysterious motive, the authorities' agonizing search for the

No one in Holcomb heard the shots from the Clutters' home (bottom left), which was on the prairie outside of town. Above: The Clutter clan during an earlier Christmas season. The older girls, Beverly and Eveanna (to the right of their father), had moved out by the time of the killings.

killers was going nowhere ... until Floyd Wells told the warden of Kansas State Penitentiary about his former cell mate's interest in Herb Clutter's safe. The warden contacted the Kansas Bureau of Investigation, and shortly thereafter, Hickock and Smith were atop the KBI's most-wanted list.

The duo fled Kansas in a stolen '56 Chevy, bouncing from Mexico to Florida and finally Las Vegas. On December 30, two alert cops matched the plate number on Hickock and Smith's Chevy with that of a vehicle recently boosted in Kansas, and the fugitives were captured.

KBI investigator Alvin Dewey had the suspects interrogated separately. On January 3, 1960, Hickock cracked, then Smith, each confessing to the grisly episode and implicating the other as the triggerman.

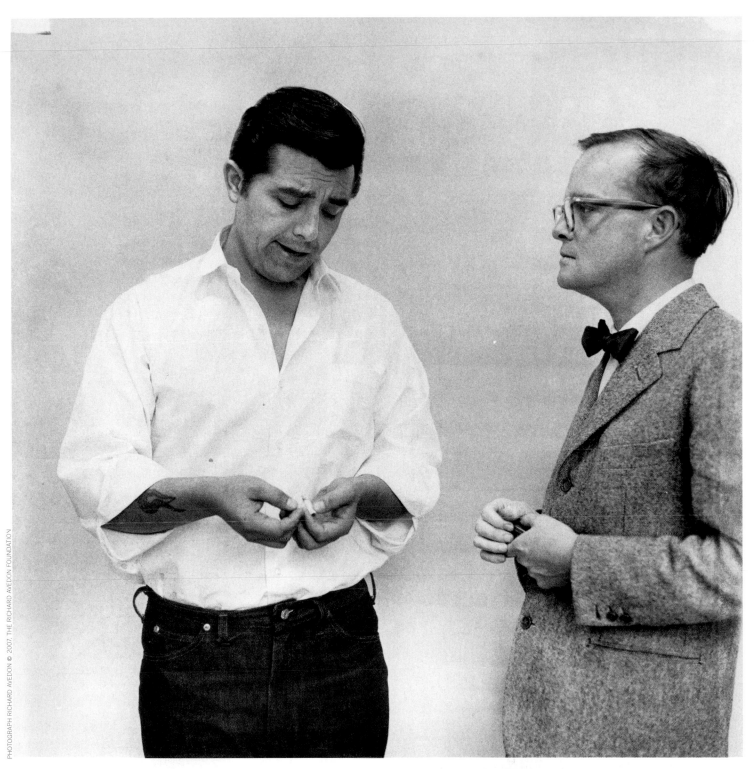

And then Truman Capote arrived in Kansas, elevating the notoriety of this sad, isolated episode on the prairie so that it perseveres all these years later. By the time the trial commenced on March 22, the celebrated writer had already immersed himself in the story. He traveled to Holcomb and, along with his friend Harper Lee, interviewed the principal players. His best-selling nonfiction novel, *In Cold Blood*, was published in 1966—the year after the killers were executed—and would come to be regarded as an American classic.

Above: Smith meets with Capote. Despite very different temperaments, the two felt an affinity for each other, and many believe that Capote painted a sympathetic portrait of Smith in his book. The same cannot be said for the wanton Hickock (below), who collapses in the custody of detectives.

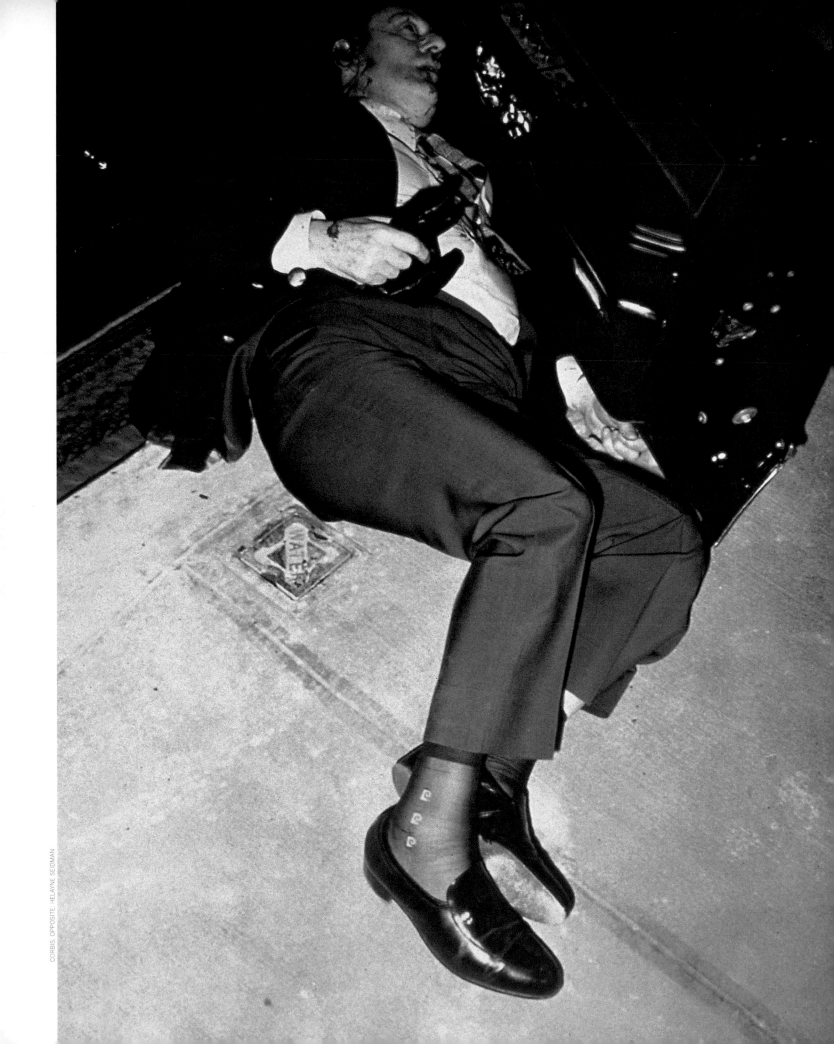

The Sparks Steak House Rubout

The executive suites of organized-crime syndicates are filled with hot seats—and the ghosts of the hotheads who once sat in them. Sometimes these execs were taken out by the law or, more permanently, by rivals.

In the mid-1970s, Paul Castellano rose to the top of New York's infamous, industry-leading Gambino crime family, but a decade later he was murdered by a colleague—a certain dapper-don-in-waiting who didn't want to wait any longer.

Born in 1915, Castellano grew up on the mean streets of Brooklyn. A felon before he turned 20, his climb up the local Mafia ladder was boosted severalfold thanks to his sister's marriage to the boss, Carlo Gambino. "Big Paul" wound up at the very top when Gambino handpicked him as the family's next don—then conveniently died of a heart attack in 1976.

Castellano's tenure was controversial not only in the eyes of the four other New York Mafia families but also among his own men. He attempted to run the day-to-day gambling, hijacking and loan-sharking activities in a more corporate style and bucked the underworld's man-of-the-people tradition by governing from a mansion in a posh Staten Island neighborhood. His campaign to whiten the Gambino family's blue-collar image conflicted with the perspective of his hard-knuckled second-in-command, Aniello Dellacroce, who became his chief critic.

John Gotti was an up-and-coming protégé of Dellacroce's, and he, too, had little use for Castellano's new brand of leadership. For one thing, Big Paul frowned on drug dealing, a business that made a lot of money for the family. Castellano and Gotti came to hold a mutual disdain for each other that grew ugly—and then dangerous.

On the other side of the law was Rudolph Giuliani, at that time an ambitious U.S. Attorney in New York City. He had specifically set his sights on the 70-year-old Castellano, and in 1985 the Gambino boss was indicted on racketeering charges along with the leaders of the other New York Mob families. In September of that same year, Castellano went on trial for his involvement in a car-theft ring.

On December 2, Dellacroce succumbed to lung cancer. Castellano's first mistake was to boycott the wake, thus insulting those who revered Dellacroce. His second was to appoint Thomas Bilotti, a thug who was despised among the rank and file, to succeed as underboss. By that point, Gotti had had enough. Two weeks after the funeral, Gotti and Castellano agreed to a sit-down at Sparks Steak House, a popular hangout in midtown Manhattan. But Gotti had an unpleasant surprise in store. As Castellano and Bilotti pulled up to the restaurant shortly before 5:30 p.m., three men walked up to them. From beneath their trench coats, they drew semiautomatic weapons and began to blast away.

Gotti, who was certainly the big winner, wasn't the only person to benefit from Castellano's death: The co-defendants in the car-theft case were able to request a mistrial. Guiliani took a big hit that day.

Above: After yet another acquittal, Gotti celebrates with Gravano at the Ravenite Social Club in Manhattan's Little Italy on February 9, 1990. Ten months later, the club was raided, and Gotti and Gravano, plus two associates, were busted—Gotti for the last time. Opposite: Castellano outside Sparks.

But time was on the law's side. In a few years, overwhelming evidence against the Gambinos' new capo—including covertly made tape-recordings and testimony from Gotti's own turncoat underboss, Sammy "the Bull" Gravano—had been compiled. In April 1992, Gotti was convicted of various crimes, among them the murders of Castellano and Bilotti, and sentenced to life in prison. This obviously cut short his reign as the "Teflon Don" and nullified all the gains he had hoped to achieve with Castellano's execution. A decade later, he died of throat cancer at the age of 61. Gotti is remembered by some as the last real don—a distinction that would have made him proud.

The Gardner Museum Heist

This was a big-time caper. Even the FBI thinks so: Its Top Ten Art Crimes list places the "Isabella Stewart Gardner Museum Theft" second only to "Iraqi Looted and Stolen Artifacts." The feds' description of the events of March 18, 1990, hints at their frustration: "The [museum] was robbed by two unknown white males dressed in police uniforms and identifying themselves as Boston police officers.... All logical leads have been followed through to conclusion with no positive investigative results." In other words, no arrests have been made, and no art has been recovered.

Which is not to say this story lacks characters. Myles Connor, for example, is an intriguing subject. The 5-foot, 7-inch native of Milton, Mass., became a person of interest soon after the heist at the Venetian-style palace, which opened in Boston in 1903 to house paintings, sculptures and artifacts accumulated by heiress and arts patron Isabella Gardner.

The intruders handcuffed the museum's two guards, then headed straight for the second-floor Dutch Room Gallery. They swiped three Rembrandts and a Vermeer. From the Short Gallery, they removed five Degas drawings. Finally, they raided the Blue Room and took a Manet. When the real police arrived, they were perplexed that the museum's most valuable piece, Titian's "The Rape of Europa," had been left behind.

Connor, a connoisseur of fine art as well as an illegal trafficker in it, said this oversight proved he wasn't involved; that painting would have been the first one he would have seized. Besides, there was no way he could have been at the Gardner that night. His airtight alibi: He was serving time for fencing stolen art.

> The late Mrs. Gardner's will stipulated that nothing ever be changed in (or removed from) the mansion. At right, an empty frame that once held a Rembrandt.

Although police suspected that Connor might have masterminded the most lucrative art theft in U.S. history from his prison cell, they followed other leads. With such a potentially huge economic upside—the black-market price tag for the otherwise priceless booty was estimated at $300 million—perhaps Boston's powerful Irish mob was involved. Or maybe the job was simply the handiwork of a couple of lucky burglars.

Not surprisingly, six years later, when the statute of limitations had run out, new information surfaced. Talking from behind bars in 1997,

Connor told *Time* magazine that he and reputed gangster Bobby Donati had cased the Gardner in the mid-1970s. Connor claimed to have had no hand in the eventual caper but pointed to Donati and an accomplice, David Houghton, as the culprits. The response of the accused? Well, dead men tell no tales: Donati was the target of a probable mob hit in 1991, and Houghton died of natural causes the following year.

The FBI was wondering if Connor was publicly angling for a deal when Billy Youngworth, an associate of Connor's, told authorities that he knew where the paintings were. He said that if they would drop the auto-theft charges against him, grant him immunity and give him the $5 million reward—plus spring his pal Connor from prison—he would help solve the case. No deal.

Connor and Youngworth were released from prison in 2000, and since then news reports have regularly suggested that either or both men might ultimately help recover the elusive treasure. Until that day, the Gardner Museum goes forward—with a hole in its heart.

The Heidi Fleiss Scandal

I n some countries, prostitution is punishable by death; in others, it is part of society's natural order. In the United States, it is legal in Rhode Island (as long as the transaction is discreet) and parts of Nevada, and illegal everywhere else, but it's never top of mind until a prostitution story involving the well-heeled, well-placed or well-regarded hits the tabloids. Then, suddenly, everybody's talking about prostitutes. Remember the Mayflower Madam? Otherwise known as socialite Sydney Biddle Barrows, she ran a high-class call-girl ring in New York City in the 1980s that, when exposed, had people gossiping for weeks.

And do you remember Heidi Fleiss's name popping up just a couple of years later?

Fleiss was born to upper-class parents—her father is a prominent Los Angeles pediatrician—in 1965. She dropped out of high school at age 16, and by the time she turned 19, she was dating millionaire playboy Bernie Cornfeld. Through him, she developed a taste for the highest of the high life.

After Fleiss and Cornfeld broke up, she dabbled briefly as a real estate agent. But she felt she was better at peddling flesh than homes, so she found employment with the locally renowned Madam Alex, the proprietor of a long-standing, prominent Beverly Hills brothel. Fleiss worked briefly as a call girl for Alex and quickly slipped into the role of protégé. She exerted her influence when she replaced much of Alex's veteran lineup with a roster of younger, more attractive women. Business boomed, but Alex got busted. Fleiss ran the operation while the madam was away, then set out on her own. (Madam Alex, who returned to the prostitution racket after her release from prison, would later accuse Fleiss of stealing her client list.)

Before long, Fleiss's own enterprise was, as she later boasted, "the biggest and best on earth." Charged a fixed fee of $1,500 a pop—satisfaction guaranteed—Fleiss's upscale, international clientele included movie stars, politicians, business moguls and other fat cats. For nearly three years, Fleiss, whose cut was 40 percent, made enormous sums thanks to the world's oldest profession.

Exactly why Heidi Fleiss was taken down and prosecuted with such vehemence has never been clear. Did the so-called Hollywood Madam upset a john? An employee? A cop? Whoever blew the whistle and for whatever reason, Fleiss, then 27, was set up in a sting operation in June 1993. A man named Sammy Lee called the brothel, identifying himself as a Hawaiian businessman looking to procure several call girls—and some cocaine, as well—to entertain his associates. When the gals showed up at his L.A. hotel room and whispered words of solicitation into his hidden microphones, police officer Lee arrested them.

After a raid on Fleiss's $1.6 million Benedict Canyon mansion, during which police confiscated her famous little black book, Fleiss was

Left: Fleiss, who forever changed the face and style of prostitution in L.A., smiles for the paparazzi as she arrives at her arraignment in 1993. Below: Her mentor, Madam Alex, in 1988.

charged with "pimping, pandering and the sale of narcotics." The book, which allegedly contained a Who's Who of Hollywood A-listers, was the central focus of prosecutors, tabloid sleuths, late-night monologuists—and, no doubt, dread-filled clients of Madam Heidi. This last group breathed a little easier when it became clear that even with her back against the wall, Fleiss was refusing to name names. She was separately convicted by state and federal juries and ultimately served a three-year prison term that started in 1996.

Since her release, Fleiss has been enjoying a second act. Ever the entrepreneur, she has parlayed her notoriety into legitimate, if sometimes salacious, ventures. She has published a memoir, *Pandering*, and produced a sex-tip video that bears the label TOO HOT FOR CABLE. She runs a fashion boutique that sells both naughty and nice items. She is moving forward on her Stud Farm project: a luxury brothel in Nevada where women will be serviced by the men of their dreams. But of all of Fleiss's recent ventures, perhaps the most whimsical is her proprietorship of a Laundromat. Naturally, it is called Dirty Laundry.

Enron

White-collar crime is often considered "victimless" since no one is shot, stabbed, beat up or subjected to other forms of physical violence. Customers of embezzled banks and defrauded companies are usually covered by insurance. Consequentially, perpetrators in suits and ties often get a gentler rap.

However, the nefarious goings-on at Enron, the Houston-based energy conglomerate that imploded with titanic force in 2001, left thousands of employees in financial ruin. The Enron scandal also led to the reformation of the accounting industry and, along with improprieties committed in that era by executives at Adelphia, ImClone, Qwest, Tyco and WorldCom, shattered the confidence Americans had in corporate ethics.

On the surface, Enron appeared to be a novel, even revolutionary enterprise—a corporation for the 21st century. What started with a 1985 merger of two natural gas companies evolved into a multinational hybrid that pioneered the online trading of commodities, including natural gas, electricity, water, coal and steel. Enron also developed and managed the construction of power plants, pipelines and other energy-related projects. It even provided broadband Internet services. The company offered almost every service imaginable, and in 2000 it claimed $111 billion in revenues, propelling its stock to a record high of $90 per share. Soon Enron employed nearly 21,000 people from around the world. *Fortune* named the energy firm the Most Innovative among its Most Admired Companies for six consecutive years from 1996 to 2001.

Some inside the executive suite knew that things were not as rosy as they seemed. Enron had actually hit a gigantic accounting iceberg years earlier and had since been taking on massive amounts of debt. A handful of officers decided to conceal the bad news and promote the good.

But the bogus bookkeeping couldn't go unchecked forever—the company was concocting money where there was none. In 2001, a clear-eyed executive touched off a chain of events that would lead to Enron's downfall. Sherron Watkins, vice president of corporate development, suspected something was rotten and met with CEO Kenneth Lay on August 22 to discuss a pair of damning memos she had previously written to him regarding Enron's highly irregular, and probably illegal,

accounting practices. Watkins had named the officers she felt were responsible and had noted the complicity of the company's accounting firm, Arthur Andersen. She had cited two deals in which Enron had reported huge profits, thus boosting its stock price, even though neither deal had involved any hard assets.

It's all very complicated, but the short of it is that once Enron was forced to face its problems—and the reality of its fiscal situation—the company unraveled quickly. By October, Enron reported a $618 million third-quarter loss and disclosed a $1.2 billion reduction in shareholder equity. It said the hit was partly related to off-the-books partnerships that had been set up and run by chief financial officer Andrew Fastow to hide debt and inflate revenue. The Securities and Exchange Commission soon began an investigation into these partnerships, and Fastow was fired before month's end.

Above: Former employees after cleaning out their offices. Opposite: In Washington, D.C., in February 2002, Lay pleads the Fifth Amendment, refusing to testify before a Senate committee investigating Enron.

Despite Lay's "all is well" pronouncements, Wall Street analysts and credit-ratings agencies grew increasingly distrustful of Enron's practices. The anxiety sent the company's stock price into a free fall; it plummeted to $7 by early November and was worth less than a dollar by the end of that month. Enron filed for Chapter 11 bankruptcy protection—the largest in U.S. history at that time—and laid off more than 4,000 employees.

Besides the inconvenience of unemployment, thousands of Enron workers endured yet another shock when they learned that their retirement accounts, which were based largely on company stock, had all but vanished. Their suffering, along with that of other stockholders whose investments had been decimated, only deepened when investigations revealed that Lay and other top officials had sold hundreds of millions of dollars worth of stock in the months leading up to the crisis. It was small satisfaction indeed when Lay, former CEO Jeff Skilling, Fastow and others were tried and convicted on a range of charges. Skilling and Fastow are in prison today. Lay died of a heart attack in 2006, before he was sentenced.

POINTLESS MAYHEM
AND SENSELESS
Murder

Some appeared to be psycho from the get-go, while others—like Ted Bundy—sought to bury their sinister nature. To no avail.

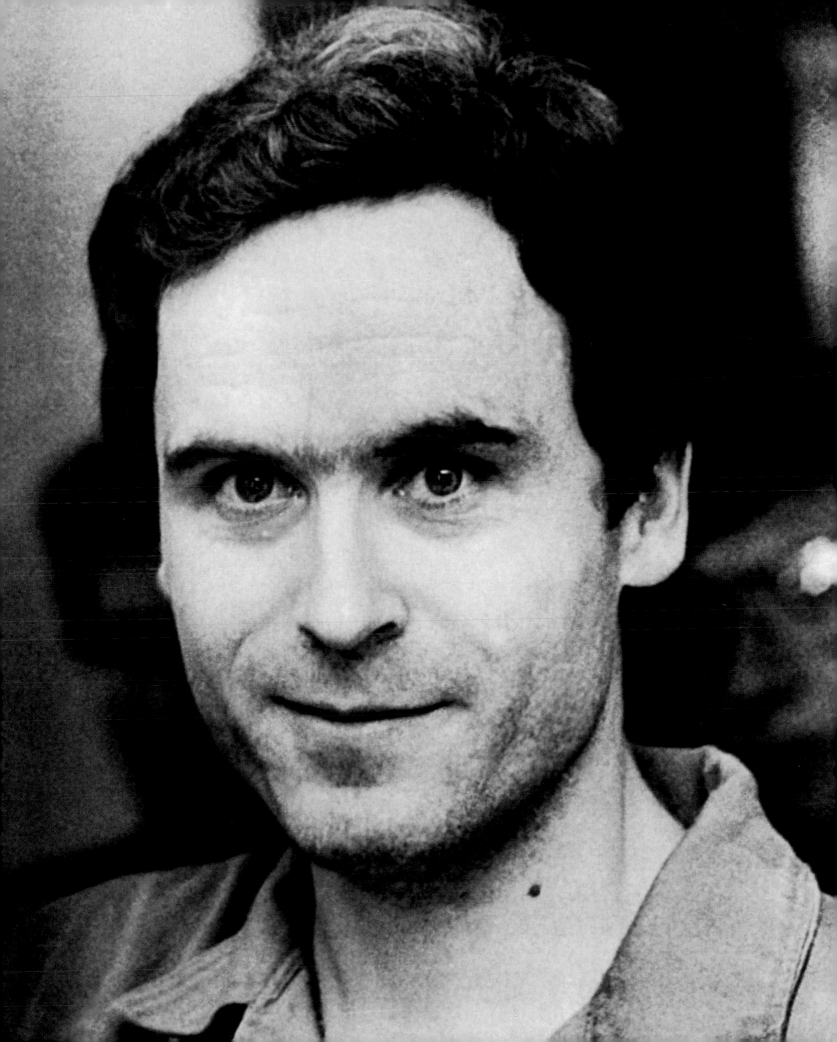

The Mountain Meadows Massacre

Mountain Meadows, an idyllic setting that would come to be associated with carnage, is located in Utah. But this story actually starts in upstate New York, where the Church of Jesus Christ of Latter-day Saints was founded by Joseph Smith. The growing religion moved westward, continually searching for a place where the Mormons, as the faithful are known, could escape harassment for their unconventional beliefs—polygamy chief among them. Brigham Young, a former

Methodist who converted to the religion in 1832, became the church's leader when Smith was killed by an Illinois mob in 1844. Young saw Utah's Great Salt Lake Valley as a kind of promised land, and thousands of followers flocked there at his direction. Broadening his authority and power, Young was appointed governor of the Utah territory by U.S. President Millard Fillmore in 1850.

Believing they were victims of wholesale persecution, the Mormons isolated themselves. In 1857, President James Buchanan was told that

the Mormons had become a rebellious theocracy. In reaction, he dispatched 2,500 troops to the Great Salt Lake area to engage in the Mormon War (which is also called the Utah War).

That same year, a wagon train of 40 pioneer families, mostly from Arkansas, rode into this incendiary situation unwittingly. Intent on reaching California, the group, called the Fancher party in honor of their main leader, Alexander Fancher, was following the Old Spanish Trail through the southwest corner of Utah. None of them was aware of the war or Young's strategy, which included a no-trade policy with outsiders, or that Young had encouraged the Paiutes, with whom the church enjoyed a peaceful if tenuous relationship, to raid wagon trains. At this point in time, the Latter-day Saints were more alarmed by white people from the East than the natives who surrounded them.

The Fancher party's encampment at Mountain Meadows was ambushed on the morning of September 7, 1857. According to testimony, at least as many as 50 Paiutes and 100 white militiamen, commanded by Mormon John Lee and disguised as Native Americans, fired upon the group. Several of the pioneers were killed, and more than a dozen were wounded. The Fancher party circled their wagons and defended themselves as best as they could during the next three days, but they could not access fresh water and were running out of ammunition. On September 11, Lee offered a deal: safe passage from Mountain Meadows in return for a surrender of

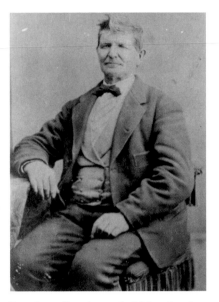

Two views of Lee, in a portrait (above) and sitting on his coffin on the day of his execution at Mountain Meadows (below). In his farewell speech, he claimed the church had betrayed him. The historic point of view agrees that he was a scapegoat.
Opposite: An illustration shows whites and Native Americans committing the massacre.

arms, cattle and supplies. The pioneers agreed and were split into three groups—the wounded, the women and children, and the able-bodied men. But then the Mormon soldiers were ordered to do their duty. Within minutes, all but a handful of small children were executed, so that no credible witnesses remained alive.

It is doubtless that 120 members of the Fancher party were cruelly murdered that day. But the accounts as to exactly what role the Mormon militia played in the slaughter and how extensive the subsequent cover-up was are less clear. Lee's report to Young, which was passed along to U.S. investigators, laid sole blame on the Paiutes. Unconvinced, Congress ordered a further probe in March 1858. A case against Lee and 37 other Mormons fell apart a year later, then the Civil War postponed any immediate follow-up.

But the memories of this nasty business were long, and in October 1874 several Mormons, Lee among them, were arrested. Lee's trial resulted in a hung jury. The federal government was still dissatisfied and reportedly worked out a deal with Young whereby Lee alone was retried two years later. This time, he was found guilty of first-degree murder. He was executed by a firing squad on March 23, 1877—pointedly at Mountain Meadows.

In 1999, at the dedication of a memorial on the site, Church of Latter-day Saints president Gordon Hinckley expressed regret for the incident but stopped short of admitting Mormons were directly responsible.

The Murder of Lizzie Borden's Parents

Who hacked Mr. and Mrs. Borden to death? Was it the couple's 32-year-old spinster daughter Lizzie, as the ubiquitous playground rhyme tells us? According to a jury of 12 men, the answer is no, but in the years since the crime was committed, no one has been able to determine who was responsible for their grisly deaths.

Sadness had already visited the house at 92 Second Street in Fall River, Mass., before the hot summer's morning of August 4, 1892. Andrew Borden, a wealthy, parsimonious and rather unpleasant bank president and real estate mogul, had already suffered the loss of his first wife, Sarah, and one of their three daughters. Andrew remarried in 1865, and accounts differ as to how well Lizzie and her older sister, Emma, got along with their stepmother, Abby. In any event, the family lived together, if not always harmoniously, over the next quarter century.

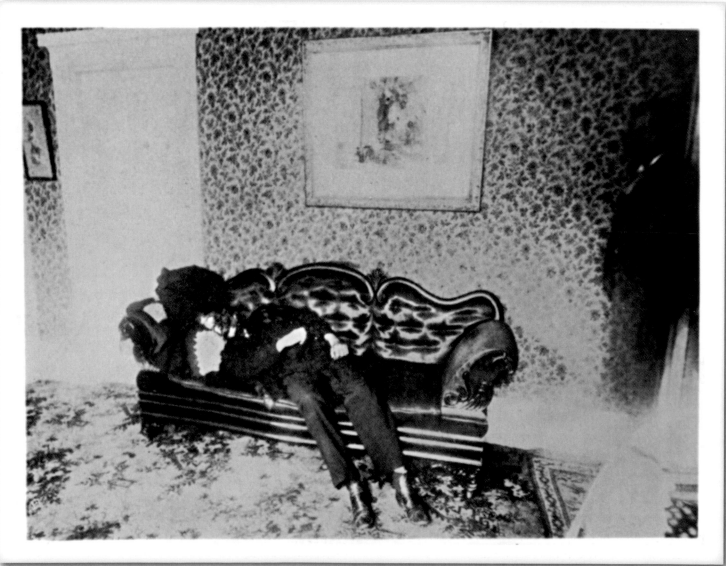

rumors of trouble with Abby surfaced. At first, a grand jury declined to indict Lizzie, but after it reconvened to hear testimony that she had burned a blue dress she had worn on the day of the slayings, she was indicted.

The trial commenced in the fishing port of New Bedford on June 5, 1893, and news from the proceedings traveled to every corner of the country each day; this murder trial was one of the first to generate a national frenzy. The prosecution obviously felt theatrics would help and opened the case by dramatically tossing Andrew's and Abby's shattered skulls onto a courtroom table. But from there on, the prosecutor was armed with mostly circumstantial evidence, much of which was deftly rebutted by Lizzie's defense team, led by former Massachusetts Governor George Robinson. The ax that had been found in the basement of the Borden home couldn't be clearly identified as the murder weapon, nor was there hard evidence that Lizzie had burned her dress. Especially damaging to the prosecution's case was the judge's decision that Lizzie's pretrial testimony, said to be full of contradictions, had been coerced and was therefore inadmissible. After just an hour of deliberation, the jury found Lizzie not guilty.

Lizzie herself possibly heard the words to the famous poem: "Lizzie Borden took an ax/And gave her mother 40 whacks/And when she saw what she had done/She gave her father 41."

The court of public opinion disagreed. Lizzie herself possibly heard strains of that famous, if mathematically inaccurate, rhyme penned by an anonymous poet: "Lizzie Borden took an ax/And gave her mother 40 whacks/And when she saw what she had done/She gave her father 41." Lizzie moved with Emma into a mansion in a prestigious Fall River neighborhood, but she continued to be ostracized by the community. She died on June 1, 1927, at age 66, and was buried near the graves of her father and stepmother.

Interest in her and doubts about her innocence have never waned. Her story has been endlessly told in books, plays, musicals, folk songs, rock songs, operas, ballets (Morton Gould's *Fall River Legend* is a modern classic), films and round-the-campfire ghost stories. She has inspired the name of a glam-metal band, as well as *The Hatchet: Journal of Lizzie Borden Studies,* an online magazine. Among the many curiosities connected to the Borden mystery is the fact that Elizabeth Montgomery of *Bewitched* fame, who starred in 1975's *The Legend of Lizzie Borden,* was distantly related to Lizzie. As for the house at 92 Second Street, it still exists. It's now a bed-and-breakfast. Spend a night there—if you dare.

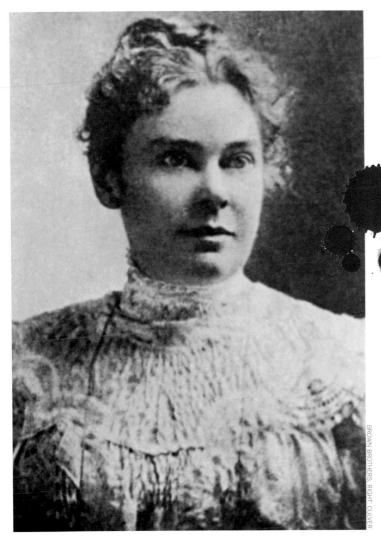

Opposite: Andrew's body was the first one found, in the sitting room. Above: Lizzie, circa 1889, three years before the killings. In an illustration from the *Police Gazette* (right) that ran at the time of the trial, Lizzie faints as she envisions "the grinning skulls of her murdered parents," according to the caption.

Then, on that fateful Thursday, 70-year-old Andrew returned home from some business at around 10:45 a.m. A half hour later, the family's housekeeper, Bridget Sullivan, was upstairs when she heard Lizzie shout, "Come down! Come down quick! Father's dead! Somebody's come in and killed him!" The horror of discovering Andrew's body in the sitting room escalated to pandemonium as Abby's corpse was found in a second-floor room shortly thereafter. Both had been bludgeoned about the head, apparently with an ax.

SHOCKING CRIME screamed the headline of *The Fall River Herald,* A VENERABLE CITIZEN AND HIS AGED WIFE HACKED TO PIECES IN THEIR HOME. The paper reported that "the bodies of the victims are...almost beyond recognition." According to the autopsy, Abby was butchered first, struck at least 18 times. The killer rained 11 blows on Andrew's head.

Initially, police suspected a laborer whom Andrew had refused to pay that morning, but soon the focus turned to Lizzie. An inquest uncovered her attempt to buy a deadly poison just before the murders, and

Leopold and Loeb

Bobby Franks was a bright 14-year-old student at Chicago's Harvard School for Boys in the spring of 1924. On Wednesday, May 21, as he was walking home from school, a gray and black Willys Knight sedan pulled up alongside him. Franks didn't recognize the driver, but he knew the passenger, Richard "Dickie" Loeb. The Loebs lived near the Frankses in the very well-to-do Kenwood section of town. Loeb offered Franks a lift home. The lad accepted, and moments after he was introduced to Nathan Leopold Jr., the blunt end of a chisel came down on his head. After dark, Leopold and Loeb drove to Wolf Lake Park, a place Leopold knew from his birding excursions. They dragged the body to the edge of a culvert, poured hydrochloric acid on the face and genitals, then pushed it down.

Why? For no better reason than to commit the "perfect crime."

This fiendish duo had become close friends in 1920, when Leopold, just 15, started at the University of Chicago, where the 14-year-old Loeb was a fellow freshman prodigy. In 1921, they had both transferred to the University of Michigan. By 1924, Leopold had mastered five languages, gained recognition as an ornithologist and was bound for Harvard Law School. Loeb, who had immersed himself in detective stories as a youngster—to the point where he not only fantasized about lawlessness but committed several petty crimes—had become one of the youngest-ever graduates from Michigan, and he, too, intended to study law.

As an extracurricular activity, they decided to plot a foolproof felony. Combining Loeb's interest in crime and Leopold's devotion to philosopher Friedrich Nietzche, who thought some men were inherently superior (Leopold and Loeb ranked themselves among these "supermen"), they schemed to get away with kidnapping a wealthy boy, killing him and collecting a ransom. With Franks's death, steps one and two were complete.

Less than 24 hours after the conspiracy was set in motion, it started to fall apart. Shortly after Franks's father received a call instructing him to deliver a $10,000 ransom, his phone rang again: The body of a boy found near Wolf Lake was that of his missing son. The other shoe dropped when police discovered a pair of eyeglasses near Franks's corpse. Though the prescription proved common among Chicagoans, the unique hinges on the frames narrowed possible owners down to three, including Leopold.

Left: Bobby Franks is the picture of innocence during his days at the Harvard school. Above: Leopold and Loeb, on the left and right of Darrow, constitute a picture of arrogance during their trial. The estimable Darrow won them time behind bars rather than death, but for Loeb, at least, it amounted to the same thing.

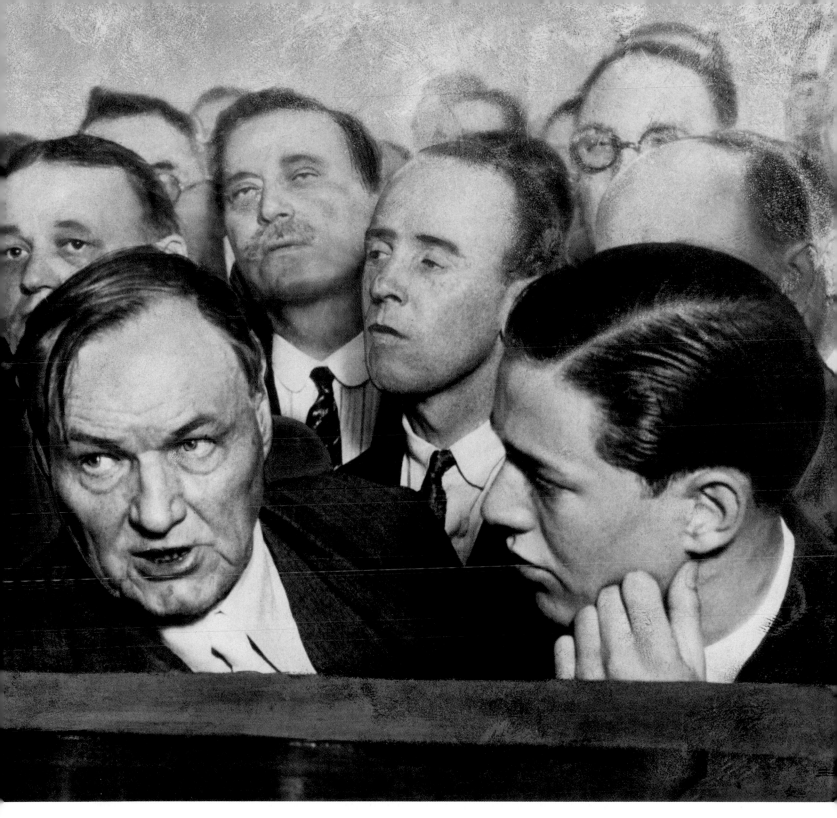

He told detectives he must have dropped them while birding. His alibi included Loeb, so the police brought him in as well. Meanwhile, investigators connected the ransom note to Leopold's Underwood typewriter.

The star of this courtroom drama was the teens' 67-year-old lawyer, Clarence Darrow. A staunch critic of capital punishment, Darrow devised a defense that would inflame the debate. Instead of declaring themselves not guilty by reason of insanity, his clients pleaded guilty. During the hearing that determined whether Leopold and Loeb would hang, Darrow presented psychiatric evidence, which was rare at that time, from a team of experts who said that the "perfect crime" fantasy was a by-product of immaturity and emotional instability. Finally, Judge John Caverly sentenced each young man to life in prison for murder, plus 99 years for kidnapping, citing their youth as a primary reason for sparing them death.

Loeb was killed by a fellow prisoner in 1936 at age 30. Leopold was paroled in 1958. He moved to Puerto Rico, married, became active in public service and died in 1971. And that was the end of the supermen.

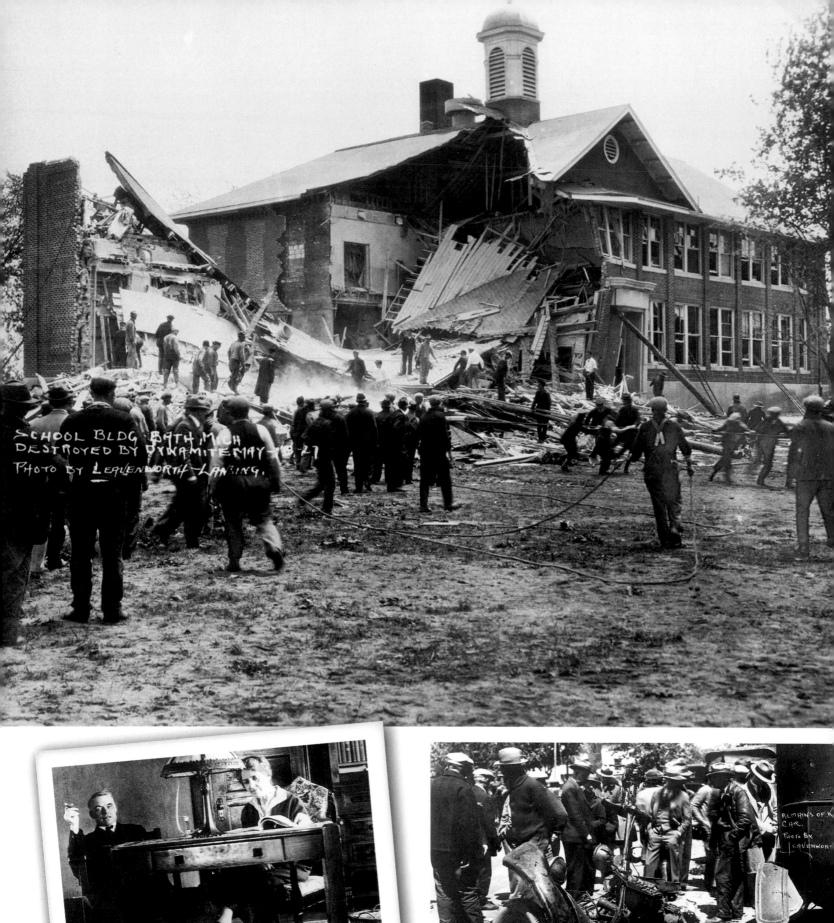

SCHOOL BLDG. BATH MICH
DESTROYED BY DYNAMITE MAY 18-27
PHOTO BY LEAVENWORTH LANSING.

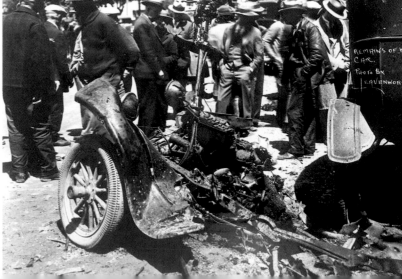

REMAINS OF K___
CAR.
PHOTO BY
LEAVENWORT___

The Bath School Disaster

Before Columbine and Virginia Tech, an inconceivable crime was committed in a Michigan village that still ranks as the largest mass murder of children in U.S. history. Thirty-eight grade-schoolers died that day, along with seven adults. Among the latter was local farmer Andrew Kehoe, whose suicide was the finishing touch on a heinous act.

In the early decades of the 20th century, the village of Bath was a farming community coming to terms with modern times. In 1922, voters decided a consolidated school should be built, and subsequently property taxes were raised to pay for it. This didn't sit well with Kehoe, who along with his wife, Nellie, owned a 185-acre farm near the village. Kehoe was a middling farmer at best, and his business never thrived. His wife's poor health added to Kehoe's woes as her hospital bills strained the family's finances. But Kehoe blamed the property tax increase for his troubles. When he couldn't meet the farm's mortgage payments and foreclosure loomed, Kehoe sought revenge.

And he had the means to exact it. In 1926, he was asked by the town if he could perform some maintenance work at the school. He agreed and thus gained the access he would need to execute his plan. He started to buy large quantities of explosives, which raised no undue suspicion since farmers routinely used dynamite. However, everyone failed to notice that Kehoe was assembling two enormous time bombs inside the school.

In the hours before or during the dawn of May 18, 1927, Kehoe murdered his wife with a blunt instrument and placed her body in a wheelbarrow. He also tied up all his animals so that they could not escape. Then, at 8:45 a.m., Kehoe set off an explosion. A raging fire would eventually level the entire farm. Meanwhile, the killer headed for town.

He had packed the trunk of his car with all manner of metal objects—a shovel head, nails, anything that would make effective shrapnel—and placed a large amount of dynamite behind the front seat. A loaded rifle sat next to him in the car.

At 9:45 a.m., the second explosion of the day rocked Bath, obliterating the school's north wing. Bernice Sterling, a teacher who survived, told the Associated Press: "It seemed as though the floor went up several feet. After the first shock I thought for a moment I was blind. When it came the air seemed to be full of children and flying desks and books. Children were tossed high in the air; some were catapulted out of the building."

Townsfolk rushed to assist in the rescue or frantically search for their own kids. Mothers were digging through the rubble; the screams of the injured (there were 58) filled the air. Ambulances from hospitals in Lansing and elsewhere rushed to the scene.

At about 10:15 a.m., Kehoe arrived to observe his handiwork. He spotted school superintendent Emory E. Huyck, the man he particularly held accountable for his financial ruin. According to witnesses, Kehoe summoned Huyck, then fired a shot into the backseat of his car, setting off a third explosion that caused a hail of lethal metal shards to claim the lives of Kehoe, Huyck, two other adults and an eight-year-old second-grader named Cleo Claton—an unlucky boy who survived the school bombing only to wander into another death trap.

Recovery efforts were halted at one point when rescuers made a shocking discovery: An additional 500 pounds of dynamite rigged with an alarm-clock timer set for 9:45 lay in the south wing of the school. Why this other cache of explosives did not detonate was a mystery. As the building was secured, a poignant realization had been made: The disaster could have been even worse.

Exhibiting a persecution complex even in death, Kehoe left behind a wooden sign affixed to a fence on his farm, hand-lettered with the words CRIMINALS ARE MADE, NOT BORN. To the last, America's worst-ever child killer refused to show the smallest measure of contrition.

> Opposite, clockwise from top: People gather around the rubble that once was the north wing of the school; the blast that killed Kehoe and four others left behind little more than a back wheel of his car; this picture of domestic bliss belies the Kehoes' misery.

The Black Dahlia Murder

We would be happy to solve the legendary Black Dahlia murder case—perhaps the most noir of all the many noir crimes in Hollywood history—over the next several paragraphs. Alas, we're no closer to fingering the culprit than Los Angeles law enforcement was more than 60 years ago. The case remains open and perhaps always will.

During her lifetime, Elizabeth Short was probably not called the Black Dahlia, though some accounts claim that she was. (There are perhaps as many myths and falsehoods surrounding this case as with any of the 50 detailed in this book.) Short probably received her exotic nickname in death, since the investigation of this raven-haired beauty's grisly demise followed close upon the release of the 1946 Raymond Chandler crime film *The Blue Dahlia*. Likely, some inspired ink-stained wretch working for one of L.A.'s tabloids channeled Chandler and anointed Miss Short with her immortal moniker.

She called herself Beth; friends and family knew her as Betty. She was born on July 29, 1924, and grew up during the depths of the Depression in the working-class neighborhood of Medford, Mass., outside of Boston. She found an occasional escape from the drudgery of the real world at the movie theater and was determined to become a star.

In pursuit of her dream, she eventually wound up in Hollywood. At one point during World War II, Short worked as a cashier at a local military base where she won the title "Camp Cutie of Camp Cooke."

On January 9, 1947, she was seen in the lobby of the Biltmore Hotel at the corner of Fifth and Olive streets in L.A. She was making phone calls while waiting for her sister, who was meeting her there. According to the official version, she was never seen alive again—except by her killer.

A number of people subsequently claimed to have spotted Short here or there, in the company of various people, during the six days that passed between her disappearance from the Biltmore and the discovery of her brutally mutilated corpse. On January 15, Betty Bersinger was walking with her three-year-old daughter when they stumbled upon what Bersinger first thought to be a discarded department-store mannequin—a "broken doll"—in a vacant lot. It turned out to be the body of Elizabeth Short, severed at the waist, naked and posed with the legs spread and the corners of the mouth cut so that they extended to each ear thus forming a frightful smile. The police soon determined that Short had been bound, tortured and killed elsewhere, then dumped. Their hunt was on.

Below: Too gruesome to be witnessed by the public, the corpse was blanketed by police. Opposite: Short was one of many starry-eyed young women who landed in Hollywood during the golden era.

And it still is, because no one has ever been charged, although scores have been suspected. Over the years, this list has included such luminaries as Norman Chandler, a publisher of the *Los Angeles Times;* Woody Guthrie, the famous folksinger, who once wrote sexually explicit letters to some California women he knew; and Orson Welles, thanks to a theory forwarded by Mary Pacios, a former neighbor of the Shorts in Medford, who wrote a book about the case in 1999.

Pacios's is only one of many books and movies that have dealt with the Black Dahlia mystery. Incredibly, two separate nonfiction accounts make the case that each of the authors' fathers was responsible. In one of these tomes, Steve Hodel's *Black Dahlia Avenger*, the former murder investigator claims that his dad, Dr. George Hodel, who cops looked at in 1949, was indeed the killer. James Ellroy, author of the classic crime novel *The Black Dahlia*, said of Hodel's book in 2004: "It's divine providence that a mad doctor spawns a son who becomes an LAPD homicide detective. And it turns out that his old man did the job.... I dig it."

In that interview with CBS News, Ellroy theorized as to why the case has endured and will last forever: "She's a ghost and a blank page to record our fears and desires. A postwar Mona Lisa, an L.A. quintessential."

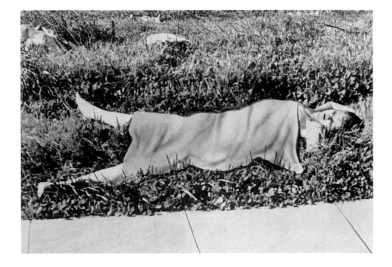

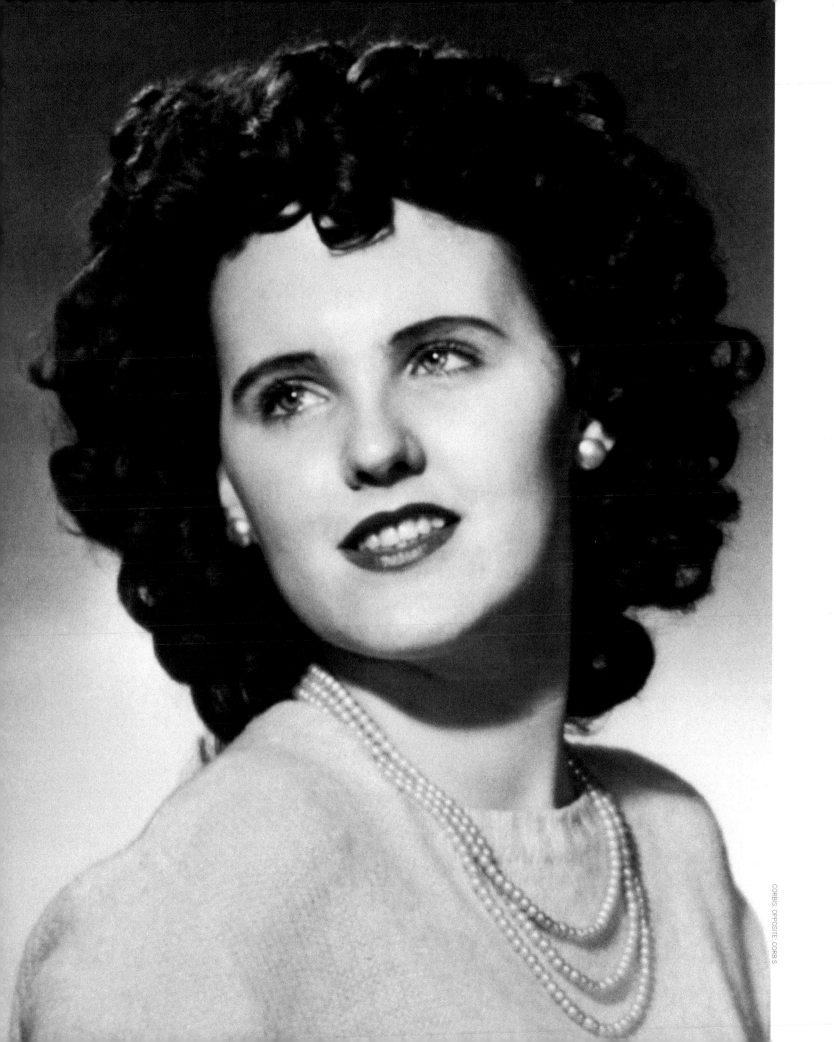

The Sam Sheppard Murder Case

You may know him as Dr. Sam Sheppard, or you may think you know him as Dr. Richard Kimball or, simply, as the Fugitive. For it has been said that the sensational, controversial murder trial of Sheppard in the mid-1950s inspired the hit 1960s TV series starring David Janssen, which was made into a film four decades later with Harrison Ford in the lead role. The creators of *The Fugitive*—both the small- and silver-screen versions—have long denied this, but there are certain similarities in the case histories of Drs. Sheppard and Kimble.

In the real-life incident, the doctor and his wife, Marilyn, were at their suburban Cleveland house in the early morning hours of July 4, 1954. According to Sheppard, he was sleeping on a daybed downstairs when he awoke to Marilyn's screams. He rushed upstairs and encountered an intruder, who knocked him out. When he regained consciousness, he found his wife had been bludgeoned to death. He rushed from the house, chasing the "bushy-haired intruder," who supposedly struck Sheppard another blow and knocked him out again.

Sheppard, a 30-year-old osteopathic physician at the time, would relate this account at his trial in the fall of '54. Judge Edward J. Blythin certainly wasn't buying it. (Later, it was revealed that on the first day of the trial, Blythin had proclaimed, "Well, he's guilty as hell.") Much of the public wasn't buying Sheppard's story, either. Fanned by a rabidly anti-Sheppard media campaign—WHY ISN'T SAM SHEPPARD IN JAIL? asked the headline of a *Cleveland Press* article—many Ohioans were demanding the doctor's scalp even before he set foot in court. This attitude was reinforced when details of a troubled marriage and the doctor's three-year affair with a nurse were exposed by the prosecution.

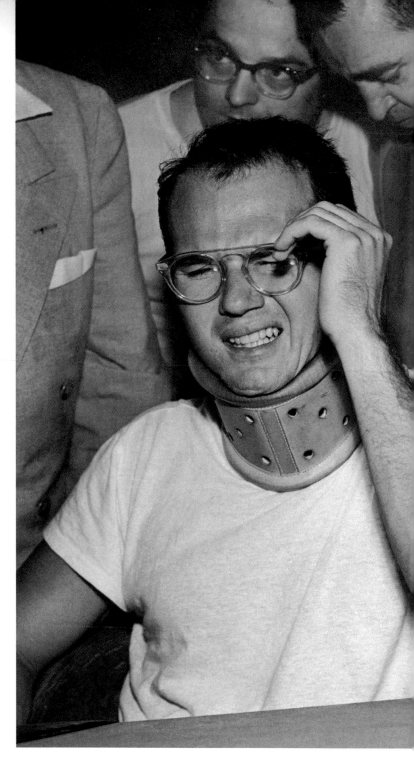

Not long after the Independence Day incident in 1954, Dr. Sheppard, his neck in a brace due to injuries suffered on the night in question, grimaces in pain.

Sheppard was convicted of second-degree murder and sentenced to life in prison. For a decade, his appeals were denied, but in 1964 a U.S. district court issued a habeas corpus, declaring that the trial had been unfair and ordering the state to place the doctor on probation or try him again. The U.S. Supreme Court agreed, citing Judge Blythin's attitude, his failure to sequester the jury or direct it to ignore news reports of the case, and the general "carnival atmosphere."

Sheppard did not take the stand at his second trial in 1966, per the counsel of his new lawyer, F. Lee Bailey, who earned a national reputation

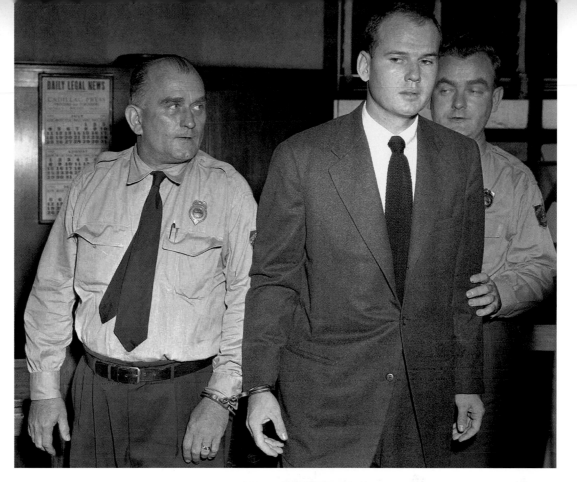

In the real-life incident, the doctor and his wife, Marilyn, were both at their suburban Cleveland house in the early morning hours of July 4, 1954, when, according to Sheppard, a "bushy-haired intruder" began to wreak havoc.

WILLIAM A. ASHBOLT/CLEVELAND PLAIN DEALER

CORBIS; RIGHT: LEE BALTERMAN. ABOVE: AP

with Sheppard's eventual acquittal. Three weeks after his exoneration, he appeared on *The Tonight Show Starring Johnny Carson*, and the carnival rolled on. At one point in the late '60s, Sheppard worked as a professional wrestler known as Killer Sheppard. He is credited with inventing the mandible claw, a renowned hold (if only he had used it on the bushy-haired intruder). He also started to drink heavily, reportedly downing up to two bottles a day. He died of liver failure at age 46 in 1970.

Clockwise from top right: After being found guilty of murder in 1954, Sheppard is brought back to his cell; attorney F. Lee Bailey (right) awaits the verdict in the 1966 retrial with the former physician and his second wife, Ariane; Sheppard and his first wife, Marilyn, water-ski.

Sheppard's son, Samuel Reese Sheppard, who was seven years old on the night his mother died, has taken up a lifelong crusade to clear his dad's name. In 1999, he sued the state of Ohio for $3 million, claiming his father had been wrongfully imprisoned. During this court case, suggestions were made that the late Richard Eberling, the Sheppards' window washer who was subsequently convicted of another murder, had killed Marilyn Sheppard. The jury found against Sheppard fils, and the son issued a defiant, if infelicitously worded, statement: "The Sheppard family may be bloodied, but we are unbowed. We have been unbowed for 45 years. We will be unbowed for the rest of time. We will know the truth of the situation."

Psycho

Now to understand it . . . you have to go back 10 years, to the time when . . . he was already dangerously disturbed. His father died. . . . His mother was a clinging, demanding woman, and for years, the two of them lived as if there was no one else in the world. . . . Therefore, if he felt a strong attraction to any other woman, the mother side of him would go wild."

These words, spoken at the end of Alfred Hitchcock's 1960 thriller *Psycho,* attempt to explain the grotesque actions of the outwardly innocuous Norman Bates. It's no coincidence that very similar things had been said three years earlier of Eddie Gein, a flesh-and-blood monster who was also seemingly harmless at first glance. The unforgettable Bates character was inspired by Gein—as were Leatherface in *The Texas Chainsaw Massacre* (1974) and Buffalo Bill in *The Silence of the Lambs* (1991).

Above: Gein after his arrest. Left and opposite: When word circulated about Gein's house of horrors, locals came by for a peek. They gazed upon a ghastly world in which Gein had spent his days reading horror novels and crime stories, poring over porn magazines and plying his ghoulish craft.

Born in 1906, Gein grew up in La Crosse, Wis., then in Plainfield on the family's 275-acre farm. He was the favored son of his domineering, fanatically religious mother, Augusta, who all but sequestered him on the farm and would read to him daily from her Bible—passages rife with promises of eternal damnation for wayward souls. Gein's alcoholic father died in 1940, his older brother in '44 and Augusta, of a stroke, in '45. Now Gein was completely alone in a ramshackle house devoid of electricity, plumbing and any semblance of happiness. He closed off Augusta's bedroom and left other rooms where they had spent time together untouched.

During his infrequent contact with outsiders over the next dozen years, Gein seemed strange but not fearsome. Then, on November 17, 1957, after witnesses said they had seen him near the hardware store of Bernice Worden, who had recently disappeared, Sheriff Arthur Schley knocked on Gein's door. He was welcomed into a foul-smelling realm of madness.

The store owner's body "was strung up by the heels in a summer kitchen," as *Time* magazine reported. "It had been eviscerated and dressed out like a deer. Her severed head was in a cardboard box, her heart in a plastic bag on the stove. Around the house the police also found: ten skins of human heads, neatly separated from the skull; assorted pieces of human skin . . . some made into small belts, some used to upholster chair seats . . . a box of noses." The corner posts of Gein's bed were topped with human skulls. Other skulls had been fashioned into soup bowls.

Gein's main hobby was grave-robbing, preferably of deceased women who reminded him of Mother. He dispassionately confessed to dismembering the corpses and taking body parts for his macabre projects. He also admitted that he had murdered the store owner and a tavern keeper who had vanished three years earlier. Though never proven, his guilt was suspected in the disappearances of four others between 1947 and '57.

Gein died in an institution for the criminally insane in 1984 at the age of 77. Today, thanks to Hollywood, he lives on in our worst nightmares.

FRANK SCHERSCHEL; ABOVE: FRANCIS MILLER. OPPOSITE: FRANK SCHERSCHEL

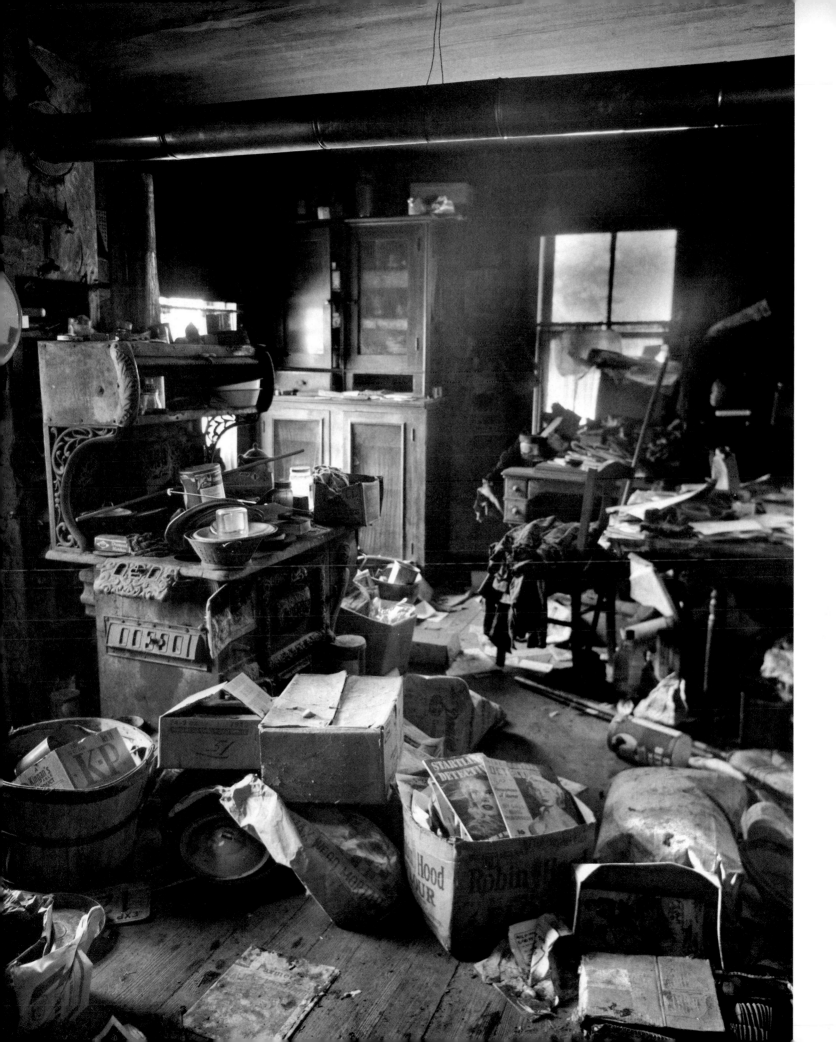

Charles Starkweather

Do we really know Charles Starkweather as he truly was? Or do we only recognize him as he has been portrayed on the big screen—in *Badlands, Wild at Heart, Natural Born Killers* and *Starkweather,* just to name a few—and in song (when listening to Bruce Springsteen's ballad "Nebraska," we hear Starkweather whistling from beyond the grave).

Starkweather's early life was more benign than one might expect. He is said to have had a normal upbringing in Lincoln, Neb., regardless of the fact that his family was poor and struggled through the Depression. The boy had a nice start, believe it or not.

School was a different kettle of fish. He was a poor student and a target of bullies. As he grew older, Starkweather built his physical strength, and he himself became the bully. His friends regarded him as fun to be around, but those he tormented during his teenage years saw him as cruel.

By 1957, the 19-year-old Starkweather had developed a James Dean fixation, emulating the rebel film star in look and attitude. At this point, he was introduced to Caril Ann Fugate, who was 13. Despite the difference in their ages, Starkweather started hanging with Fugate all the time. He taught her to drive, sort of—she crashed his car into another. When his father had to pay damages, an altercation between the two Starkweathers ensued, and Charles was booted out of the house.

At a gas station that November, Starkweather saw a stuffed animal he knew Fugate would simply love. He tried to buy it on credit but was refused. He returned to the station three more times that night—first for cigarettes, then for gum. On the third trip, he took the gas station attendant hostage. After a scuffle, Starkweather blew him away with a shotgun. Even he could not have realized at the time that the crime spree had begun.

One day in January 1958, Starkweather came calling for Fugate, but her parents told him she wasn't home and they didn't want him to see her anymore. Furious, he shot Fugate's mother and stepfather, then stabbed her two-year-old sister, Betty Jean. He hid the bodies. Fugate returned from school, and she and Starkweather stayed in the house together for several more days. Finally, they took off.

They killed an old friend of the Starkweathers' and murdered two fellow teens who had offered them a ride. Then they made their way to an upper-class neighborhood, slew a wealthy couple and their maid, and fled in a Packard packed with loot. They scooted to Wyoming and traded the Packard for a Buick by killing its occupant, a traveling salesman.

Soon, a dragnet of more than 1,200 cops was on Starkweather and Fugate's tail. As Starkweather was speeding down the highway in Wyoming at 100 miles per hour, a cop was able to strike him with a bullet. He abruptly surrendered.

First, Starkweather said Fugate was blameless, then he claimed that

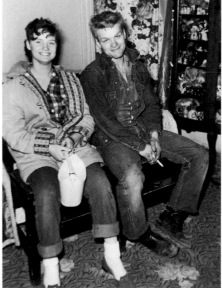

Below: Fugate and Starkweather at his landlady's home in Lincoln. Opposite: The serial killer tries to maintain his James Dean aura after his arrest.

she was an accomplice. In the end, both were convicted. He was electrocuted in 1959, while she was sentenced to life in prison. (A model prisoner, she was paroled in 1976. She relocated to Lansing, Mich., to lead a quiet life as a medical assistant.)

A flood of pop culture references to their crimes would issue forth in the years to come: all those movies were made; master of horror Stephen King nodded to them in his books; a heavy metal band named itself Starkweather. Are these tributes? Hopefully they are not. Whether Charles Starkweather was "natural born" or evolved, he was a killer—viciously taking the lives of 11 innocent people—and we should never forget that.

He returned to the gas station three more times that night—first for cigarettes, then for gum, then with a shotgun. He blew the attendant away. Even Starkweather didn't yet realize that the spree had begun.

The Boston Strangler

I n 1962, someone started sexually assaulting and strangling women in their apartments in Boston, and the community became frozen in collective fear. Women took to putting tin cans in the hallways of their buildings, hoping any intruder might trip over them and make his presence known. "The Animal Rescue League cannot keep up with the demand for watchdogs," *Time* magazine reported on March 22, 1963, in "The Phantom Strangler," an article that ran after what was thought to be the 10th such killing in nine months.

The total number of murders linked to the Boston Strangler will probably never be known, since questions remain nearly half a century later about how many stranglers there might have been, which crimes fit the principal profile and whether or not the man who once admitted to being the strangler was, in fact, the primary perpetrator. The number of victims ranges from 11 to 12 or 13, all of them single women, killed between 1962 and 1964. But these figures no longer reflect the woman referenced as the 10th victim in the *Time* article—a woman who might well have been killed by the strangler and whom we will return to shortly.

The "first stage" of the spree began on June 14, 1962, and followed a tight pattern: Seamstress Anna Slesers, 55, was found in her kitchen, a bathrobe belt around her throat; two weeks later, physiotherapist Nina Nichols, 68, was discovered in her bedroom, stockings knotted around her neck; two days later, nurse Helen Blake, 65, was strangled with her stockings; eight days later, Margaret Davis, 60, was choked by hand; on August 19, Ida Irga, 75, was suffocated with a pillowcase; a day after that, nurse's aide Jane Sullivan, 67, was killed with her stockings.

In a little more than two months, half a dozen older women had been molested and murdered. Then there was a pause before the "second stage," which began on December 5, when 19-year-old medical technology student Sophie Clark was strangled with three stockings intertwined with a half slip. Over the next 13 months, five other women who are now linked to the case were murdered. The final victim was Mary Sullivan, 19.

In October 1964, a 33-year-old handyman named Albert DeSalvo posed as a detective, entered a woman's home, tied her up, sexually molested her, then left, saying, "I'm sorry." After he was charged with her rape, he told a fellow inmate, and then police investigators, that he was the strangler. During 50 hours of interrogation, he offered details of 13 murders, two of which had not been connected to the strangler. At the time, authorities felt they had their man, even though there were some inconsistencies in DeSalvo's account and police had found no physical evidence linking him to any of the crimes. He was sentenced to life in prison in 1967—but for other crimes, including the October '64 rape. On November 25, 1973, he was murdered in the infirmary of Walpole State Prison.

Although DeSalvo's arrest did much to calm the women of Boston, his confession has failed to bring a great deal of clarity or closure to the Boston Strangler case. Some investigators feel there were at least two or possibly more killers involved; others wonder if additional crimes not

Above: While the strangler terrorized Boston, LIFE sent photographer Arthur Rickerby to capture the mounting tension. Among his subjects was this undercover police officer, who bravely prowled the streets, posing as prey.

Below: A Boston woman constructs a makeshift alarm out of bottles placed in her doorway. Bottom left: DeSalvo in custody. Many believe he didn't commit all the murders.

included in the strangler dossier belong there. The family of Mary Sullivan, for one, doesn't think DeSalvo committed her murder.

To illustrate how muddled this story remains, let's return to the woman mentioned in *Time*. Her name was Bessie Goldberg, 62, and she was strangled in her suburban home. Roy Smith, a housecleaner, was convicted in the case. Now, if Smith did kill Goldberg, he still couldn't have murdered eight of the other women, because he was in prison at the time. Moreover, the strangler attacks continued after he was arrested in the Goldberg case.

When housewife Ellen Junger heard about the Goldberg murder, she went outside and told the young man who was working on an addition to her house that the Boston Strangler had struck nearby. That man was Albert DeSalvo. Was he, perhaps, Bessie Goldberg's killer? Decades later, that housewife's son, the writer Sebastian Junger, asked this question in his 2006 book, *A Murder in Belmont*. His conclusion, like so much else involving the Boston Strangler: You just can't be sure.

The victims (top row, from left to right): Matusek, who loved antiquing; Farris, who hoped to become a pediatric nurse; Gargullo; (middle row) Pasion, who like Gargullo came to the U.S. to become a nurse; Wilkening, who enjoyed watching her brother race cars; (bottom row) Davy, who was engaged; Jordan, the ill-fated visitor; Schmale, who was a former swimming champion.

Richard Speck

T he tattoo on Richard Speck's left arm read BORN TO RAISE HELL. Surely, this lifelong loser saw these words as a self-aggrandizing boast. What the slogan became in the summer of '66 was a prophecy fulfilled.

Ah, but there is one positive thing to be said about that tattoo: It was the reason Speck got caught.

Richard Franklin Speck was born in Kirkwood, Ill., on December 6, 1941. His father died when he was six, so he moved with his mother and one of his siblings to a low-rent part of Dallas. He dropped out of school in ninth grade and, following his first arrest at age 13, piled up 35 more juvenile offenses, from public drunkenness to burglary. Alcohol would become a constant; he did little else through his teens and early twenties except drink and commit crimes. Speck stole, he forged, he assaulted a woman with a knife, he spent stretches behind bars. Released from a Texas state prison in 1965, he made his way back to Illinois.

Speck's aimlessness starkly contrasts the ambitions of the young women he attacked, all of whom were in their early twenties and lived at a nurses' dorm on Chicago's South Side: Pamela Wilkening, Suzanne Farris, Nina Schmale, Patricia Matusek, Gloria Davy and three Filipina exchange students—Valentina Pasion, Merlita Gargullo and Corazon Amurao. These women wanted to become nurses, they wanted to help. Also at the dorm on that fateful night was Mary Ann Jordan, whose brother was engaged to Farris and who had dropped by to review wedding plans.

Amurao answered a knock on the door at around 11 p.m. on July 13, 1966. Speck, who had spent most of the day drinking, barged in—a pistol in one hand, a butcher knife in the other. He forced Amurao and Gargullo into a bedroom, where Wilkening, Matusek and Pasion were roused. They were soon joined by Schmale. "I want money," he told them, so they handed over the contents of their purses. Using his knife, Speck cut long strips from a bed sheet, then used them to bind each woman's wrists and ankles. Davy arrived home from a date around 11:30 and found a stranger with a gun ordering her to sit on the floor with the others. "Don't be afraid," he said. "I'm not going to kill you."

But he did. He pulled Wilkening into another bedroom, just as Jordan and Farris came home. He forced them into a third bedroom, where he stabbed and strangled Farris and stabbed Jordan. He returned to Wilkening and killed her. He grabbed Schmale next. The five nurses remaining in the big bedroom, still bound, hid under the beds. Speck came back and pulled them out, one by one.

In his drunkenness, Speck neglected Amurao, who remained concealed, listening for several hours to the screams of her friends. When she finally felt it was safe to come out, at about 5:30 a.m., she crawled onto a ledge and screamed, "Help me! My friends are all dead!"

The police were able to get a description of the killer from Amurao, and an official at a nearby hiring hall matched these details to a work application and photo of Speck. Over the next two days, the fugitive evaded a dragnet, then, in a drunken stupor, slit his wrists with a broken bottle. He was rushed to a hospital where an alert ER doctor identified

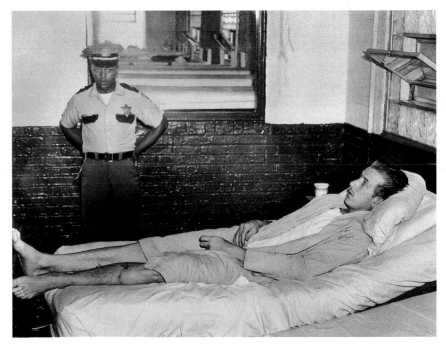

Above: After his arraignment on August 1, 1966, Speck reclines in the presence of one of the several guards who were assigned to watch him around the clock.

Speck—by rubbing dried blood off his left arm to uncover the telltale tattoo.

Amurao's chilling testimony was the most crucial evidence against Speck, and on April 15, 1967, after deliberating for just 49 minutes, the jury returned a guilty verdict against him. He was sentenced to death, a decision reversed by the U.S. Supreme Court in 1972 when it declared the death penalty unconstitutional. He died of a heart attack on December 5, 1991—unmourned.

Members of the clan: Beausoleil, who committed the first murder, sits at left; Brunner is in the middle; and Lynette "Squeaky" Fromme, who would later try to assassinate President Gerald R. Ford, is third from the right. Opposite: The leader in 1969.

Charles Manson
and His Family

Charles Milles Maddox was born in Cincinnati on November 12, 1934, to an unwed teenager; he received his notorious surname from his mother's brief first marriage. Manson's childhood was miserable, and he spent time at reformatories in Indiana, Washington, D.C., Virginia and Ohio. As an adult, his penchant for theft and violent behavior did not dissipate, and he wound up

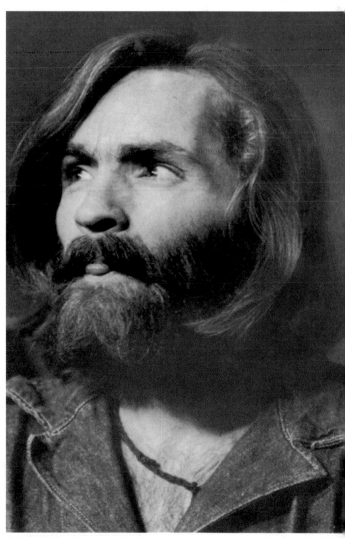

MIKE HAERING

123

Manson, left, poses with a
fellow Death Valley resident in
the late '60s. Manson and
members of his Family slept
wherever they could, often in
abandoned ranches.

in prisons in California and Washington State. As his release date neared in 1967, Manson had little else on his résumé beyond burglar, car thief, forger, sodomite, escapee and pimp. He had spent more than half of his 32 years in detention centers. Prison was the only home he had known, so he asked the authorities that he be allowed to stay. He later elaborated on his plea in a television interview with Tom Snyder: "I said, 'I can't handle the maniacs outside, let me back in.'"

If only the authorities had found a way to comply with his request.

After his release, Manson earned money by panhandling in Berkeley, Calif. He moved in with Mary Brunner, 23, who was an assistant librarian at the University of California at Berkeley. Brunner, who is considered the first of the many female members of the so-called

Manson, left, poses with a
fellow Death Valley resident in
the late '60s. Manson and
members of his Family slept
wherever they could, often in
abandoned ranches.

Manson Family, gave birth to his son in the spring of 1968.

By that time, the Family was burgeoning. Traveling in a Volkswagen van and later a school bus, settling for a time here or there, Manson and Brunner roamed the Western seaboard, recruiting adherents. He set himself up as a guru of sorts, and some two dozen individuals became affiliated, loosely or fiercely, with his world. The Family's headquarters were eventually established at several ranches, abandoned or otherwise, in Southern California, and Manson started to insinuate himself into the music-world orbit of Beach Boys drummer Dennis Wilson, musician and producer Terry Melcher and others. At

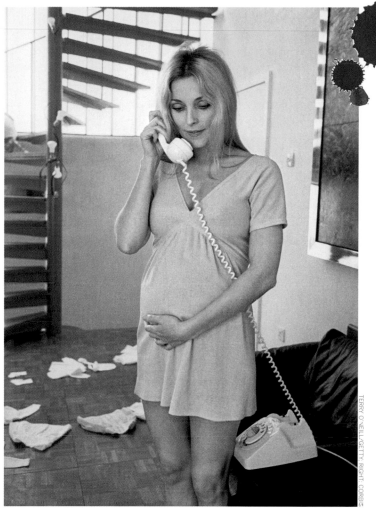

(who was not there)—it mattered not. The mayhem that followed was merciless. Victims fleeing outside were tracked down, screaming as they died. Tate pleaded for her unborn baby's life but was stabbed 16 times by Atkins and Watson. Atkins wrote the word PIG on the front door of the house with Tate's blood. Five were murdered that night, and two more the next: Leno and Rosemary La Bianca, who lived nearby. Manson went on this second mission, again orchestrating but not committing the murders. Among the words painted in blood inside the LaBianca house were HEALTER SKELTER, misspelled on the refrigerator door.

The Beatles link and Manson's twisted philosophy became part of a courtroom circus that yielded death sentences against four Family members, including Manson. When capital punishment was eliminated in 1972, the penalties were automatically commuted to life terms. And so prison—the only home he's ever known—is where Charles Manson will spend the rest of his days.

Above: Tate talks on the phone three days before her death. Right: Manson family members Leslie Van Houten, Krenwinkel and Atkins, the latter two of whom were present at the Tate murders, strut into court.

one point, Manson auditioned his singer-songwriter skills for Melcher, who remained a friend of Manson's but declined to work with him.

Manson was primarily obsessed with two things: the Beatles and the approaching apocalypse. He merged the two by using the name of a Beatles song as a code word for the coming chaos—"Helter Skelter"—then set it into motion on August 8, 1969, telling his acolytes: "Now is the time for Helter Skelter!" Twelve days earlier, Manson had already ordered Bobby Beausoleil to kill Gary Hinman to settle a dispute over money. Beausoleil was under arrest for that crime when, on the 8th, Manson told Tex Watson to go to "that house where Melcher used to live [and] totally destroy everyone in [it], as gruesome as you can." Manson sent Susan Atkins, Linda Kasabian and Patricia Krenwinkel with Watkins, telling the women to "leave a sign . . . something witchy."

The four Family members arrived around midnight. If they even knew who they were about to kill—no one linked to Melcher but instead actress Sharon Tate, eight-and-a-half-months pregnant with the child of film director husband Roman Polanski, plus associates and friends of Polanski

Fatal Vision

This complicated, twisting story seems a cross between the Sam Sheppard case and the Manson murders. At the outset, it brims with graphic violence and chapter upon chapter of courtroom drama. It has a Clutter family aspect, too, since a best-selling book made the episode even more famous than it already was.

Today, Dr. Jeffrey Robert MacDonald sits in a federal prison in Maryland. He was convicted in 1979 of the murders of his pregnant wife, Colette, and their two daughters, Kimberley, 5, and Kristen, 2, nine years earlier. That such a fate awaited MacDonald would once have been inconceivable to the citizens of Patchogue, N.Y.—the Long Island village where MacDonald grew up during the 1940s and '50s. He won a scholarship to Princeton University and earned a medical degree from Northwestern

He might have remained free if it hadn't been for the initiative of Colette's stepfather, Freddie Kassab. He had testified at the hearing, "If I ever had another daughter, I'd still want the same son-in-law," but after reviewing transcripts and monitoring MacDonald's behavior following his exoneration, Kassab changed his thinking drastically. He launched a campaign to have the case reopened. Months of indecision ensued, but the government finally convened a grand jury in 1974, and MacDonald was indicted in early '75. Then came years of legal argument—double jeopardy? right to a speedy trial?—over whether the case should come to court. There have been more appeals, decisions and reversals in this one, both before and since MacDonald's 1979 conviction, than in perhaps any other case in this book. Charges have been made that evidence was suppressed. To this day, the defense is presenting affidavits that imply the guilt of others. Though MacDonald was denied parole in 2005, there is no certainty that this matter is finished.

As MacDonald's day in court approached in 1979, he welcomed the noted writer Joe McGinniss into his camp. MacDonald felt that a book by McGinniss detailing the injustice that had been done could only help his plight. McGinniss, however, became convinced of MacDonald's guilt, and his book *Fatal Vision* was damning. MacDonald sued McGinniss for fraud, claiming the writer had falsely represented himself in order to get information from MacDonald. There was a mistrial, then an out-of-court settlement for a reported $350,000. That case, at least, is closed.

University. He performed his internship in 1968 at the Columbia Presbyterian Medical Center in New York City.

MacDonald first dated Colette Stevenson when they were students at Patchogue High School. She became pregnant during his time at Princeton, so they got married. Kimberly was born in the spring of 1964, then Kristen followed in the spring of 1967.

Opposite: The Green Beret captain reacts in 1970 as the Army says there is not enough evidence to move forward. Above: Jeffrey and Colette on their wedding day in 1963. Below: Dr. MacDonald practicing in Long Beach, Calif., in 1975.

Upon finishing his internship, Dr. MacDonald joined the Army as a surgeon with the Green Berets; he was assigned to Fort Bragg, N.C. Colette became pregnant with their third child. To this point, the MacDonalds appeared to be a singularly fine, truly all-American family.

And then, in the early hours of February 17, 1970, a frenzied struggle and murderous rage visited the MacDonald home. Colette was beaten and stabbed 37 times. The girls were also stabbed multiple times. Dr. MacDonald, who called Fort Bragg authorities at 3:42 a.m., suffered cuts and bruises. The Army officers who arrived at the scene also found the word PIG written in blood on the headboard of the MacDonalds' bed.

Was this a copycat of the Manson case? It certainly sounded that way when MacDonald gave his version to investigators: He was attacked by three men and a woman, who chanted "Acid is groovy, kill the pigs." At one point, he was knocked out.

But after the crime-scene and forensics investigation was complete, the Army's Criminal Investigation Division came to a different conclusion: MacDonald was fighting with his wife. As he was beating her, Kimberly got hurt too. The situation spiraled, and MacDonald wound up murdering his wife and daughters, then staging the scene to resemble the Manson Family rampage. His wounds were believed to have been self-inflicted.

After an Army hearing in 1970, charges against MacDonald were dismissed, with Fort Bragg's commanding officer finding "insufficient evidence" against him. MacDonald received an honorable discharge and returned to civilian medical practice—first in New York, then California.

The
Disappearance
of
Jimmy
Hoffa

Jimmy Hoffa's middle name was Riddle. Or should we say his middle name *is* Riddle? Could he possibly still be alive?

The government thinks not, having declared the pugnacious former leader of the International Brotherhood of Teamsters legally dead on July 30, 1982. Others believe he was already deceased seven summers earlier, eliminated by one of the thugs with whom he had had a long association. The Mafia was always with Hoffa during his rise and fall as the kingpin of organized labor in the U.S. Was the Mob there at the bitter end?

It remains a question—a riddle, if you will—since no sign of Hoffa, nor any hard evidence of his murder, has ever surfaced.

Though we don't know precisely when (or if) Hoffa left this world, we do know when he entered it: on February 14, 1913, in Brazil, Ind. Hoffa dropped out of school after ninth grade, and by 19, he had moved with his family to Detroit, where he got his first taste of hard-nosed labor relations while unloading boxcars for 32 cents an hour in a grocery warehouse. Leaving a shipment of perishable fruit on the loading dock, he organized a strike for higher wages—and won.

As leader of Teamsters Local 299 a few years later, he fought, often literally, for his union. "I was hit so many times with nightsticks, clubs and brass knuckles, I can't even remember where the bruises were," he said. "But I can hit back. Guys who tried to break me up got broken up."

Hoffa clawed his way up the Teamsters national leadership ladder. His strong-arm tactics and economic interests found him regularly in the

Opposite: Hoffa is the very image of a tough union boss. Right: During the 2006 FBI search in Milford Township, Duke's takes advantage of Hoffa's past patronage to entice people in for a bite.

company of organized-crime figures, who helped him solidify power and influence. He seized the national presidency of the union, 1.4 million members strong, in 1957. Then he tirelessly (and ruthlessly, critics charged) grew its membership to 2.2 million.

But his hobnobbing with criminals did not escape notice. U.S. Attorney General Robert F. Kennedy battled Hoffa in televised hearings. Ultimately, the law won, and the Teamsters czar went to prison in 1967 to serve a 13-year sentence for jury tampering, fraud and conspiracy. In 1971, President Richard Nixon commuted Hoffa's sentence—a release that carried the stipulation that he refrain from union activities until 1980.

But he just couldn't. The still-tough, 5-foot, 5-inch, 58-year-old bulldog started angling for a return to power. The problem: While Hoffa had been in the slammer, his successor, Frank Fitzsimmons, had consolidated his own base—not just among the rank and file but with some of the mobsters who had infested the organization.

On Wednesday, July 30, 1975, Hoffa reportedly drove his green '74 Pontiac Grand Ville to the Machus Red Fox Restaurant in Bloomfield Township, northwest of Detroit. Some have speculated that a midday sit-down had been arranged with local mafioso Anthony "Tony Jack" Giacalone and New Jersey racketeer Anthony "Tony Pro" Provenzano to quell a feud and discuss Hoffa's future with the Teamsters. If so, it seems that the mobsters knew precisely what Hoffa's future looked like.

When he still hadn't returned home the next morning, his wife, Josephine, called the police, who found his unlocked car in the restaurant's parking lot. Given Hoffa's connections, foul play has always been presumed. Among the theories as to what happened to him:

• His body, in the trunk of a car, visited a giant compactor near Detroit.

• He was whacked in Michigan and unceremoniously interred at Giants Stadium in New Jersey, which was under construction in 1975.

• He was buried somewhere in Michigan—in a gravel pit in Highland, under a swimming pool in Bloomfield Hills, beneath a garage in Cadillac.

• And the sunny one—he ran south to Brazil with a go-go dancer.

In May 2006, the FBI searched Hidden Dreams Farm in Milford Township, Mich., where a drug dealer said that he had seen "suspicious activity" some years earlier. The feds came up empty.

So Hoffa's fate remains a riddle. And he remains legally dead.

The Son of Sam

I am a monster," read the note left at the scene of a deadly night-time shooting on April 17, 1977. "I am the 'Son of Sam.'"

The rambling missive continued from there, further confounding the New York City Police Department, which had been stymied by a series of seemingly connected killings for nearly a year. The city, meanwhile, was living in constant fear. *Who will be the next victim? What kind of demented beast is lurking out there?* The mystery killer took on the awesome image of Satan himself.

So imagine the public's disbelief four months later at the sight of a pudgy 24-year-old postal worker, sporting Elvis sideburns and a goofy half smile, being escorted into police headquarters. This David Richard Berkowitz was the monster who had killed six people, wounded seven and terrorized millions? This dumpy guy was the Son of Sam?

He was.

Berkowitz's reign of terror began in the small hours of July 29, 1976. Donna Lauria, 18, and her friend, Jody Valenti, 19, were chatting as they sat in Valenti's car in the Bronx. A man approached them, pulled a revolver out of a paper bag and pumped five bullets through the passenger's window. Lauria was killed instantly; Valenti was wounded in the thigh. With no strong clues, police chalked up the incident as one more senseless murder in a violent town.

On October 23, a young couple sitting in a car parked on a dark street in Queens were attacked. On November 27, again in Queens, two more teenage girls were shot. On January 30, 1977, another boyfriend and girlfriend...

At this point, a savvy detective noticed that uncommonly big bullets from a large-caliber gun had been used in a number of unsolved shootings. Also, the targets in these cases were usually attractive young women with long, dark hair. The same MO fit the March 8 slaying of Virginia Voskerichian, a 21-year-old college student walking home alone from a Queens subway station. The bullet from a .44-caliber Charter Arms Bulldog revolver retrieved from that murder matched the one that had killed Lauria, as well as bullets recovered from the other recent shootings. The tabloids picked the nickname the ".44-Caliber Killer." With the April 17 murder in the Bronx of Valentina Suriani, 18, and Alexander Esau, 20, and the discovery that night of the Son of Sam letter, the killer assumed a new moniker.

Women with dark hair were bleaching it, while 300 police officers were following up on thousands of tips. It was the largest manhunt in the city's history.

Shortly after three a.m. on June 26, Judy Placido, 17, was sitting in a car telling her boyfriend Sal Lupo, 20, "This Son of Sam is really scary." Seconds later, bullets ripped through the window, wounding them both. Then on the last day of July, Stacy Moskowitz and her date, Robert Violante, both 20, were each shot in the head. She died; he was blinded.

Berkowitz had parked his Ford Galaxie too close to a fire hydrant that night in Brooklyn. Police traced one of the summonses that had been issued to Berkowitz at an address in Yonkers, just north of New York City. On August 10, cops surrounded the apartment building where Berkowitz lived. They peered inside the Galaxie and saw a rifle. Unaware of the stakeout, Berkowitz walked outside, got into his car and, moments later, was arrested without a struggle. "Well, you got me. What took you

so long?" The .44-caliber Bulldog was in his car. He had intentions, he later admitted, of stalking more prey that night.

Berkowitz readily confessed to being the Son of Sam and offered a bizarre, unsettling tale concerning his motivation. "Sam," Berkowitz told police, was an ancient demon that possessed his neighbor Sam Carr. "[Sam] really is a man who lived 6,000 years ago," he said. "I got the messages through his dog. He told me to kill. Sam is the Devil." According to Berkowitz, he had been commanded by a black Labrador retriever named Harvey to commit murder. Obviously, Berkowitz's sanity was in question, but he never allowed it to be determined legally, as he pleaded guilty, thereby avoiding a trial. Today, he is incarcerated at an upstate New York prison, where, as a Christian convert and jailhouse pastor, he ministers to fellow inmates. The Son of Sam—the erstwhile incarnation of Satan—now pledges allegiance to Christianity's Son of God.

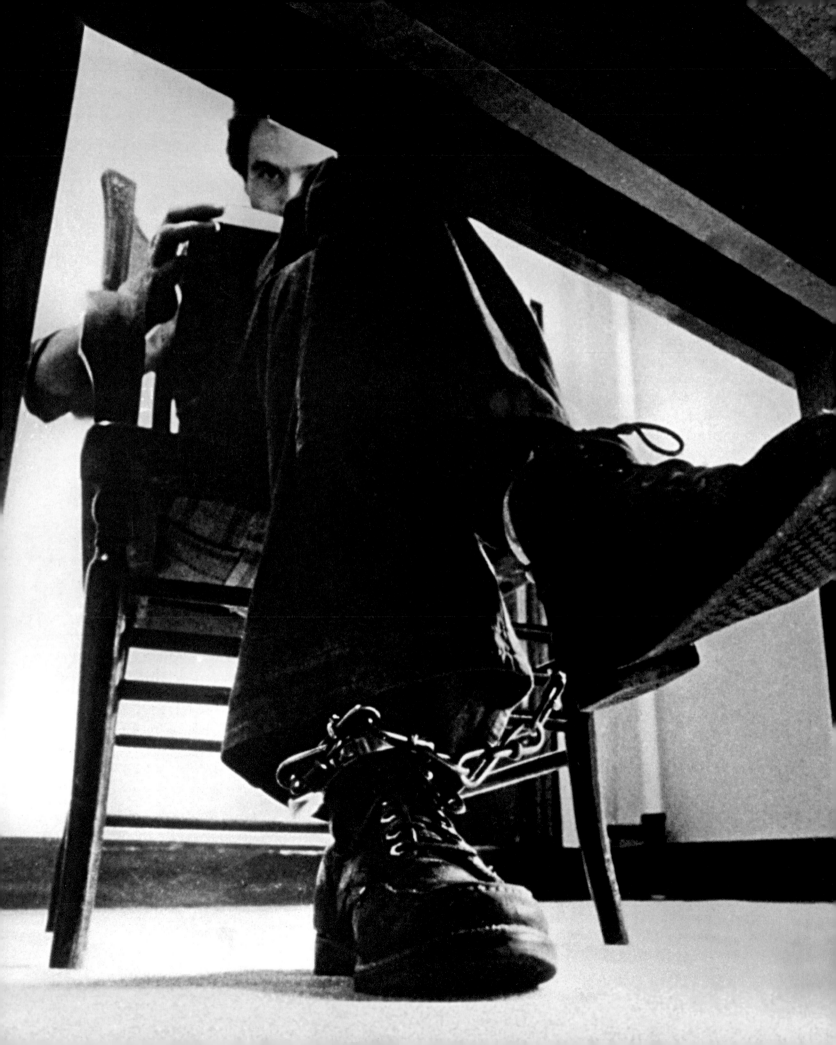

Ted Bundy

He was handsome, clean-cut and well-dressed. With a cast on his arm, this charming gentleman would ask for a hand loading stuff into his cute VW bug. And, of course, each one of the pretty girls who "friendly Ted"—as he introduced himself—asked for help didn't think twice before saying yes. No one is sure exactly how many innocent young women Ted Bundy murdered during his leisurely five-state killing spree, which extended from 1974 to 1978. Official estimates, based on investigations and his own confessions, put the number at 36, though some fear it could be more than 100.

Bundy's 42 years of existence, which ended in an electric chair on January 24, 1989, were freaky from the moment he was born at the Elizabeth Lund Home for Unwed Mothers in Burlington, Vt., on November 24, 1946. Theodore Robert Cowell, the illegitimate son of Louise Cowell, was not told the identity of his biological father. When his mother moved in with her parents in Philadelphia, a conspiracy was hatched whereby Ted's grandparents posed as his dad and mom, thus sparing Louise the public shame. Ted spent his early years believing Louise was his sister. It's not clear what she told him when she moved them to Tacoma in 1950 and married John Culpepper Bundy a year later.

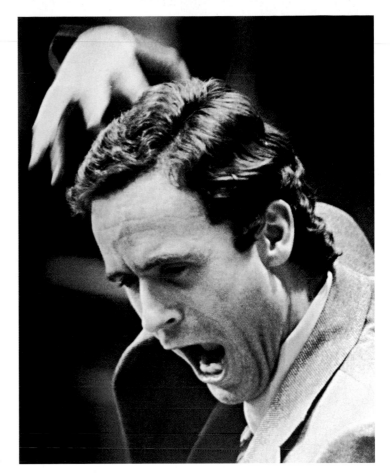

Left: Ever dramatic during his imprisonment and trials, Bundy casts a menacing glare. Top right: In the Florida courtroom, he reacts vigorously as he hears the verdict against him.

As a youth, Ted was a shy loner but a good student who advanced to the local University of Puget Sound in 1965. He was attending law school at Puget Sound in 1974 when he committed his first known murder. On January 31, he snuck into a house where University of Washington student Lynda Ann Healy was sleeping, knocked her out, wrapped her in a sheet and took her away. Over the next few months, more coeds mysteriously disappeared. A number of witnesses reported encountering a handsome young man who called himself Ted—with an arm or a leg in a cast or a sling—asking them to help him put something in his car.

Bundy transferred to the law school at the University of Utah, taking his traveling horror show with him. By the fall of '74, several young women had vanished from the Salt Lake City region; some of their bodies were found sodomized and mutilated. In January 1975, Bundy crossed into Colorado, where over the next few months he murdered more women. Moving next to Pocatello, Idaho, he kidnapped, raped and drowned a teenage girl, then returned to Utah, where he killed yet again. On August 16, a police officer in a suburb of Salt Lake City arrested a man driving a VW Beetle, in which the cop found a ski mask, a crowbar and other suspicious items—including a pair of handcuffs. The collar, identified as Bundy, was soon connected to an unsolved abduction. He was convicted of kidnapping in 1976 and sentenced to 15 years in prison.

Meanwhile, investigators in several states cross-referenced their evidence in a number of unsolved murder cases. In October, Bundy was charged with the death of Caryn Campbell, 24, who had been bludgeoned in Aspen, Colo. He was extradited to that state in June 1977. He escaped from a Colorado prison and headed for Florida. In Tallahassee, he slipped into a Florida State University sorority house on January 15, 1978, and clubbed four women as they slept, then strangled two of them. Three weeks later, Bundy raped and murdered 12-year-old Kimberly Leach in Lake City.

She would be his last victim. On February 15, Bundy—driving a stolen VW bug—was stopped for a traffic violation in Pensacola and arrested. He was charged separately with the Leach and sorority-house murders.

Bundy went on trial for his Florida crimes in 1979 and again in 1980, and was sentenced to death twice. Over the next eight years, he filed several appeals, all of which were denied. He also periodically revealed the grisly details of many of the murders he had committed. The night before his execution, in a final attempt to deflect his guilt, he granted a television interview during which he blamed violent pornography as the trigger for his heinous acts. He never blamed himself.

On December 14, 1980, six days after the shooting outside the Dakota apartment building, fans gather across the street in Central Park to mourn the loss of their idol.

HARRY BENSON

The Murder of John Lennon

The Beatles were important in ways that entertainers seldom are. Their music mattered to people far beyond its melody. When the Beatles sang or spoke, people leaned in and listened closely. The band's two principal songwriters, John Lennon and Paul McCartney, became, to use the cliché, spokesmen for their generation. And then, in April 1970, the Beatles called it quits, and the quartet from Liverpool, England, went their separate ways.

Lennon continued to make music and to command a unique adoration from his audience.

He was a complicated man with an often prickly personality, to put it charitably. Born during a brief lull in the German bombardment of Britain in 1940, Lennon was raised principally by a doting aunt. School proved problematic: He skipped classes and was often in trouble. The lad was foundering, but a ray of light came in the form

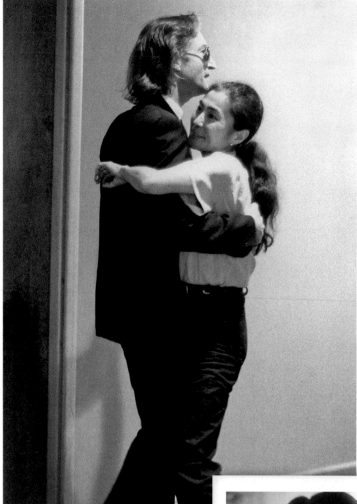

By the late 1970s, Lennon had arrived at a good place. He and Yoko were living in New York, a city they loved. They had finally been able, on October 9, 1975, to have a child. Retreating from the music business, Lennon became a devoted father to little Sean. In 1980, he was ready to get back to work, and he and Yoko made a strong comeback album, *Double Fantasy*.

On December 8, at about five p.m., the couple left their apartment building, the Dakota, on New York City's Upper West Side. Just outside the gates, a few fans were waiting to catch a glimpse of Lennon. The singer paused and signed a copy of the new album held out to him by a young man. This "longtime fan" was Chapman.

At 10:50 p.m., when Lennon and his wife came home from a recording session, Chapman emerged from the shadows calling out, "Mr. Lennon." He shot a .38-caliber revolver five times, hitting Lennon with four of the hollow-point bullets. A Dakota doorman called 911, then approached Chapman, who had sat down on the sidewalk to wait for the police. "Do you know what you've done?" the doorman asked.

"I just shot John Lennon."

That night Lennon died at age 40.

All of this seems madness, of course, and Chapman was expected to plead insanity when he was charged with second-degree murder. But over the objections of his lawyer, Chapman pleaded guilty. He was ruled competent to make the plea and sentenced to 20 years to life in prison.

Who was he, and why did he do it?

At the time, he was a 25-year-old born in Fort Worth, Tex., who had had a difficult upbringing, had suffered from mental illness and survived a suicide attempt, and had developed a number of obsessive passions: for Jesus, for J.D. Salinger's *The Catcher in the Rye*, for the Beatles.

John and Yoko dancing at the Hit Factory Studio (top left) in the fall of 1980, shortly before he was killed; and John feeding Sean (inset) at the Dakota in November 1975. Opposite: The man who took it all away, in a 2000 portrait.

of Elvis Presley. In May 1956, a friend played "Heartbreak Hotel" for him. Here was something that called out to him, took hold of him, something that made him feel alive. He begged his aunt relentlessly to buy him a guitar. She did, and his journey began.

Lennon was the Beatles' principal punk and their primary poet—the philosopher asking in his songs for peace and love and often baring his soul. His first post-Beatles LP was *Plastic Ono Band,* an unflinching album that bored deep into his fears and disillusionment. For the remainder of his career, Lennon produced works that were mainly serious explorations of serious issues: politics, religion, war and his often complex relationship with his second wife, Yoko Ono. People who listened to his music felt that they knew him personally. One of those people was Mark David Chapman.

As to the why, Chapman initially said the answer lay in the Salinger novel, but he might have come closer to the truth when he subsequently told an interviewer that he had been listening to *Plastic Ono Band* in the week before the killing: "I would listen to this music, and I would get angry at him, for saying that he didn't believe in God…and that he didn't believe in the Beatles.… I just wanted to scream out loud, 'Who does he think he is, saying these things about God and heaven and the Beatles? Saying that he doesn't believe in Jesus and things like that.' At that point, my mind was going through a total blackness of anger and rage."

Today, Chapman resides at Attica Correctional Facility and has been denied parole four times.

Across the street from the Dakota, a section of Central Park has been named Strawberry Fields in memory of Lennon. Pilgrims gather there every day. Embedded in mosaic at the site is the word IMAGINE, which references a famous Lennon song—and also asks visitors to consider what might have been.

The Beltway Snipers

For weeks in the fall of 2002, the nation's capital and areas surrounding it were paralyzed with fear. The assumption at the time: A lone sniper was on the loose, shooting people with a high-powered rifle, then racing back onto the Beltway and heading to his next murder. He was methodical and brazen; in one day alone, he had killed five people in five different locations in Maryland and Washington, D.C. The authorities were stymied.

In hindsight, it is clear that some of the thinking was correct, some wasn't. First of all, there were two snipers. And their murders were not restricted to that time or place but included others across the country. Investigators were, in fact, homing in on the suspects by following clues not only in Washington, D.C., but in places ranging from New Jersey to Alabama to Washington State. And the Beltway spree, bad as it was, represented only a preliminary phase in what was planned as a nationwide wave of murder.

On September 5, 2002, a pizzeria owner in Clinton, Md., was shot and wounded, and 16 days later in Montgomery, Ala., a liquor store employee was killed. No one knew it then, but John Allen Muhammad, 41, and Lee Boyd Malvo, 17, had begun a rampage that would eventually leave 10 dead and three wounded. On October 2 at 5:20 p.m., the window of a store in Aspen Hill,

Muhammad (opposite) and Malvo (right). During their spree, fear ruled the day: Field trips were cancelled. Gas stations draped the areas around their pumps with tarps so that customers wouldn't be visible from a distance (inset). Parks were empty on sunny afternoons.

Md., was shattered by gunfire, but no one was hurt. Forty-four minutes later, the first of the so-called Beltway Sniper Murders took place when a man was shot dead in the parking lot of a grocery store in Wheaton. The next morning, another man was killed while mowing grass in White Flint; a taxi driver was murdered while pumping gas at a Mobil station in Rockville; a woman was killed while reading on a bench in nearby Silver Spring; and a second woman was shot down while vacuuming her car at a Shell station in Kensington. Later, Muhammad and Malvo moved from Maryland to Washington, D.C., where, to top off their deadly day, they murdered a 72-year-old retiree strolling along Georgia Avenue.

At one point, a phone tip prompted police to look into the liquor store killing. In Montgomery, they found Malvo's fingerprints (which were on file with immigration services since he had emigrated from Jamaica). This clue led to Bellingham, Wash., where Malvo had lived with Muhammad. Further investigation showed that Muhammad had purchased a blue Chevy Caprice in New Jersey in September and that the murder weapon might be an XM-15 rifle shoplifted from Bull's Eye Shooter Supply in Tacoma. On October 24, police found Muhammad and Malvo in a rest area in Maryland, sleeping inside the Caprice.

At the first trial, held in Virginia, Muhammad received the death sentence, while Malvo, who was obviously in thrall to Muhammad, was given life in prison. At that time, Malvo said he had been the triggerman, but in 2006, he cooperated with authorities in the Maryland trial of Muhammad and admitted he had lied in hopes of sparing his mentor from capital punishment. He said that sometimes Muhammad had been the shooter and that the two of them had also killed people in California, Arizona and Texas—perhaps as many as 16 or 17 in all. He went on to reveal details of Muhammad's grand, mad design: to use as much as $10 million in ransom from the U.S. government to establish an autonomous "pure black" state in Canada with a group of poor orphaned recruits. Muhammad, a radical Islamist and an expert marksman during his years in the Army in the 1980s, would train these young people to fight, and then they would be dispatched to conduct murder missions in the U.S. similar to his and Malvo's. Muhammad used the word *jihad.*

Today, Muhammad sits on death row; Malvo is locked up forever. This particular warped vision of a holy war is over.

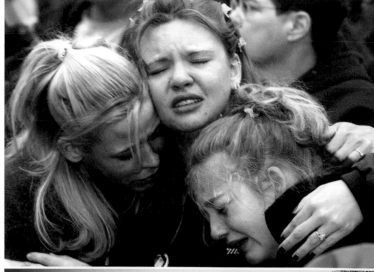

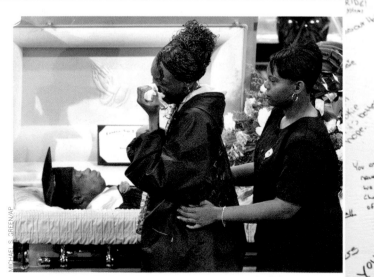

The School Shootings

Center: A vigil in front of Virginia Tech's War Memorial Chapel on April 16, 2007—the day of the shootings. Clockwise from top left: Blacksburg, Va., police rush to the Virginia Tech campus; high school students comfort one another on April 21, 1999, the day after the Columbine shootings; Josh Swans spots his brother, a Columbine student, safe inside a bus; a funeral procession on October 6, 2006, for Anna Mae Stoltzfus, 12, a victim in the Amish schoolhouse shootings; a state trooper reads a Virginia Tech memorial board; family and friends mourn Isaiah Shoels, killed at Columbine; a student weeps during a convocation for the Virginia Tech victims.

Some crimes are too painful, unjust and simply too fresh—too close at hand, too recent—for us to contemplate. It seems cruel, somehow, to dwell upon them.

And yet a book about the most notorious crimes in American history must at least touch upon these incidents, or it neglects its ambition. Thus we deal here in this ultimate chapter with the contemporary phenomenon of the random killing of young people in United States schools. Among heartbreaking tragedies, these have few equals.

But is this trend contemporary? Is it truly exclusive to the modern age?

Certainly the Bath School Disaster, which we recounted earlier in this section, proves that criminal violence aimed at our schools has been with us for some time—at least fourscore years. And the baby boomers among us can readily recall Charles Whitman, who, in 1966, killed 13 and injured dozens more during a shooting spree from atop a 27-story tower at the University of Texas at Austin.

However, from the events in 1999 at Columbine High School in Littleton, Colo., to the shootings on the campus of Virginia Tech, in Blacksburg, Va., in 2007, there has been an ever-growing alarm that this singular form of crime—propelled by rage or a desire for revenge or both—has become part of the American fabric.

Columbine was the wake-up call. When Dylan Klebold, 17, and Eric Harris, 18, ran amok at their school, attended by 900 fellow students, on April 20, 1999—killing 12 kids, a teacher and themselves, and wounding 24—the country's shock was outweighed only by its grief. "You should be safe at school," one Columbine survivor said, expressing the sadness of millions. "This should be a safe place."

But school had become a dangerous place on that day in the town south of Denver—and on the day precisely one month later at Heritage High School in Conyers, Ga., and on March 5, 2001, at Santana High School in Santee, Calif., and on January 16, 2002, at the Appalachian

141

School of Law in Grundy, Va., and on September 24, 2003, at Rocori High in Cold Spring, Minn., and on February 3, 2004, at Southwood Middle School in Miami, and on March 21, 2005, at Red Lake High in Red Lake, Minn., and on November 8 of that year at Campbell County High School in Jacksboro, Tenn. According to the Cleveland-based National School Safety and Security Services, the number of lives claimed in shootings, suicides and murder-suicides in our schools, beginning in the year of the Columbine shootings, breaks down like this:

1999–2000: 33
2000–2001: 31
2001–2002: 17
2002–2003: 16
2003–2004: 49
2004–2005: 39
2005–2006: 27

And then came the 2006–2007 school year. It began darkly with three fatal incidents at U.S. schools in one week. On September 27, 2006, a 53-year-old man took six female students hostage at Platte Canyon High School in Bailey, Colo., and mortally wounded one of them before taking his own life. Only two days later, a 15-year-old student at Weston High School in Cazenovia, Wis., shot and killed the school's principal. And on October 2, Charles Carl Roberts IV, a 32-year-old milk truck driver, entered the one-room Amish schoolhouse in Nickel Mines, Pa., took 10 young girls hostage and bound them. When the police arrived, Roberts threatened a rampage. Marian Fisher, 13, pleaded to be shot first by Roberts, hoping to buy time for the younger girls. Roberts complied and fatally wounded Fisher and four other girls ages seven to 12; he took his own life before police burst in.

The Amish school shooting again captured the nation's attention. President George W. Bush ordered a conference on school violence. But conferences can only do so much: On January 3, 2007, a junior at Henry Foss High School in Tacoma shot and killed another student, an incident that was followed by the Virginia Tech tragedy. There, on April 16, 2007, student Cho Seung-Hui took the lives of 33 students and teachers, including his own. It was the deadliest shooting in the history of our land.

Of course, this story has no silver lining. The school shootings represent a criminal tendency that we can get neither our arms nor our minds around. To see young people with such promising futures senselessly murdered is excruciating.

But maybe in that pain, there is some hope.

We ponder who may have pulled off the Gardner Art Museum heist like we're trying to solve an Agatha Christie mystery, and we recite the ghoulish Lizzie Borden poem for the amusement of our friends. The school shootings, however, touch us deeply, truly, whenever we contemplate them. Of all crimes, they seem the most unfair.

In our judgment of them lies a spark of humanity, and that spark is necessary in our vigilant never-ending fight against crime.

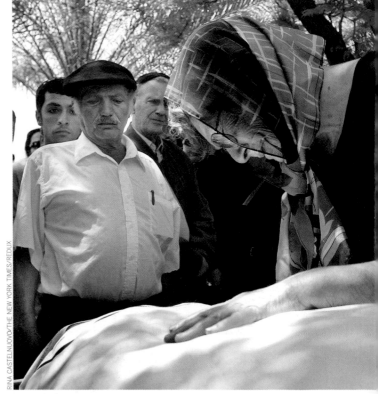

RINA CASTELNUOVO/THE NEW YORK TIMES/REDUX

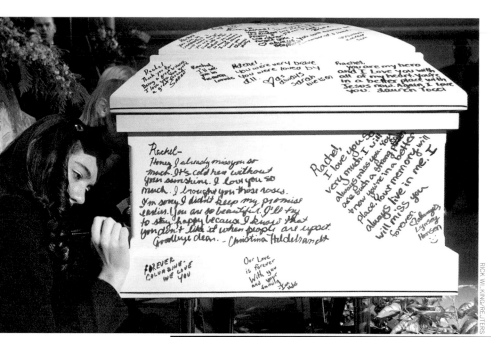

Clockwise from top left: The casket of brave young Marian Fisher is carried to her resting place in Bart Amish Cemetery; mourners of Rachel Scott, a Columbine student, sign her casket; Virginia Tech cadets support one another; two days after the schoolhouse shooting, three Amish children peer cautiously from their buggy; Marlena Librescu, widow of professor Liviu Librescu—who saved students while losing his own life—grieves; Virginia Tech students watch as police swarm their campus.

143

MARC ASNIN/REDUX

In Response to Crime

We move on. The criminals go their way, and we go ours. We are a resilient species, and so we gather what we need and head toward tomorrow. The Amish carry their lunches across the field and return to school. They are unbroken. School doesn't end, work doesn't end. For those of us still here, life goes on. And it ever will. Crime comes and goes, and will come and go forever. But crime doesn't pay—and it will never prevail.